The Art of Riot

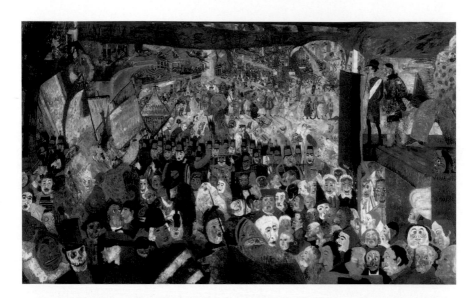

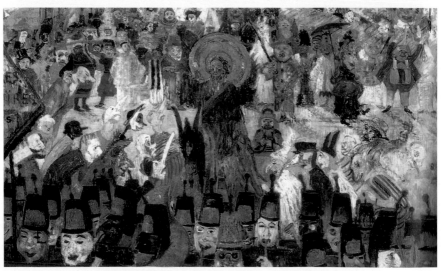

James Ensor, *The Entry of Christ into Brussels in 1889,* painting (1888), and detail. © Artists Rights Society and SABAM. Courtesy of the J. Paul Getty Museum.

THE ART OF RIOT

in England and America

Ronald Paulson

All now was turn'd to jollity and game,
To luxury and *riot*, feast and dance.
Milton. [*Paradise Lost*, 11.714–15]

Transform'd to serpents all, as accessaries
To his bold *riot*.
Milton. [*Paradise Lost*, 10.520–21]

EXAMPLES UNDER **RIOT,** JOHNSON'S *DICTIONARY* (1755)

OWLWORKS

This book has been undertaken by The Archangul Foundation:

Cataloguing information is available from the Library of Congress

ISBN 978-1-934084-06-9

Owlworks is an imprint of The Archangul Foundation, Inc.

Baltimore MD

Typeset in Minion OT

Printed by Thomson-Shore, Inc., Dexter MI

Contents

1. Introduction

Ensor's Entry of Christ into Brussels in 1889

I begin with a well-known representation of a crowd: the Anglo-Belgian artist
James Ensor's *L'Entrée du Christ à Bruxelles en 1889* (1888, frontispiece). This
painting, over eight feet high and fourteen feet wide, will serve as a model for the
art of riot. All the elements are here, together with their ambiguity, and beginning
with the question: When does a crowd become a riot?

A dense mass, filling the picture space, is advancing upon the viewer ("threat-
ening to trample the viewer");[1] it is a sort of parade winding from the distance
into the immediate foreground, and yet it overflows the picture space in all direc-
tions, and is in reality directionless. Although it is a crowd as sheer mass, each
face is individuated. The people are dressed as clowns, many are masked. The
masks are carnival masks, which conceal as they reverse identities. In the tradi-
tional crowds at carnival or some more insurgent enterprise men disguised them-
selves, often as women, in the Boston Tea Party as Indians. At the same time, given
the carnival, the masks may have the effect of containing the subversive energy, re-
ducing these rioters, as threats to social order, to harmless mimes.

There are also, in the middle distance, columns of soldiers, but they include a
marching band with drums and horns, and in the center foreground a figure in a
bishop's mitre, acting as drum major, is leading the crowd. The general sense of
disorder is set against, or qualified by, the indication of order and authority in the
columns of soldiers. The ambiguous relationship of crowd and military order in
The Entry of Christ is clarified by a number of drawings Ensor made in the same
years: One, *Belgium in the Nineteenth Century* (circa 1889, Brussels, Bibliothèque
Royale), shows the bearded King Léopold II, in the pose of God the Father, pre-

1. *Masterpieces of Painting in the J. Paul Getty Museum* (Los Angeles: Getty Museum, 2003), cat. no.
66, p. 120.

siding over a riot—a crowd that has been designated "riot" by Léopold; a "riot" that is being turned into a counter-riot or massacre by his royal troops. In another drawing, *The Strike or The Massacre of the Fishermen* (1888, Antwerp, Koninklijk Museum of Fine Arts), the police and civic guard are suppressing fishermen protesters. The reference is to the social-protest demonstrations that took place in Brussels and throughout Belgium in the 1880s. The troops, in short, represent military intervention, supporting an order that is being threatened by the crowd.

Deep within Ensor's procession, demonstration, or riot, and both defining it and contained by it, is the figure of Christ. He is small, slightly off-center, ambiguous because he represents (as if conflating in the Roman Triumph Caesar and Vercingetorix) both the crowd's icon and its victim: he is leading the crowd or being led, entering the city as Christ did at Passover, thereby threatening the Roman and Judaic law represented by official Jerusalem.

Surrounding Christ, the carnival masks recall the grotesque faces of the mockers and torturers in the depictions by earlier Flemish artists of *Ecce Homo* and the *Flagellation* (Bosch, Brueghel, Massys). The closest model was Bosch's *Christ Carrying the Cross* (1510-16, Ghent Museum of Fine Arts—or the version in London)—Christ's head surrounded, almost obliterated, by the caricatured and grotesque heads of his persecutors and mockers. These faces are transferred by Ensor's irony from the soldiers and priests within the walls of Jerusalem/Brussels to the supposed followers of Christ who lead him into the city: as if to anticipate his fate and, ironically, to make the insiders and outsiders, his followers and persecutors, one.

With the mitred bishop, Ensor's painting appears to show what would happen if (as in Dostoevsky's story of the Grand Inquisitor) Christ were to return to Brussels in the year 1889. *This* is what he would encounter if he returned. Various explanations offer themselves, such as that, assuming that his entry into Brussels recapitulates his entry into Jerusalem, the crowd once again will abandon and scapegoat him; or that people are too involved in their own revelry to acknowledge the presence of the Savior; or that, with the foreground occupied by the officialdom of the military, religious, and political authorities of Belgium, they have coopted Christ.

Christ is now merely a symbol appropriated for "VIVE LA SOCIALE", balanced by "Vive Jesus, roi de Bruxelles". He is a monstrance or icon carried along in yet another "religious" procession. Compare this with Brueghel's *Christ Carrying the Cross* in Vienna, where there is the same ratio of crowd to the Christ figure and the

people are moving about aimlessly, indifferent to the Passion that is taking place — another *Fall of Icarus* (Brussels) on a large scale. The Ensor crowd, from the perspective of the crowd *within* the city, is a riot in progress, but in fact it has already been appropriated by the Romans and the priests who will try and crucify Christ. It has been contained.

Ensor's crowd action is typological: Its title indicates the date, 1889. The contemporary setting evokes the past — the New Testament story and paintings of the Passion. Karl Marx's comment about repeating as farce a subject that was tragedy, while giving a name to his own practice in *The Eighteenth Brumaire of Louis Napoleon* (his attack on the younger Bonaparte), also designated a genre: burlesque, the essential form of Saturnalia. Marx showed how burlesque relates to typology: he turned typology upside down. Christ *fulfills* the promise of David or the story of Jonah; whereas if we show a contemporary in the pose of Christ (Louis in the story of his uncle, the great Bonaparte) he subverts the Christ image, repeating the Passion as farce, the sacred as secular.

Ensor's painting represents a political demonstration, a religious spectacle, an official arrangement of the elements of riot by the government, and an artistic representation of the same. Most commentators on the painting have identified Christ's face as a likeness of Ensor's (a practice consistent with many of his other works), which turns the painting into a story about the artist. And most immediately, Ensor's image recalls and parodies (and corrects) certain kinds of contemporary, official, upbeat art of the Belgian Academy. From the recent past it recalls a popular painting, Jan Verhas's equally huge *The Review of Schoolchildren in 1878* (1880, Brussels, Musées Royaux) in which the neat rows of pretty children are in perfect formation across the public square, or, further back in time, any of the numerous "Joyous Entry" pictures, academic scenes of heroes or victors or monarchs, Charles V and others, entering Brussels in triumph.[2]

The most famous, or infamous, English parallel to Ensor's *Entry of Christ* was not a painting but a painting realized. This event was the Quaker James Naylor's entry into Bristol in 1656, on a donkey and surrounded by his supporters, imitating Christ's entry into Jerusalem; an act that Naylor may have regarded as typology, or a Second Coming, but many saw as a burlesque and a riot, which prompted

2. Patricia G. Berman, James Ensor's "*Christ's Entry into Brussels in 1889*" (Los Angeles, Getty Publications, 2002), 5; see also, for background, Stephen C. McGough, *James Ensor's "The Entry of Christ into Brussels in 1889*" (New York: Garland, 1985), 72–73.

quick and brutal punishment. It was an image that reverberated into the eighteenth century.

In the case of Ensor's painting it is obvious who is representing the riot. In the English example it is not an artist but a leader of the crowd who imposes his representation upon its forms and movements. The crowd can be represented by a leader or by itself, by the customs collected under the title "crowd ritual" or "subculture counter-theater", and by an artist.

There is one final element to note in Ensor's painting, and that is the presence of spectators—in the grandstands at right and left, elevated above the melee—making of the scene a theatrical event, emphasizing the memory of the spectacular Roman Triumph, but also, in modern terms, introducing the philosophy of aesthetics, the experience of the sublime or beautiful or, in this case perhaps, the grotesque, which distances and neutralizes the actual gritty reality of riot.

English Riots: Festive and Seditious

Riot itself is an ambiguous word. Note the progression of definitions in the *OED*:

- — "Wanton, loose, or wasteful living; debauchery, dissipation, extravagance"

- — "Unrestrained revelry, mirth, or noise"

- — "An instance of coarse or loose living: a noisy feast or wanton revel; a disturbance arising from this"

- — "Violence, strife, disorder, tumult, esp. on the part of the populace"

- — "A violent disturbance of the peace by an assembly or body of persons; an outbreak of active lawlessness or disorder among the populace"

The progression is from wanton living and dissipation to unrestrained revelry to a violent disturbance of the peace; and from singular to plural, from the individual to the populace, the microcosm to the macrocosm, the one to the many.

In his *Dictionary* of 1755 Samuel Johnson's first meaning of riot was "Wild and loose festivity", and the second "A sedition; an uproar". "Wild and loose festivity" comes first, I suspect, because the senses of "riot" in the Bible are entirely of the

first sort: the Prodigal Son who "wasted his substance with riotous living" (Luke 15.13); Paul's instruction to "walk not in riot and drunkenness, not in chambering and wantonness, not in strife and envying" (Rom. 13.13).[3]

In English law the Riot Act (I Geo. 2. 5.1715), the context being the Stuart rebellion of that year, referred to "the tumultuous disturbance of the public peace by an unlawful assembly of twelve or more persons who refuse to disperse within an hour of the reading of the Act", and this was called a felony, capitally punished. Riot becomes rebellion (open resistance to an established government), felony treason.

Unlike a rebellion or an uprising, a riot has only a limited aim. Types of riot include food riot, student riot, prison riot, race riot — protesting a food shortage, an unpopular social issue, the conditions of incarceration, racial discriminations, in the forms of what is now technically known as civil disobedience. But the principled demand for rights and goods to which the rioting crowd feels entitled offers a supplementary opportunity for the criminal classes, who often exploit the riot, returning to a form of the "wild and loose festivity" of the first definition. Contemporary examples are the Watts and Rodney King riots, like the Gordon riots of the eighteenth century, ostensibly for justice but branching off into theft and destruction of property.

There may be implicit in the idea of riot something in excess of the local demand — something more generally subversive, or a subtext, as in the Gordon riots, that extends the repeal of an Act of Parliament to the burning of prisons and magistrates' houses.[4] There is always, if we combine the two senses of riot, a satiric cutting edge to the festival that can slip over into violence directed outward from the burning of symbols to the burning of buildings; sometimes inward, as in the self-destruction following upon the pillaging of distilleries.

Festival and sedition, in practice, tend to take the forms of celebration and protest. A riot in the second sense is *against* something — as against the Hanoverian Succession. But the first definition shifts the sense of against — *against* civil order — to *for*, if nothing else for resistance, insubordination, profligacy; and its

3. See also Peter 1:4.4; Titus 1.6.

4. Why is *riots* usually plural (Penlez riots, Gordon riots, Bristol riots)? Presumably because they extend over a series of days or because they crop up in different places, simultaneously or in sequence (at the Houses of Parliament, at Newgate Prison). They are not regarded as a continuous, growing riot but each day a new one. An exception would be the Attica riot, limited to the prison.

most notable form, as Ensor's painting shows, is theater, parade, demonstration, burlesque, and carnival. When people donned masks, the losers became the victors, the world was turned upside down, and slaves ruled their masters, momentarily.

When we say "He's a riot", we mean he is very amusing or laughable (slang from the 1930s); but when we refer to the Watts riots, if we are not a rioter, we think of burning buildings and looting. And yet there is, for the rioters, a sense of release and carnival, of temporary entitlement in the word "riot". Riot is a release from inhibitions, which inevitably involves some insubordination, and so sallies into the second sense, sedition, which by the Riot Act has come to demonize riot. "Irrational exuberance", Alan Greenspan's description of the active stock market, describes festive riot.

Much important work has been done by historians on the phenomenon of the riot and the crowd in the eighteenth century. But in the index of Nicholas Rogers's *Crowds, Culture and Politics in Georgian Britain* (Oxford University Press, 1998), where we find the names of Lefebvre, Rudé, and Thompson, Wilkes and Gordon, one looks in vain for the names of Dryden, Pope, Fielding, Hogarth, and Rowlandson, let alone scholars of literature or art. The same is true of Adrian Randall's more recent *Riotous Assemblies: Popular Protest in Hanoverian England* (Oxford University Press, 2006).

Rogers and Randall, like Lefebvre and the others, explore the economic, social, and political sources, the popular interventions, particular local pressures and manipulative agitations, of the many riots in eighteenth-century England — more food riots than can be counted. Closer to my subject are the essays of E.P. Thompson from the 1960s, which outline the myths that fired the insurgents' (the "radicals'") imagination — the formal structures that shaped "riots", in particular traditional forms of "crowd ritual".

Supplementary to the historians' analysis of the so-called "history from below" or the "traditional forms of protest", I have attempted to add the utilization and elucidation of these myths and symbols by artists. The riots I describe are literary riots, a parallel universe to the real riots (all those food riots), although they intersect at some high points, such as the Gordon riots. Historians do not study these "riots" to learn how riots actually evolved, only how riot was seen or imagined or predicted by painters and writers.

The purpose of this essay is to sketch a taxonomy of riot, English and American, balancing what we know of actual riots against an artist's representation of them.

I start with the two senses of riot, the one legal and the other lexical: the "sedition" of the Riot Act and "wild and loose festivity", which converge in violence, a term that covers both a demonstration that is extralegal in the sense of carnival or Saturnalia and the purposeful physical destruction of symbols of the ruling order.

One question raised by taxonomy, evident in Ensor's painting, is the synonomy of riot and crowd. When does a crowd (more than twelve people) become a riot? As a noun a crowd is a large number of people gathered closely together; but the word also denotes the common people, the *mob*, the *mobile vulgus*, the lower orders that participate in, and are transformed by, carnival or Saturnalia; and as a verb, *crowd* is to press, push, and shove. We are speaking here of the representation of a crowd as an overwhelming mass of people, individuals yet merged, a modern image that replaced the emblem of the hydra, the poisonous snake with many heads—when one is cut off others grow in its place: John Dryden refers to the crowd in *Absalom and Achitophel* (1681) as "a whole Hydra more / Remains of sprouting heads too long to score".[5] The comparison, according to the *OED*, was based on the Lernaean hydra's "baneful or destructive character, its multifarious aspects, or the difficulty of its extirpation", all applicable to both crowd and riot, as in the "hydra of revolt lay stunned and prostrate".[6]

As a crowd implies openness, it wants to grow, to consist of more and more people; it is in the nature of a crowd to be expansive and so to exceed boundaries, to destroy windows and doors, ultimately houses (though not institutions; at that point riot becomes something else). What Elias Canetti in *Crowds & Power* calls the closed crowd[7]—closed, organized, hierarchical, an elite; for example, a club, church, or congregation, a parade, procession, or column of soldiers marching— is in fact not a crowd but, contra a crowd, a group. A church or congregation is a club or a group.

But there is a third category: The Sermon on the Mount took place in the open, people gathering without boundaries, "directed against the limiting [architecture and] ceremoniousness of the official temple".[8] Pauline Christianity broke out of the tribal boundaries of Judaism; and in the eighteenth century Wesley's and Whitefield's Methodism, like the Sermon on the Mount, preached in open air, ex-

5. John Dryden, *Absalom and Achitophel* (1681), ll. 541–42.
6. *OED*, citing Charles Marivale, *The Roman Empire* (1865), 2.xii.59.
7. Elias Canetti, *Crowds & Power*, trans. Carol Stewart (New York: Viking, 1962), 16–17.
8. Ibid., 21.

ceeded and expanded upon the possibilities of the Church of England. To some
degree this corresponds to the license of carnival or the festival crowd.

When does a crowd become a riot? When does "a wild and loose festivity" be-
come a riot? When it gets out of control. Or when the constabulary or military de-
cides it is a "riot". Without the criteria of the Riot Act, riot is only a row or a
ruckus.[9] While there are food, student, prison, and race riots, there are also police
riots. A police riot designates a protest demonstration that has been turned into
a riot by the police and, in notorious cases, turned into a massacre.

The Riot Act, at its worst, intersects with the festive riot, and massacre can be
one result. The idea that peaceful demonstrators are turned into (called) a riot by
the authorities and then themselves "rioted" goes back in England to the St.
George's Fields and the Peterloo massacres, in America to the Boston Massacre
and on up to Attica and Kent State. Obviously, when we introduce police and army,
we are talking in a general way about id and superego, which describe as well the
battle of Carnival and Lent. Riot is defined in relation to the in-place social order,
symbolized by the police.

The taxonomy of riot I propose balances what we know of the riot against the
artist's representation of it and examines the interaction of fact and fiction, fictions
influencing facts as well as facts influencing fictions. To seditious and festive, ac-
tual and fictive riots, we can add effective and affective: the effective (effectual,
consequential) riot vs. the affective (to move or stir the emotions). Has there ever
been an effective riot? It is hard to think of one. Riots usually have more affect
than effect (they are remembered), and this is by way of the literary or graphic re-
verberations that follow the riot. The Gordon riots had an effect: burned buildings
and dead rioters, but in terms of its effectiveness (repeal of Catholic Relief) none;
but its affect, positive and negative, in prints, paintings, writings, and oral reports,
was great. The police riot is not effective — it is suppressed — but it can be highly
affective. The Peterloo Massacre had the notable affect of demonizing HMS armed
forces and establishing the police riot as the model English riot.

I am suggesting that, beginning with the presence in representations of a spec-
tator, there is a significant correspondence between the effective and affective and
the actual and fictive riots. The actual Peterloo Massacre has an affect and may it-

9. *Riot* is related, at least by consonance, to *ruckus* and *row*; a progress in degree from *ruckus*, noisy
confusion or uproar, to row, noisy quarrel, dispute, squabble, or brawl; thence to *ruction*, a riotous out-
break, an insurrection.

self produce (or contribute to) change. But it is the poems and pictures that realize and transmit the affect of Peterloo (or Amritsar), that stir the emotions so as to bring about change or, alternatively, to produce an aesthetic response, aesthetics being the philosophy of spectatorship.

So, by *The Art of Riot* we mean three things: (1) The actual riot: the artifice of riot-making, framed and carried out by the rioters, who adapt conventional structures of the subculture and repeat the shape of riot developed by their predecessors. (2) The fictive riot: the art of representing a riot, or riot; first, the riot created by the artist as representer, but second, also the riot created by the artist as participant — the artist as rioter. (3) The aesthetics of riot: the experiencing, the affect (vs. effect) of riot on spectators, not participants — of the riot itself, of the representation of riot, and of the (conventional) analogues of riot in fire, water, and natural catastrophes — and, of course, representations of these also.

The aesthetics of riot corresponds to the two aspects of riot as festivity and sedition: Festivity engages an aesthetics of variety and complexity — all those details and movements of a crowd, especially a rioting crowd. The terms, set up by Addison but much extended and human-oriented by Hogarth, were the beautiful, novel, and strange. Sedition finds its aesthetic equivalent in Burke's sublime, based on the analogy of the riot/revolution with analogous upheavals in nature. Sometimes one is displaced onto the other — or replaced, riot by the burning Houses of Parliament or, conversely, a fire by the memory and threat of riot-revolution.

2. Fictions of Riot: The Eighteenth Century

Hogarth's March to Finchley

In the eighteenth century William Hogarth's *March to Finchley* of 1750 (fig. 1; I use the widely distributed engraving rather than the painting) is probably the best-known image of a British crowd in action, an image which draws upon two traditions — Western art and popular (plebeian) expression. (We can assume that Ensor had seen engravings of *The March to Finchley*, and that Hogarth's image is somewhere behind his, mediating between Ensor and Bosch or Brueghel. Ensor at one point noted that his use of caricature shared common ground with the works of Hogarth, Rowlandson, and other English artists.)[10]

In the tradition of Western art there were representations of armies (soldiers in formation and in battle) and of crowds; the latter, disordered armies, included the damned in hell (as opposed to the ordered ranks of the blessèd in heaven), but the crowd that most resembled a riot appeared in scenes of the Passion. The crowd is what surrounds Christ in the many pictures of Christ threatened and mocked. Whether leaving the garden of Gesthemene or carrying the cross to Golgotha, Christ is a still point in a procession that, contrasted with his idealized figure, is formally chaos, politically sedition, and, essentially, given the situation, the ultimate treason. I reproduce an example by Dürer (fig. 2), but you will remember Brueghel's painting *Christ Carrying the Cross* in Vienna, and many other panoramic views of crowds with a tiny figure of Christ almost lost in the crowd.

10. Berman, op. cit. For a full account of *The March to Finchley*, see Paulson, *Hogarth*, 2 (New Brunswick: Rutgers University Press, 1992), chap. 14; Paulson, *Hogarth's Graphic Works*, 3rd ed. (London: The Print Room, 1989), cat. no. 184.

With the rise of Humanism the sacred image of the evil crowd was supplemented by the secular crowd or kermess, the tumultuous mobs of Brueghel (in particular his *Carnival* and *Lent* paintings, a template for images of riot and suppression) and in a different mood of Rubens and Jordaens. Hogarth's *March to Finchley* draws upon this tradition without altogether abandoning traces of the sacred. The young grenadier at the center is not a Christ but the classical Hercules, in a Choice of Hercules composition (choosing between Virtue and Pleasure) — and yet the memory of Christ remains: for the recondite, Hercules was a type of Christ. Given the sign of the Adam and Eve Nursery on the left side, with a modern Abel and Cain fighting beneath it, one is asked to interpret the crowd itself as a fallen mankind. On the right side, opposite Adam and Eve, is the sign of Charles II, a brothel. The central figure ought to be Christ in human form and the subject Redemption. But, probably because of the military context, Hogarth's grenadier is the modern Hercules; and yet Hercules is always shown alone at the crossroads with only the two women, Virtue and Pleasure. Here the context, surrounding him with "wild and loose festivity" if not "mockers", urges upon us the sacred allusion, in one form or another, as a subtext. The memory of Christ is present but displaced to an unmistakable Madonna and Child, seated on a cart in the middle distance.

Ten years earlier in the first plate of Hogarth's premier performance, *A Harlot's Progress* (1732), the Harlot was seen typologically, in shifting gestalts: first as a Hercules at the Crossroads (a classical type), then as Mary the Mother in a Visitation (a Christian type), and finally as a specific London prostitute of the 1730s — a likeness of one Kate Hackabout. Hogarth demonstrates thereby the transformation of "old master" history painting into what he called a "modern moral subject". The recollection of the *Harlot's* typology is relevant because a year after publishing *Finchley* Hogarth alluded to the Dürer print of *Christ in the Garden of Gesthemene* in the third *Stage of Cruelty*, where Tom Nero, who has just murdered his lover, is treated by a crowd of rustics as Christ was by the Romans and Jews: the irony is deep and subversive, a sense of "riotous" that pervades Hogarth's work. Typology for Hogarth, an artist of the Enlightenment, was a form of burlesque that repeated the Passion as farce.

As Ensor's *Entry of Christ into Brussels* parodies pictures of "Joyous Entries" into Brussels and ordered ranks of happy schoolchildren, Hogarth's picture recalls the paintings of victorious battles (Le Brun's *Victories of Alexander*, Laguerre's *Marlborough's Victories*) that showed rank upon rank of soldiers successfully di-

rected by a heroic equestrian general.[11] He had an important intermediate influence, Antoine Watteau, who, in his early paintings of the War of the Spanish Succession, portrayed not the battles but the scenes before and after, when the soldiers, out of marching or battle formation, are reduced to their opposite, mere crowds. Similarly, Hogarth defines his crowd against "march" and the idea of "army".

In *Finchley* the crowd, which according to the title should be columns marching to meet the troops of the Stuart Pretender, who had invaded England to restore Catholic tyranny and idolatry, is instead soldiers aimlessly moiling about, disobedient of orders, mixing with camp followers. Dominating, filling the whole foreground and middle distance, is the crowd, which has absorbed the soldiers and designates not a patriotic march to defeat the Catholic Pretender but Saturnalia; and the contrast is reflected in Hogarth's ironic dedication of the print to the King of Prussia, a backhanded reference to the Mutiny Bill of 1749–50, advocated by the duke of Cumberland, the victor (aka "Butcher") of Culloden, who was said to treat English soldiers "rather like Germans than Englishmen".[12] Charles James Fox was later uttering a similar sentiment when he contended that it is better to "be governed by a mob than a standing army".[13] We could say that Hogarth's "army" is what Elias Canetti calls a "feast crowd", characterized by celebration, sexual activity, and inebriation. What might be called "criminality", demonstrated in the foreground, consists of stealing a kiss from a milkmaid, syphoning off her milk, elsewhere gin, pilfering a pastry—all essentially practical jokes, not felonies. But given the Riot Act's criterion of more than twelve people assembling, and refusing to disperse, against the ideal of the troops marching in the background, this is by legal definition a riot.

11. Rouquet's *Description du Tableau de Mr. Hogarth, qui représente la Marche des Gardes à leur rendez-vous de Finchley* (1750).

12. The king's grenadiers were under the immediate command of the duke of Cumberland, "subjected to rigorous military regulations"; while the "hatmen" of the foreground were "closer to a counter militia with all of their failings on full display" (Elizabeth Einberg, "Milton, St. John, and the Importance of 'Bottom': Another Look at Hogarth's *March of the Guards to Finchley*", *The British Art Journal*, 5:30). See also Douglas Fordham, "William Hogarth's *March to Finchley* and the Fate of Comic History Painting", *Art History*, 27 (2004): 95–128; also T. Hayter, *The Army and the Crowd in Mid-Georgian England* (New York: Macmillan, 1978).

13. Christopher Hibbert, *King Mob: The Story of Lord George Gordon and the Riots of 1780* (New York: Dorset Press, 1958), 121.

The Penlez Riots

The context for *The March to Finchley* was the '45, the rebellion led by Charles
Edward, the Stuart pretender to the throne, who landed with an army on the coast
of Scotland, attracted many of the Scottish clans to his cause, and marched south
toward London. At this point the troops of George II were marching north from
Finchley to meet him.

This was no riot, rather a rebellion; the riot in *Finchley* never happened, though
there was something "riotous" in the way of subversion about Hogarth's showing
the "march" as in fact a festivity. And there was the story that George II exclaimed
in anger at Hogarth's treatment of his grenadiers when he was shown the print.[14]

If there was an actual riot on Hogarth's mind it was the Penlez riots of the pre-
ceding summer. On 1 July 1749 three sailors off the H.M.S. *Grafton* were cheated
in a brothel near St. Mary's-le-Strand; they returned with "great numbers of armed
sailors who entirely demolished the goods, cut the feather-beds to pieces, strew'd
the feathers into the street, tore the wearing apparel, and turn'd the women naked
into the street, then broke all the windows and considerably damaged an adjacent
house". [15] The riot spread along the Strand, and over three days three brothels and
adjacent property were destroyed before the civil authority intervened. The civil
authority happened to be Hogarth's friend, the Bow Street Magistrate Henry Field-
ing, who suppressed the riot and prosecuted the ringleaders, including one Bosav-
ern Penlez, a peruke-maker and not one of the sailors, who was caught with a bit
of stolen lace. Fielding was a controversial political figure, a supporter and ap-
pointee of the Pelham ministry, and the Opposition journal *Old England* attacked
him by representing the mob (counter-intuitively) as "honest tars who, having
served their country gallantly on the high seas, wanted now, in an access of patri-
otic zeal, to rid the capital of vice", that is, to destroy brothels. *Old England* saw
Fielding, the author of *Tom Jones*, protecting the brothels, probably taking bribes
from the brothel-keepers, against the brave English soldiers and sailors who de-

14. John Ireland, *Hogarth Illustrated* (1795 ed.), 2:141–42.
15. *Gentleman's Magazine*, "Historical Chronicle", for July 1749.

molished them.[16] Fielding replied in *The True State of the Case of Bosavern Penlez* (1749) that the sailors were

> a licentious, outrageous Mob, who in open Defiance of Laws, Justice or Mercy, committed the most notorious Offences against the Persons and Properties of their Fellow-subjects. ... The Clamour against Bawdy-Houses was in them a bare Pretence only. Wantonness and cruelty were the Motives of most, and some, as it plainly appeared, converted the inhuman Disposition of the Job to the very worst of Purposes, and became Thieves under the Pretense of Reformation.[17]

This was riot not as an agency of reform but as the appropriation of goods. Defending himself against *Old England's* accusation that he (like Tom Jones) defended brothels, Fielding wrote: "The Law clearly considers them as a Nuisance, and hath appointed a remedy against them; and this Remedy it is in the Power of every Man, who desires it, to apply", that is abstinence (58–59). In his *Charge to the Grand Jury*, delivered just before the riots on 29 June (published shortly after), he had spoken out against brothels as tending "directly to the Overthrow of Men's Bodies, to the wasting of their Livelihoods, and to the indangering of their Souls".[18] In his legal pamphlets, as well as in his periodical *The Covent Garden Journal*, Fielding consistently attacked prostitutes — as he would not have earlier in his career, for example in his farce *The Covent-Garden Tragedy* (1732). In his *Enquiry into the late Increase of Robbers* (1751) he referred to such "Licentiousness" as "Saturnalia".[19]

Hogarth, the author of *A Harlot's Progress*, would have disagreed with Fielding about the evil of prostitutes, though they would have agreed in lamenting the sixteen-year-old girl who has been suborned into a life of prostitution (Hogarth's Harlot was about the same age).[20] In *Finchley* Hogarth shows prostitution as part

16. *Old England*, 15 July 1749; for commentary, see Malvin R. Zirker, introduction, Fielding, *An Enquiry into the Causes of the Late Increase of Robbers and Related Writings*, ed. Zirker (Middletown: Wesleyan University Press, 1988).

17. Fielding, *A True State of the Case of Bosavern Penlez*, in *Enquiry*, 58–59.

18. Fielding, *A Charge delivered to the Grand Jury*, in *Enquiry*, 23.

19. Fielding, *An Enquiry into the late Increase of Robbers*, in *Enquiry*, 80.

20. See Paulson, *Hogarth*, 2: 369–71.

of his comic contrast — or corrective — to the regimented columns of the army (formally reflected in the perpendiculars of the brothel, out of whose windows the whores are saucily protruding). He also shows Fielding's "licentious, outrageous Mob" without passing Fielding's harsh judgments on the men.

Fielding's relatively puritan position on the riots, the result in part of his official position as Westminster magistrate, was highlighted by the subsequent trial and capital conviction (6 Sept.) of the supposed inciters of the riot, in particular of the "unfortunate Penlez". The presiding judge, Lord Chief Justice Sir John Willes, rejected the jury's plea for mercy and thrice refused to advise the king to grant a pardon (based on public petitions to the duke of Newcastle) on the grounds that the condemned men must be made an example of — another principle enunciated by Fielding in his legal pamphlets. Hogarth's attitude toward the Penlez affair can be inferred from his inclusion of the face of Chief Justice Willes among the judges of *The Bench* (1758), who illustrate the principle of bad judgment without mercy. Hogarth was in London at the time of the riots — a letter dated the 6th was written to his wife, Jane, who was in their country house in Chiswick — and would have had firsthand experience of them.[21]

Penlez and fourteen others were hanged on 18 October, the anti-ministerial re-action was strong, and Fielding came in for attacks. He responded with *A True State of the Case of Bosavern Penlez* and with a proposed bill for more stringent laws against crimes and a more efficient police force — recalling, Hogarth may have felt, the Mutiny Bill. Fielding's bill extended the range of criminals to include "anyone of low birth found in the streets armed, or in a public house with a concealed weapon; any gamester; anyone guilty of open acts of lewdness, or of profane cursing and swearing; brawlers and drunkards and street-walkers; ballad singers and street musicians; indeed, anyone found abroad or in a public house after ten o'clock who could give no good acount of himself" — crimes that came close to the Riot Act with its mob of twelve people.[22] These are the folks Hogarth showed "rioting" in *Finchley*.

Reading Fielding's account in his *A True State of the Case of Bosavern Penlez*, Hogarth would have noted that his old friend, a colleague of the Opposition to Walpole, had changed his tack. In the 1730s the Riot Act was a repressive Hanoverian weapon used against the liberties of a free people. In those days it was regarded

21. He would have seen a print, *The Sailors' Revenge or the Strand in an Uproar*, which has a composition roughly suggesting the one he used in *Finchley* (reproduced, *Enquiry*, xxxvii).

22. Martin and Ruthe Battestin, *Henry Fielding: A Life* (London: Routledge, 1989), 479.

by the Whigs and their anti-Walpole journal *The Craftsman* as "cruel and oppressive", an expression of "the infamy of the Present Government", an attack on the fundamental principle of English liberty. By the end of the '40s, however, Fielding was working for the government, and in the Penlez pamphlet he defends the Riot Act, reminding his readers that their ancestors have ever "taken the strongest Precautions to guard against so dangerous a political Disease, and which hath so often produced the most fatal Effect". A riot is "High-Treason within the Words Levying War against the King", and he compares it to an army "in manner of War arrayed, ... levying War within the Purview of the above Statute". In the accompanying note he adds that such a group is "called an Army" by Sir Edward Coke.[23] In *Finchley* Hogarth conflates riot and army.

In summary, the elements selected in *The March to Finchley* are disorder, and of a particular kind associated with festivity, including alcohol, inebriation, and sex; misbehavior, theft, and pillaging of a minor sort; and insurgency, in this case because the soldiers shown in the foreground are not following orders, and their actions are defined against the military presence in the distance, a counter-ideal of order to highlight the disorder. All of these elements are of a relatively benign sort, or regarded humorously, for the final element is the presence of spectators, within the picture (the prostitutes at their windows) but also, of course, without — the purchasers of print.

Brueghel had supplemented the disorderly and threatening crowds of the Passion with the listeners and spectators at John the Baptist's sermons and at Christ's Sermon on the Mount, thus providing the further category of spectator — for witnessing, learning, or only appreciating. The spectators in *The March to Finchley* make possible, or imply, enjoyment. The prostitutes represent one pole of value or contrast, a kind of liberty, as they hang out the windows of the Charles II brothel opposite the sign of the Adam and Eve nursery, but they are also enjoying the play going on beneath them. They are, of course, sharing in the riot (they are implementing the soldiers' disobeying of orders), but they are primarily spectators, distanced by their position above and beyond the action, not quite contained by the windows out of which they peer.

Finally, the Hogarth riot is festive, seditious, but also static; it is not going anywhere, has no aim other than denial; *non serviam* but without the subsequent rebellion. It is reacting against restrictions, and only that mild sense righting a

23. Fielding, *True State of the Case*, in *Enquiry*, 34–35, 37; see 34n.

wrong; it is not even Ensor's procession/demonstration. It is not making a demand, only asserting the value of riot against military regimentation. It is primarily concerned, as the presence of spectators attests, with affect rather than effect.[24]

Indoor Riots

In his Penlez pamphlet, Fielding distinguished between private and public riots. The first is when at least three people assemble "in a tumultuous Manner, and commit some Act of Violence amounting to a Breach of the Peace", the purpose being "to redress some Grievance, or to revenge some Quarrel", but specifically "of a private Nature ... in which the Interest of the Public is no ways concerned". A public riot requires "an indefinite Number of Persons" — which will "commit any open Violence with an avowed Design of redressing any public Grievance" such as (in the Penlez case) pulling down bawdy houses.[25]

Hogarthian riot is in Fielding's sense private as well as public and takes place indoors as well as outdoors. If *Finchley* is an outdoor riot, *A Midnight Modern Conversation* (1733, fig. 3) is an indoor riot.[26] What makes *Finchley* a riot in the first, festive sense is obvious; in the second is its subversive tenor — the festive people are disobeying orders to march to Finchley. *Midnight Modern Conversation*, though private, is similarly subversive of law and order — purposeful in that it shows a negative reaction to Sir Robert Walpole's Excise Bill. Hogarth announced his subscription for the print on 18 December 1732; on 8 December the vintners of London had launched a full-scale attack on Walpole's proposed excise on wine and tobacco, which became the most controversial issue of his career. The city of London was strongly against the Excise Bill, and Hogarth adapted a painting of a few years earlier that showed both tobacco and spirits being consumed with abandon and produced this engraving, published in March 1733.

The word *Conversation* in the title — like the word *March* in *Finchley* — indicates the element of burlesque inherent in riot. The "conversation piece" or "picture"

24. I take the context of the Militia Bill (as well as the general tendency of all Hogarth's work) as evidence that the military is not the hint of an ideal in a satire on disorder.

25. Fielding, *True State*, in *Enquiry*, 35–36.

26. For *Midnight Modern Conversation*, see *Hogarth's Graphic Works*, cat. no. 128.

was a Flemish or French genre, associated most recently with Watteau, showing a portrait group usually in an interior but sometimes outdoors, engaged in a party or some other genteel social gathering. Hogarth, celebrated for his ability to catch "likenesses", had made his reputation in the 1720s with conversation pieces. Here the gentlemen, ironically said to be in "conversation", are, in the sense of the Riot Act, rioting. The difference lies in the fact that they are in a private room, not in a public space (a "disturbance of the public peace by an unlawful assembly") and with no indication of the restraining force of public order ("the reading of the Act"); the only sign of order is the grandfather clock. In fact, there is one less than the number required by the Act. And their behavior is self-destructive — vomiting, setting fire to themselves, falling and breaking things, and passing out — consequences that do not reach, have no effect or affect, outside this room.

I have suggested that the models for Hogarth's representation of the rioting crowd in *The March to Finchley* were found in North European painting: not in the heroic battle scenes of Le Brun and Laguerre, nor the evil New Testament crowds of Bosch and Brueghel, though there were traces of these, but in the festive celebrations of Brueghel and Rubens. In *A Midnight Modern Conversation* there were the raucous tavern drinking scenes of Brouwer, Steen, Ostade, and Jordaens. There were also actual riots, for *Finchley* the Penlez riots of the previous summer, for *Conversation* the responses to the Excise Bill. But there was no correspondence between the crowds in London stopping the carriages of Walpole supporters and forcing them to cry "No Excise" and Hogarth's riotous interior; the correspondence was only to the tradition of art.[27]

Subculture Counter-Theater

Hogarth's crowds were culture-specific to England, which means that they reflected the in-place fictions of two English traditions — religious iconoclasm and

27. In fact, in April Walpole's majority in Commons fell disastrously, and the next day he announced withdrawal of the bill. The announcement was met with public celebration: "On the streets of London Walpole was burnt in effigy, along with Queen Caroline, and also, such was the mob's sense of humour, with Sarah Malcolm, a murderess whose bloody crimes had lately enthralled newspaper readers [and whom Hogarth had portrayed in a popular print]. The violence of the populace caused something of a reaction on the back-benches" (Paul Langford, *A Polite and Commercial People: England 1727–1783* [Oxford: Clarendon Press, 1989], 31). In short, Hogarth imagined a scene of riot in reaction to the unpopular bill; but when celebratory riots took place his print could be read as a second kind of riot, celebration of

crowd ritual and subculture counter-theater. Iconoclasm originated with Henry VIII's anti-popery — the systematic breaking of religious images, from the beheading of saints to the burning of relics or of heretics who believed in transubstantiation. Iconoclasm was officially sanctioned in the reign of the Tudors, again in the the practice of the Commonwealth; ambiguous in that it was supposedly directed against those in power, that is the pope in Rome, but was carried out on the orders of the secular authority in London.

Official iconoclasm took the form of substitution, or displacement, replacing Christ with King Henry VIII, the Virgin Mary with Queen Elizabeth, Corpus Christi with carnival, saints' days with national holidays — or perhaps Hercules with a young English grenadier. The popular version of these substitutions has been interpreted by historians as either the lower orders appropriating the symbols and rituals of authority, as they chair their heroes or light bonfires for them (as the nation does for its king or military heroes), or alternatively, as the ruling class institutionalizing plebeian license, offering the lower orders a controlled release from their everyday restraints. From the official perspective there are acceptable ways of release, such as parades on certain calendar days, and unacceptable ones, such as drinking, whoring and, ultimately, thieving, murdering, and rioting. The difference depends on whether the official calendar festivals are used by and for the ruling class, or appropriated by the lower orders and made into their own, tendentious expression.[28]

The riot tells us something about the failure of political and social organization in a civil society. The English crowd was a *faute de mieux* substitute for ruling-order law, as in the "marriage auction" (described by the historian E.P. Thompson),which was the subculture way of dealing with divorce when divorce was only available to the ruling class.[29] At the local fair the husband auctioned off his wife,

the successful crowd ritual that caused the bill to be withdrawn. (For *Sarah Malcolm*, see Paulson, *Hogarth's Graphic Works*, cat. no. 129).

28. Cf. my discussion of the crowd ritual in the chapter "The Crowd", in *Popular and Polite Art in the Age of Hogarth and Fielding* (Notre Dame University Press, 1979).

29. See in particular E.P. Thompson, "The Moral Economy of the English Crowd in the Eighteenth Century", *Past and Present*, 50 (1971): 76–136; reprinted with various other pertinent essays by Thompson in *Customs in Common: Studies in Traditional Popular Culture* (New York: New Press, 1991). The dustjacket design is Hogarth's *Skimmington*. For a critique of Thompson's position, see John Stevenson, "The 'Moral Economy' of the English Crowd: Myth and Reality", in *Order and Disorder in Early Modern England*, ed. Anthony Fletcher and John Stevenson (Cambridge: Cambridge University Press, 1985), esp. 234–35.

selling her for one shilling to her lover, and then the three of them repaired to a local tavern and the ex-husband used his shilling to pay for drinks; they were thus in subculture law divorced.

Thompson's term "moral economy of the crowd" referred to the fact that "behind every form of popular direct action some legitimating notion of right is to be found" — what we could call "popular justice". [30] The plebeian crowd rituals were counter-theater in the sense that they acted out, or mimicked, the actions of their betters but did not actually "live out" their actions. They burned effigies, not people. This was a typically English sanitation of dissent, a containment of potential revolt. But counter-theater has two edges, a pragmatic alternative to the law of the ruling society and a criticism of it, as in the reversals of Saturnalia. For example, by adapting a state holiday or celebration of a national hero, the subculture says *this*, not *that*, is the true holiday or hero.

There is, in social history, the self-presentation "from below" of the subaltern classes in the theater or ritual of the crowd that formalizes riot (as opposed to less formalized or indeed anarchic riot). Then there is another sort of representation — the art of the riot seen "from above", as represented in one way or another by an artist. Hogarth's print *Hudibras and the Skimmington* (fig. 4), from his 1726 *Hudibras* series, shows a crowd carrying out a punishment that is extralegal, extrajudicial, and symbolic, by reversing the roles of husband and wife; he is henpecked and probably cuckolded as indicated by the distaff, petticoats, horns, and (Hogarth's own addition) the sign of the scissors, implying both cuckoldry and castration. The crowd is correcting a case of disorder that is outside the purviews of the official legal system, and Hogarth represents it in his engraving.

Two points: First, there is within the print a spectator. The scene-as-theater is also being observed — above by a contrastingly happy couple in a window, and below by the uncomprehending, quixotic Hudibras and his squire Ralpho. In *Burning the Rumps at Temple Bar* (fig. 5), from the same series, the despised Puritans of the Rump Parliament are being burned and hanged in effigy — another form of symbolic iconoclasm; and again, the scene is observed, enjoyed by spectators as a kind of theater.

Second, carnival was, in effect, the plebeian alternative to law. Inherent in both the crowd ritual and the Hogarth crowd is burlesque. *Finchley* burlesques a troop formation, *Skimmington* burlesques religious and civic processions — and as well

30. Thompson, *The Making of the English Working Class* (Harmondsworth: Penguin, 1977), 73.

it burlesques Renaissance paintings of processionals, most appropriately Annibale Caracci's *Procession of [the marriage of] Bacchus and Ariadne*, another kind of marriage procession, idealized in high art. The parody draws attention to Hogarth's primary agenda, which is aesthetic, the replacement of heroic continental Renaissance art with a native English art, parallel to the populace's replacement of ruling-class law with its demotic equivalent. (This was also Ensor's agenda.)

Closer to *The March to Finchley*, in the last two plates of *Industry and Idleness* (1747, figs. 6, 7) an execution burlesques a Lord Mayor's inauguration. The cuckold and the Rump MP become the ambiguous figures of the condemned felon and the inaugurated Lord Mayor, balanced and equated. In Plate 12 the crowd is ostensibly celebrating the Lord Mayor — but both crowds are drunk and disorderly. Spatially the condemned man and the Lord Mayor, one overlapping the other, coincide and evoke the concept of scapegoat, a person selected as a substitute — a social reject, frequently a criminal — for the real perpetrator, often the king (or the Christ of Ensor's painting).

In one important respect, however, the condemned man and the Lord Mayor are contrasted. The condemned man, raised above the crowd, like the couple in *The Skimmington*, is nevertheless of the crowd, while the Lord Mayor is enclosed in his carriage, insulated from the crowd, from his point of view threatened by the crowd. He represents legal authority, a small alien body bobbing in the midst of riot, serving a purpose similar to the distant columns of soldiers in *Finchley*. Among the spectators at the Lord Mayor's procession, high above both mayor and crowd, are the representatives of rule, the Prince and Princess of Wales.

Twelve years before *The March to Finchley* Hogarth had made a painting and print called *Night*, part of *The Four Times of the Day* (1738, fig. 8); it depicts the end of popular celebration.[31] The oak boughs on the barber's sign, the oak leaves in the Freemason's hat (and the hat of the small man with the wooden sword), the burning links, the bonfire, and the candles in the windows all show that it is May 29, the anniversary of Charles II's restoration in 1660. Although strictly proscribed, "Restoration Day" was celebrated by Jacobite sympathizers under cover of its close proximity to George I's birthday (28 May): the Pretender's birthday followed on June 10. The statue of the Stuart martyr Charles I indicates the am-

31. See *Hogarth's Graphic Works*, cat. no. 149.

biguity of the holiday being celebrated, both Restoration Day (for Tories and Jacobites) and George I's birthday (for Whigs), a typical subculture burlesque, using an official holiday to celebrate an unofficial one.

In *Finchley* the elements are ebullient crowd, buildings closing them in on either side, and the thin line of soldiers marching in order in the far distance. The drama is spatial, and the basic ratio of riot to police, greatly in favor of riot. The same subjects are in *Night*: two characters in the foreground are drunken Freemasons staggering home. "Bagnio" and "New Bagnio" are signs for brothels. The celebratory bonfire in the middle of the road has caused the coach (carrying provincials arriving in London from Salisbury) to overturn. The occupants are spilling out, and two spectators in the immediate foreground, their backs to us, watch the helpless passengers; someone has thrown a burning link into the coach (another burns on the ground). In the distance smoke is billowing from a large fire. The cart of furniture passing in the distance may be refugees fleeing the fire. Unlike the positive riotous behavior of *Finchley*, in *Night* it is physical destruction, with no columns of soldiers against which to judge the disorder; rather, all there is to replace the military presence is the statue of Charles I, a king, but a long-dead, indeed dethroned one. Hogarth does not endorse the celebration, does not intimate that he has Jacobite sympathies, but his image implicates the viewers in the subversion of social values being enjoyed by the two spectators who serve as our surrogates.

The crucial issue in discussion of carnival and crowd ritual has been whether the action was contained or uncontained, plebeian-oriented or set up by the ruling order as an escape valve. For Hogarth, the political realist, plebeian theater and ritual both expressed and contained the subversive energies of the crowd. I don't take this, as some have, to be Hogarth's selling out to the establishment.[32] Rather I think he sees hope in Samuel Johnson's first dictionary sense of riot — "wild and loose festivity" — but fears the second sense, "sedition", riot with art removed, and can discern no hope of success in this form of "riot"; he can only show how by rioting the lower orders find pragmatic ways to survive — whether by theater or parody, inebriation or religion.

32. See David Solkin, *Painting for Money* (New Haven: Yale University Press, 1992).

Tory Fictions of Riot

In eighteenth-century England there were the Tory and Whig fictions or myths of riot and then there was the reality of an insecure Protestant Hanoverian regime threatened (it was felt) by the Stuart papists abroad and Jacobites at home. The great exemplar, the Gordon riots of 1780, focused on the Catholics, with, as background, the revolution in the Colonies, and the later retellings of it, the replications and reinterpretations, were shadowed by the revolution in France.

One fiction, which I will call the Whig riot, carried a relatively positive valence and was a reaction to the Tory fiction of riot. Developed in the Restoration, formulated as a response to the Exclusion Crisis of the 1670s, and presupposing a crowd synonymous with riot, the Tory riot was literary in origin. In his verse satire *Absalom and Achitophel* (1681), about the Exclusion Crisis, John Dryden makes a passing reference to the old emblematic many-headed hydra, but at length he invokes the Old Testament Jews as his *mobile vulgus*, a crowd that foreshadows the New Testament crowd that threatens Christ:

> The Jews, a headstrong, moody, murm'ring race
> As ever tri'd th'extent and stretch of grace;
> God's pamper'd people whom, debauch'd with ease,
> No king could govern, nor no god could please …
> These Adam-wits, too fortunately free,
> Began to dream they wanted liberty;
> And when no rule, no precedent was found
> Of men by laws less circumscrib'd and bound,
> They led their wild desires to woods and caves,
> And thought that all but savages were slaves. (ll. 45–56)

This crowd consisted of the Protestant protesters, the Dissenters who, for Dryden and his patron Charles II, were memories of the crowds in the 1640s, inspired by religious and political firebrands, that first beheaded church icons and finally the king himself. The fiction included a villain who "manipulated" or "orchestrated" the riot, taking advantage of the traditional forms of protest.

The fiction Dryden constructed in *Absalom and Achitophel* consisted of (1) a crowd, the *mobile vulgus*, volatile, dangerous, and easily swayed; (2) a plot, the so-

called Popish Plot, that dupes the crowd into riot and revolt; (3) an ambitious courtier, the earl of Shaftesbury (Dryden's Achitophel), who exploits the plot to incite the mob to overthrow Charles II (King David), and, finally, (4) a semi-royal figurehead for the mob to follow, an Absalom or a royal bastard, the duke of Monmouth.[33]

Dryden alluded in the story of Charles II and Monmouth to the story of the son Absalom rebelling against his father David in Second Samuel, and behind that to the larger story of rebellion in Milton's *Paradise Lost* (1667). The Tory riot was based on this story of betrayal, seduction, and rebellion of Eve and Adam by Satan, grounded in human intentionality. The unruly crowd was the host of Satan's rebel angels, compared to "a pitchy cloud / Of *Locusts*", who are "seduced' to that foul revolt" against God — by Satan's "guile / Stirr'd up with Envy and Revenge". We see Satan waving his spear "to direct / Their course" (l. 340–41, 333–35, 347–49).

Dryden's Tory narrative was, accommodating contemporary theology, typological: Shaftesbury was related by analogy to the historical precedents of Achitophel and, before him, Satan; the crowd of 1680 was similarly a fulfillment of the Puritan crowd of the 1640s and the Jews of David's Jerusalem.

Since Dryden's ontology was Christian, the rioters were from the outset impotent to do any harm. Their riot was merely part of, subservient to, God's plan; all the king, David or Charles, had to do was reassert his power as God did against Satan, as George III did in 1780 against the Gordon rioters. Hogarth evokes this model in *The March to Finchley* with the Sign of Adam and Eve, which in the context of the '45 suggests, in Elizabeth Einberg's words, "the ultimate account of a failed rebellion against a legitimate higher authority"[34]; and Johnson in his *Dictionary* definition of *riot* as sedition.

And yet Dryden's Achitophel was based on historical facts. The principles of organization were controlled, and a strategy laid out, by Shaftesbury, the organizer, and carried out tactically by his lieutenants. The anti-papist crowd rituals were already in place — real, not fictional, choreographed by the Shaftesbury party. The myth on which Shaftesbury's "plot" was based went back to papal threats on the lives of Henry VIII and Elizabeth — the story Titus Oates concocted of a Popish

33. See Bernard N. Schilling, *Dryden and the Conservative Myth* (New Haven: Yale University Press, 1961); Paulson, *The Fictions of Satire* (New Haven: Yale University Press, 1967).

34. Einberg, op. cit., 31.

Plot that included the murder of the king, the substitution of his popish broth-
er, and the invasion by the French. Dryden simply concocted another plot to
counter the Popish — one of riot and rebellion rather than murder and usurpa-
tion.

A second Tory fiction of riot, Jonathan Swift's, significantly modified Dryden's:
Swift also locates the source of sedition in the *mobile vulgus*, most radically in the
Dissenter congregation, the preacher's tub-pulpit, and the preacher himself. The
crowd (as seen on the title page of *Leviathan*) is a huge body made up of many
Hobbesian men, for whom desire is constantly succeeded by desire moving rest-
lessly about, waiting for a purpose, any purpose. In *A Tale of a Tub* (1704), in
the chapter called "A Digression concerning Madness", Swift uses a natural model,
the human body, the Body Politic, one source being the lines in *Absalom and
Achitophel*:

> For, as when raging fevers boil the blood,
> The standing lake soon floats into a flood,
> And ev'ry hostile humor,which before
> Slept quiet in its channels, bubbles o'er:
> So sev'ral factions from this first ferment
> Work up to foam, and threat the government. (ll. 136–41)

Dryden assigns the ultimate source of rebellion to Shaftesbury's body — "A fiery
soul which, working out its way, / Fretted the pigmy body to decay" (ll. 156–57),
and burst out in rebellion.

Swift taps into the powerful, long-lasting imagery of the organic state, based on
the resemblance to a human being with its significant parts and organs, its health
and illness. In his example something goes wrong in the body: an errant vapor, re-
ferred to as "semen adust", seeks an outlet — a natural one would be in the sex act;
when it can find none it rises to the head, overturns the brains, and the conse-
quence is war if it's a king, revolution if it's a commoner. Swift's vapor is no more
than a natural source of desire for sexual fulfillment that gets diverted into lust
for power in the form of a new religion, government, or philosophy. Thus the un-
satisfied lust of King Henry IV of France finds vent in a war. The charismatic re-
ligious fanatic named Jack (after John Calvin) attempts to overthrow established
religion. Swift made no more distinction between riot, or street demonstrations,
and "revolution" (the word he used to describe the overturning of the brain) than

Dryden, implying that they were the same, and the blanket term was "madness". Sexuality, associated with the source of religious belief, is at the bottom of this natural cataclysm — "semen adust" is what seeks an outlet, and Swift's metaphor makes Eve rather than Satan the chief cause of Adam's fall.

A subsidiary fiction of Tory riot has the riot succeeding; the king has been won to the rioters, and Christ returns as the "Antichrist of Wit". Carnival has replaced civil order. In Pope's *Dunciad* (1728 ff.), the dunces, led in procession by Lewis Theobald (in a later version, by Colley Cibber), are taking over St. James's Palace and the seat of government. In the fourth book (added in 1743) they are in control. They advance, with no trace of order, from the plebeian East End to the aristocratic West End, from Bedlam and the City to Westminster, the cultural and political center of England (as the petitioners of Lord George Gordon will do), and in the process destroy and replace the symbols of value in the high culture with their plebeian shows. They parody the Lord Mayor's procession, which is also a kind of demonstration and riot, as in Hogarth's *Industry and Idleness*. Pope's *Dunciad*, going beyond riot, is a fiction of overthrow, with echoes of apocalypse and the Book of Revelation.

But the dunces, like their models in the *Aeneid*, take time out for games, festive, scatological, and obscene, as they pass through the Strand — racing and diving contests, pissing and noise-making contests. On the darker side, the duncical crowd, as Alvin Kernan has noted, traces a regressive path from creation to uncreation, from order to chaos, with the characteristic verbs of water out of control: it pours, spreads, sluices, gushes, swells, o'erflows, and trickles; as well as creeps, crawls, meanders, flounders on, slips, rolls, waddles, loiters, slides, and lumbers.[35] The dunces recall the Goths sweeping across Europe, the forces of darkness moving from east to west, engulfing one civilization after another: in short, they express both aspects of riot.

Pope's riot is effective, a successful riot, but it is a purely literary event — a fantasy with no referent in history, rather a metaphor for the "riot" of publications by literary hacks, mostly Whig, that were flooding the market and, in Pope's opinion, served to perpetuate Gresham's Law that the bad drives out the good. And yet the Dunces' progress from the City of Westminster anticipates the procession of

35. Alvin B. Kernan, *The Plot of Satire* (New Haven: Yale University Press, 1965), Chap. 8. See also Aubrey Williams, *Pope's "Dunciad": A Study of its Meaning* (Baton Rouge: LSU Press, 1955).

Gordon's Protestant Association fifty years later, similarly based on the counter-theater of the subculture. Both were fictions of legal form or legal redress, and in both cases the crowd retains its fiction of injustice and substitution.

Whig Fictions of Riot

The most popular fictions of riot, employed by both Tory and Whig, were based on nature. Their ultimate literary source was that basic Augustan text of cultural capital, Virgil's *Aeneid*. In Book I Neptune looses the seas upon Aeneas's ships. The sea is the vehicle of a metaphor, civil chaos is the tenor, but the sea is itself politicized, compared to "a crowd of [contemporary Roman] people / ... rocked by a rebellion, and the rabble / rage in their minds, and firebrands and stones / fly fast" — a riot only calmed by Neptune, who is compared to "a man [probably Octavius] remarkable / for righteousness and service" who addresses and calms the crowd.[36]

The Greek soldiers are "a torrent / that hurtles from a mountain stream, lays low / the meadows, low the happy crops, and low / the labor of the oxen, dragging forests / headlong ..." (2:414–20). Again, the Greeks are compared to a "foaming river / when it has burst across resisting banks / and boundaries and overflows, its angry / flood piling in a mass along the plains / as it drags flocks and folds across the fields" (2:684–88).

In Book II fire, "the strongest and oldest symbol of the crowd",[37] is both metaphor and metonymy. The Greeks inside the city of Troy literally produce the conflagration, and are therefore themselves compared to fire — "as when, with furious south winds, a fire / has fallen on a wheat field". Fire was the chief instrument of the Trojan wives' riot in Book 5: they set fire to their husbands' ships to keep them from reaching Italy and founding Rome: "some / snatch from the inner hearths [i.e., the heart of the Roman family], and others / strip down the altars, flinging leaves and branches / and firebrands" (5.870–73).[38] There is also a human

36. *Aeneid*, I:210–20. My translation is Alan Mandelbaum's *The Aeneid of Virgil* (New York: Bantom, 1961). See Canetti, *Crowds & Power*, on fire. 75–77; on water and the sea, 80–81.

37. Canetti, *Crowds & Power*, 26; also 20, 27, 75–80.

38. The description of Juno is from 7.378, where she summons Allecto to stir up a war between the Trojans and the people of Latium. To illustrate her success, Virgil describes the crowd as a top Allecto has set spinning, which activates the riot (7.502–09).

agency: a jealous Juno orders Aeolus, god of the winds, to set the storm against the Trojans's ships, as she later inspires Iris and Allecto to stir up riot in, respectively, the Trojan wives and (Book 7) King Latinus. But while the agency is ultimately with the gods, the riot itself is, unlike the Tory fiction of wicked personal intention and action, a force of nature that is beyond human control.[39]

In his formulation of a Whig fiction in the 1710s, Joseph Addison in *The Spectator* took the Tory image of the rioting crowd, the essential metaphor of breaking out, negative and burdened with Christian images of original sin and rebellion, and gave it a positive valence, removing the villainy, intentionality, and personality. Swift's was a Whiggish release not of pent-up energy (a positive) but of evil vapors, sexually/religiously based, dangerous to the Body Politic. But it may, in fact, be a good (a natural) thing for a pent-up river to "burst across resisting banks / and boundaries and overflow", because, aesthetically as well as politically, it is beautiful: "The Mind of Man", Addison writes in "The Pleasures of the Imagination",

> naturally hates every thing that looks like a Restraint upon it, and is apt to fancy it self under a sort of Confinement, when the Sight is pent up in a narrow Compass, and shortned on every side by the Neighbourhood of Walls or Mountains. On the contrary, a spacious Horison is an Image of Liberty, where the Eye has Room to range abroad, to expatiate at large on the Immensity of its Views, and to lose it self amidst the Variety of Objects that offer themselves to its Observation.[40]

Liberty, variety, observation: These are the Addisonian terms, attached to the aesthetic term beauty (including physical, sexual attraction), the terms that will join the politics of Hogarth and John Wilkes. Addison, the clever rhetorician, appropriates the persuasive power of aesthetics, including its alleged disinterestedness, to serve his Whig political and social agenda. In other words, he introduces an "action-oriented" aspect (vs. "contemplation-oriented") into aesthetics, as he introduces the aesthetic dimension into politics.

The common ground between the Tory and Whig riots is in nature. The Tory focused on the human body, the Body Politic. The alternative image of riot was

39. A third metaphor employed by Virgil in the *Aeneid*, with the intentionality that explains fire and flood, on a human level, is madness. But in this case it is the Trojans who, deceived by the Greeks, push the horse that will destroy them into Troy.

40. *Spectator* No. 412, in *The Spectator*, ed. Donald F. Bond (Oxford: Clarendon Press, 1965), 3:540–41.

natural phenomena, emerging politically from the idea of natural rights, an equally unstoppable force, but one that therapeutically finds a proper outlet. In effect, the difference in the Tory and Whig imagery depends on the evocation of the rights of Englishmen or of natural rights; between the source of human rights in society or government or in nature. What this amounted to was replacing issues of human intention and culpability with the natural phenomenon of large metaphoric forces breaking through barriers and expanding limits. This political fiction began as Addison's counter to the older, at the time he wrote dominant, Tory fiction, the literary tradition that attributed generally malign human motives to a phenomenon regarded as, in the Christian context, unredeemably bad.

The party out of power naturally tended to regard riot most favorably, and the Tories were in power when Addison formulated his sense of riot as liberty from restraint and natural exuberance. When the Whigs held power, for the long stretch following 1714, they passed the Riot Act themselves, and it was Opposition (or anti-Walpole) Whigs who in the 1720s and '30s found the Riot Act a limitation on their rights as Englishmen and attacked it as "cruel and oppressive", an expression of "the infamy of the Present Government".[41]

Politics and Aesthetics

In *The March to Finchley*, as well as in Hogarth's other crowd scenes, we have noted the presence of spectators — the prostitutes peering down out of the windows of the building on the right, and elsewhere the audience of a Skimmington, an execution, or an inauguration — in other prints the spectators at a play who may attend or disrupt, applaud or hiss the action. In Plates 11 and 12 of *Industry and Idleness* (figs. 6, 7) — as in the scenes of Christ's Passion — the crowd is itself spectatorial. In Edmund Burke's terms executions were displays of judicial theater demonstrating the strength and majesty of the law, and for the spectator pity and terror: But Hogarth's emphasis in *Industry and Idleness* Plate 11 is on the lawless audience who, supposedly being admonished by the scene, is in fact enjoying it, insubordinate to the figures of authority who immediately contain the condemned. Its response carries both a political and an aesthetic charge.

41. See *The Craftsman*, no. 214 (8 Aug. 1730).

Addison aestheticized politics for a pragmatic and rhetorical end, to defeat the Tories; Hogarth ostensibly dropped the politics for a pure aesthetics when he published *The Analysis of Beauty* (1753), but politics remains as a subtext. Like Addison's, his aesthetics supports a Whig ideal of mixed government (Parliament balancing the monarch) as against Tory-Jacobite absolutism. In Plate 2 (fig. 9) and in the text Henry VIII embodies power and stability; Holbein's portrait of Henry figures the qualities of strength, power, and sexual potency. Henry VIII reached the eighteenth century as a figure, physically and politically, of concentrated and absolute power.[42]

Holbein's Henry VIII, who "makes a perfect X with his legs and arms", is Hogarth's primary example of *uniformity*—like "the front of a building", to disrupt which one would like to throw a tree or the shadow of a cloud "or some other object that may answer the same purpose of adding variety"—that is, to reduce the uniformity. Henry's uniformity as stability, "the idea of firmness in standing", is contrasted with delicate serpentine figures by Guido and Correggio, as "necessary, in some degree, to give the idea of rest and motion. But when any such purposes can be as well affected by more irregular parts, the eye is always better pleased on the account of variety".[43] Hogarth's ideal of beauty as well as politics is, formally, "the utmost variety without confusion", or *concordia discors* (a riot within limits), as opposed to uniformity or Tory absolutism.

The two crucial chapters of the *Analysis*, near the beginning, are "Of Variety" and "Of Intricacy". The beautiful object is "a composed variety; for variety uncomposed, and without design, is confusion and deformity" (28); for the spectator, it is "*a composed intricacy of form*" which "may be said, with propriety, to *lead* the eye *a kind of chace*" (34); for Hogarth, the crowd is the ideal subject, the best venue for the love of pursuit, which leads the eye's wandering journey around and throughout the spectacle.

His aesthetics assumes, like his prints, that everyday domestic objects and activities, including the sexual act, are beautiful; aesthetics is about the "beauty" and

42. See Paulson, "The Henry VIII Story in the Eighteenth Century: Words and Images", in *Henry VIII and his Afterlives: Literature, Politics, and Art*, ed. Christopher Highley, John N. King, and Mark Rankin (Cambridge: Cambridge University Press, 2009), 115–40.

43. Hogarth, *The Analysis of Beauty*, ed. Paulson (New Haven: Yale University Press, 1997), 29–30. See also, for the background, Paulson, *The Beautiful, Novel, and Strange: Aesthetics and Heterodoxy* (Baltimore: The Johns Hopkins University Press, 1995).

(which he argues is the same thing) utility of simple activities like making and cooking and engraving. Though he starts with Addison's nature, he means human nature, not landscape.

In terms of human activity, he locates beauty in the dance, especially the lively country dance. If he had to draw upon, in the graphic tradition, the unruly crowds of the Crucifixion and the Tower of Babel, he also had, on a lower level, those peasant festivities, which gave his crowd their normative form, socially and aesthetically. The peasant dances of Brueghel and Rubens, comic not tragic, were presumably his models for the dancers in Plate 2 of *The Analysis of Beauty*, though he places them inside a room, not outdoors, and, by hanging portraits of the kings of England on the walls, politicizes them.

The dance, which he compares to both the waving "Line of Beauty" and the waves of the ocean, is his climactic example of the human forms and actions that display "the greatest variety of movements in serpentine lines imaginable" within a unity, that is, of the riotous crowd aestheticized — he would say, civilized, or we might say contained (63, 109–11). His examples of the crowd tamed in the text of *The Analysis* proceed from the minuet to the country dance by way of Italian peasant dances and the *commedia dell'arte*, as well as the stage comedy of his own time — to which he contrasts (thinking of continental history paintings) "pompous, unmeaning grand ballets" — "serious dancing", he adds, "being even a contradiction in terms", and best danced by "very low people" dancing "in merriment, [who] are generally most entertaining on the stage" (111).

This includes "provincials", and especially pleasing in the country dance, he writes, is "when my eye eagerly pursued a favourite dancer, through all the windings of the figure": he is referring to a female dancer, as throughout, and particularly in the illustrative plates, the female body is his preferred example.[44] The nucleus of the *commedia dell'arte* plot was the comic trio of young lover, young lady, and the old husband or father — around which the braggart soldier and others danced. It is this explosive trio that appears at the lower right of Hogarth's *Analysis*, Plate 2. It is also the sexual nucleus of *Paradise Lost* but seen, as it was in

44. He is correcting the Shaftesbury aesthetics of the male body (note the Antinous in Plate 1 who is being propositioned by an effeminate dancing master). P.N. Furbank, in a review of my edition of *The Analysis of Beauty* in the *NYRB* (18 Dec. 1997), calling my introduction "perverse", was offended by my argument for Hogarth's heterosexual aesthetics (vs. Shaftesbury's homosexual) and the centrality of the woman to his sense of the beautiful.

Finchley, as comedy.[45] *Paradise Lost* provides not only Hogarth's epigraph but the significant lines to describe his dance: "Mazes intricate, / Eccentric, intervolv'd, yet regular / Then most, when most irregular they seem", lines Milton uses to describe the motions of the fallen angels as they prepare for their revolt against heaven" (5.622–24; 111).

Given Hogarth's evolution during these years from political to aesthetic theory, it is possible to understand the crowd in *The March to Finchley*, moving as it does within and without the architectural forms at left and right of the nursery and brothel, as foreshadowing the formal principle of variety. With the architectural closure "it finds relief in a certain degree of sameness; ... and contrasted with variety, [the architecture] adds to it more variety" (27).

The Wilkite Riot: Celebration

John Wilkes was a rake, a friend of Hogarth's in the 1750s, who went into politics as a Pitt Whig supporter. After William Pitt's resignation as first minister in 1761, Wilkes used *The North Briton* to attack the Tory ministry that succeeded Pitt's, putting an end to his successful foreign wars (the Seven Years War); ultimately, in the notorious No. 45, he attacked the king himself, which led to his arrest and the protests known as the Wilkite riots of the later '60s.

Wilkes agreed with Hogarth at the outset on one thing: riot carried both senses, both "against government or lawful authority" and "wild and loose festivity", which took the form of demonstrating, celebrating, and making a symbolic statement about society. Wilkes apparently interpreted *The March to Finchley* and *The Analysis of Beauty* as libertine and was shocked to find that, in the new reign of George III, Hogarth's politics had apparently changed sides. From Hogarth's perspective (now a supporter of the Tory ministry of the earl of Bute), in *The Times, Plate 1* (1762, fig. 10), the Whig crowd has gotten out of hand, become "variety uncom-

45. Hogarth intuits the close relationship of riot to festival and so to dance, those forms that share "[t]he capacity for generating collective joy and warm sense of commonality by feasting, dressing up, singing or shouting and rhythmically moving together", all qualities included in his sense of the beautiful (William McNeill, reviewing Barbara Ehrenreich, *Dancing in the Streets: A History of Collective Joy* [New York: Henry Holt, 2007], in *NYRB*, 27 Sept. 2007, 72).

posed ... confusion and deformity", a positive has turned negative, festivity into fire and destruction, and riot into uprising; liberty from restraint has been pushed over the edge, becoming a threat to law and order. *The Times, Plate 1* derives from *Night* (fig. 8), and if *Finchley* represented variety/beauty, then *Night* pointed to its contrary, confusion and deformity.

Fire, as in the *Aeneid*, is the manifestation of riot, the "flinging" of "firebrands" by Pitt and his supporters, that perpetuated the Seven Years War; they are now fanning the flames, they want the war to continue, and the mob of City officials, merchants, and bruisers clanging their bones and cleavers are worshiping Pitt, who is raised on stilts, a false idol. In the first state of the print Hogarth gives Pitt the figure of Henry VIII, his image of absolutism. He is invoking the Tory fiction in which Pitt is Absalom, the epicenter of riot, while above, in a window, the covert prompter Achitophel, now represented by Wilkes, accompanied by his friend Charles Churchill and his patron Earl Temple, directs the operation.

Riot at this point consisted of crowds that hailed Pitt and threatened Bute's carriage when they appeared in the streets of London. There was not yet a Wilkite riot. The riot of *The Times* is the fanning of the fire, not the fire (of war) itself. Hogarth's print, appearing in September 1762, shows only a projection into riot of "the violence of [Wilkes's] diatribes"[46] in *The North Briton*, which had begun to appear in June—the verbal abuse and ridicule Wilkes heaped upon the Ministry, which according to the legal prosecution was "a breach of the peace", an incitement to riot. Hogarth's argument with Wilkes was no more than Pitt vs. Bute, Whig vs. Tory, imperialist vs. isolationist, war vs. peace. The riot in *The Times* is merely a metaphorical equivalent for the violence of Wilkes's propaganda, based on rhetoric rather than reality—a metaphor, however, that proved proleptic and was to materialize shortly in physical riots. Hogarth predicts correctly that Pitt's City supporters, from butchers up to aldermen and the Lord Mayor, the "people", as Wilkes claimed, will become the Wilkite mob.

The first appearance of this crowd, referred to by one bystander as "of a far higher rank than common mob", was in May 1763 after Wilkes was arrested for his attack on the king (a "breach of the peace") in *North Briton* No. 45. The crowd attended Wilkes to Westminster Hall and celebrated his acquittal with the cries of

46. George Rudé, *Wilkes & Liberty: A Social Study of 1763 to 1774* (Oxford: Clarendon Press, 1962), 21. See, in particular, John Brewer, *Party Ideology and Popular Politics at the Accession of George III* (Cambridge: Cambridge University Press, 1976), chap. 9.

"Liberty! Liberty! Wilkes for ever!"[47] A crowd of more than 500 on 3 December pelted the sheriffs with "hard pieces of wood and dirt" and smashed the glass of Alderman Harley's coach, and demonstrations for "Wilkes and Liberty" took place in Aylesbury, Canterbury, and Dover as well as London and Westminster.

A more radical iconoclasm than Hogarth envisaged made Wilkes, not Pitt, the crowd's icon. The crowd detached horses from Wilkes's carriage and drew him along, the "true" king of England ("God save great Wilkes our King"), or carried out a mock execution on Tower Hill with effigies of the earl of Bute, the dowager Princess of Wales, and Henry Fox, beheaded by a chimney sweep. They were fictive celebrations of misrule, with Wilkes the Lord of Misrule.[48]

As the Wilkite riots showed, riot could go in the direction of sedition, but its primary aim was celebration, like those on the centenary of the 1688 Glorious Revolution or, a year later, on the recovery of George III — the same symbols of a positive sort, with immense amounts of liquor, as for the acquittal or election of Wilkes. The obverse was the lynching riot. In 1756 the affair of Admiral Byng — his alleged cowardice that lost Britain the island of Minorca — produced a crowd action focused on a scapegoat, with extralegal and symbolic lynchings which were then legally materialized in a court martial — to placate "a clamorous and enraged populace", according to Thomas Turner.[49] Political prints came into play, but rather than recording the demonstrations they participated in them, producing parallel images of symbolic executions. The Byng riots were orchestrated by the Ministry, placing blame on Byng that was in fact shared, involving even the forging of papers. The opposite was the effect of the Admiral Keppel riots of 1778–79. Keppel was also court-martialed, for the same offense, but the demonstrations were Wilkite, *for* Keppel and against the Ministry. The celebrations after the acquittal recall the Wilkite riots and anticipate the parading of Lord George Gordon a year later. Wilkes, Keppel, and Gordon were heroes of the celebratory riot.

Hogarth's response to Wilkes's celebration was equally demotic — his caricature of Wilkes hoisting the "cap of liberty" on a staff over his head. At this point, before the French Revolution adapted the symbol of the "cap", it would have recalled the famous Roman coin minted after the assassination of Julius Caesar, showing the

47. Horace Bleackley, *The Life of John Wilkes* (London, 1917), 85.

48. See Brewer, op. cit., 190.

49. *The Diary of Thomas Turner 1754–1765*, ed. David Vaisey (Oxford: Clarendon Press, 1984), 93.

"cap", the distinctive headgear worn by Roman slaves when they were freed, poised between two daggers, and underneath, the inscription "Ides of March".[50] Hogarth has Wilkes crowning himself with both a halo and the treasonous cap of "liberty".

There was also, as far as Hogarth was concerned, another dimension to the phenomenon of Wilkite politics. In 1757, four years after he published *The Analysis of Beauty*, Edmund Burke published *A Philosophical Enquiry into the Origin of our Ideas of the Sublime and Beautiful*, correcting Hogarth's idea of beauty as *concordia discors* with an aesthetic of power, pain, and terror, which he called the sublime. A lake or a stream is beautiful, the sea or a natural disaster — the unexpected, the awe-inspiring — is sublime. In *The Times, Plate 1* the crowd, fanning the flames of a fire already begun, shows the effects of the sublime demagoguery of Pitt and Wilkes, and the small group of government (Bute) supporters is trying, like Hogarth, to put out the fire, preserve the state, and reinstate the beautiful. Riot as celebration was, according to Hogarth, a sense of the beautiful; but riot as sedition, taking pleasure in violence, pain, and ruins, was Burke's sublime.

If a palace is beautiful, it follows that its ruins are sublime — "images of a tower, an archangel, the sun rising through mists, or in an eclipse, the ruin of monarchs, and the revolutions of kingdoms".[51] Hogarth's last print, *Tailpiece: or The Bathos* of March 1764 (fig. 11), was an image of the End-of-Things, the world in ruins, which Hogarth regards (returning to the Popean Tory vocabulary) not as sublime but, the consequence of Wilkite riot, as mere *bathos*. To Hogarth, primed not only by his change of allegiance but by his critical reading of Burke's aesthetics of the sublime, the Wilkite celebrations denoted not variety and intricacy but confusion and deformity, their consequence *Bathos*.

The Wilkite Riot: Martyrdom

The Wilkes riots of the post-Hogarth years (Hogarth died in 1764) remained largely true to the more limited end of "wild and loose festivity" as celebration.

50. See *Hogarth's Graphic Works*, cat. no. 214.

51. Edmund Burke, *A Philosophical Enquiry into the Origin of our Ideas of the Sublime and Beautiful*, ed. J.T. Boulton (London: Routledge, 1958), 62. I suspect that *The Bathos* also includes memories of (from September 1763) Wilkes's *Essay on Woman*, that "most scandalous, obscene, and impious libel", the work — in Pitt's words — of "the blasphemer of his God and the libeler of his king" (Bleackley, 137).

Wilkes returned to England from his exile in France, and early in 1768, he stood for Parliament, first in the City of London and then in Middlesex. The demonstrations followed a pattern:

> The mob paraded the whole town from east to west, obliging every body to illuminate and breaking the windows of such as did not do it immediately. The windows of the Mansion-house [the mayor's residence], in particular, were demolished all to pieces, together with a large chandelier and some pier glasses, to the amount of many hundred pounds. They demolished all the windows of Ld Bute, Lord Egmont, Sir Sampson Gideon, Sir William Mayne, and many other gentlemen and tradesmen in most of the public street of both cities, London and Westminster.[52]

These demonstrations, beginning as parodies of the celebrations for national victories, substituting Wilkes for the national hero, took the form of the celebration of "Wilkes and Liberty" by illuminating windows ("Damn you, light up your candles for Wilkes") and marking the number 45 for the *North Briton* that had led to his prosecution, and, if the windows will not be illuminated, breaking them.

There are two considerations: First, the idea that Wilkes stands for liberty and has suffered for it at the hands of the enemies of liberty, thus the sublime. As Burke acknowledged, "since the fall of Ld Chatham, there has been no hero of the Mob but Wilkes", and the duke of Newcastle noted that "Wilkes' merit is being a friend to Liberty; and he has suffered for it; and, therefore, it is not an ill symptom that it should appear that that is a merit with the Nation".[53] Suffering referred to the prosecutions for *North Briton* No. 45 and *The Essay on Woman*, the first sedition and the second obscenity (the issue of General Warrants and Seizure of Papers, violations of liberty), and the charge of "outlawry" hanging over him as he prepared to take his seat in Parliament. Wilkes's discourse was of the "liberty" of English-men, but his subject was General Warrants and his personal liberty in that contest: both in the sense of his libertine behavior (including his *Essay on Woman*) and his being at liberty and not in prison.

Second, the form the demonstrations took was based on the Whig (and Hogarthian) metaphors of Enlightenment and breaking out of confinement (now

52. *Annual Register* (1768), 86.

53. Edmund Burke to Charles O'Hara, 11 April 1768, *Burke Correspondence* (Cambridge: Cambridge University Press, 1958), 1:349, Newcastle to Richmond, 4 April 1768, cited, Rudé, *Wilkes*, 46.

intensified by the threat for Wilkes of prison). The metaphor of a natural phenomenon was implicit in liberty and release, and one form it took was breaking into ale houses and drinking to "Wilkes and Liberty". This had, before Hogarth's allegiance to the Tory ministry, been a positive shared by Hogarth and Wilkes.

The Enlightenment — to which Wilkes's followers drew attention with their imagery of illumination — was the age of "Natural Law", and the riot could be seen as an attack on a wrong that, on the principle of "natural rights", should be and will be righted. The riots were about restraints and the breaking of restraints, and so invoked the metaphor of the ungovernable natural forces of fire and water. So the Tory viewed riot as a perversion of nature and the Whig as a natural phenomenon.

On 27 April Wilkes surrendered himself and was lodged (after some of the usual celebratory parading) in the King's Bench prison near St. George's Fields.

> The next day the prison was surrounded by a prodigious number of persons, but no disturbance happened till night, when the rails which enclosed the footway were pulled up to make a fire, and the inhabitants of the Borough were obliged to illuminate their houses, but a Captain Guard arriving soon after 12 the Mob dispersed.[54]

Demonstrations, which had been fairly regular since the end of March, now continued up to the fatal gathering in St. George's Fields on 10 May. The crowd was converging on the King's Bench with threats to liberate Wilkes. The demonstration coincided with the opening of Parliament, and it was feared that the mob would free Wilkes so he could assume his seat in Parliament. Fearing the worst, the authorities added a Troop of Horse and 100 men of the Third Regiment of Foot Guards to the magistrates. The rumor was spread "that an attempt would be made to break open the prison doors & set Mr. Wilkes & all the prisoners there at Liberty".[55] A poem pasted to the prison wall included the lines,

> Venal judges & Ministers combine
> Wilkes and English Liberty to confine.[56]

54. "Historical Notices of the Borough of Southwark" (MS. account by Richard Corner, preserved in Southwark Library), 134–35; cited, Rudé, *Wilkes*, 48.

55. Add. MSS. 30884, f. 69; cited, Rudé, *Wilkes*, 50.

56. T.S. 11/946/3,457; Add. MSS. 308844, f. 72; cited Rudé, *Wilkes*, 50.

The demonstration grew to as many as 20,000, even 40,000. The Riot Act was read, answered by jeers and stones, and one stone wounded a magistrate. This man, Samuel Gillam, then ordered the guards to pursue the man, who was shot dead, and subsequently to fire into the crowd. A dozen people were killed, some mere bystanders or spectators.

The imagery of Wilkes, liberty, and suffering (scapegoat) was materialized in the "massacre" of the St. George's Fields "riot". The massacre was followed by riots in which the crowd "pulled down" the houses of the men who had suppressed the demonstration. One conclusion drawn by the duke of Newcastle was that "We must either be governed by a mad, lawless Mob, or the peace be preserved only by a Military Force; both of which are unknown to our Constitution".[57] And, as George Rudé concludes,

> Thus the 'massacre' was made to appear among a wider public not merely as the mishandling of a difficult situation by a weak though well-intentioned administration, but as an affair deliberately staged by a brutal and tyrannical executive which would not even scruple, in order to impose its will and to trample on Englishmen's liberties, to hire the muskets of an alien [Hessian] soldiery![58]

Here we have the prototype of the violent repression of riot by the forces of authority, as demonstration (peaceful or otherwise) is labeled riot and turned into a massacre, a police riot.

The Nature of Representation

Not only the representation of an action—a crowd either celebrating or rioting—but the nature and claims of the rioters divided Wilkes and Hogarth. Appearing before the court to defend *North Briton* No. 45 (May 1763), Wilkes defined the principle of liberty as "The liberty of all peers and gentlemen, and"—he added, significantly—"(what touches me more sensibly) that of all the middling and inferior set of people, who stand most in need of protection".[59] What he and Hogarth

57. Newcastle to Rockingham, 13 May 1768, Add. MSS. 32990, ff. 39; Rudé, *Wilkes*, 55.

58. Rudé, *Wilkes*, 56.

59. Quoted, George Nobbe, *The North Briton: A Study in Political Propaganda* (New York, 1939), 230–31.

apparently shared was the representation (in both political and artistic senses) of a crowd formerly unrepresented. Wilkes's idea of "liberty", libertine behavior on the private level, was in the public sphere an extension of the franchise. But the crowd — perhaps more accurately group — Wilkes represented, from which he drew his strength, was "that class of subjects whose property entitles them to [enfranchisement]" — or "representation"; it was not, as *The Plain Dealer* claimed in one of its attacks on Wilkes, "that rude, licentious rabble, who having neither fortune to lose nor reputation to risk, indulge themselves in clamorous invectives against their governors, according to their own capricious humours, or the artful suggestions of others".[60] Those were the people Fielding had attacked in his Penlez pamphlet and his *Enquiry*. Wilkes's crowd demanded liberty, in the sense of the franchise; Hogarth's, the "rabble", sought sheer survival, which ordinarily involved a special kind of riot, inward-turned rather than outward.

We come to the relationship between riot and representation — representation of riot and of the people. Two senses of *representation* apply, one aesthetic and the other political. *Representation* denotes not only the making of a likeness, as of a riot ("to bring clearly and disinctly before the mind by description or depiction; to make visible or manifest"), but, in the second half of the eighteenth century, began to evoke Reform: how the *representative* acts in the place of, or on behalf of, the whole people: who actually represents these people — as who represented the taxed colonists in America? A riot says: This is how these people have to be — have no choice but to be — represented — outside Parliament, by petitioners, posters, and pamphlets; by parades, the breaking of windows, overturning of coaches, and burning of buildings. With Wilkes this becomes the issue of the English riot, focused on the extension of the franchise.

Parliamentary reform as a political issue began with the Wilkite riots of the 1760s, but Wilkes's primary concern was personal — with general warrants and personal liberty, with the liberty to behave in certain ways and to be free from arbitrary imprisonment. Parliamentary reform did not become an issue for Wilkes until the General Election of 1768, when he was elected MP for Middlesex but was rejected (April 1769) by the House of Commons in favor of a candidate with fewer votes.[61] Reform began to be a cause of rioting only after the St. George's

60. *Plain Dealer*, 25 June 1763.
 61. John Cannon, *Parliamentary Reform, 1640-1832* (Cambridge: Cambridge University Press, 1973), 60–67.

Fields massacre of April 1768, and by this time Wilkes's own energies were directed toward a career in the City of London (from Alderman to Lord Mayor). He was briefly a symbol of the need for Parliamentary reform, but the cause was pursued by others; it may have been a subtext of the Gordon riots, and it certainly was luridly illuminated by the French Revolution.

But the case of Wilkes—with all of his rioting followers—raised the issue of "what was the nature of representation". The reference was to attacks on rotten boroughs and the demands for more equal representation in Parliament—the question of equal representation vs. the "polite fiction" of virtual representation. In the background was the American agitation of the later '60s and '70s concerning "taxation without representation", and after 1776, the revolution. As Wilkes proved, and the colonists demonstrated, one form of representation—*faute de mieux*—was a riot.

Representation for Hogarth extended to the "rude, licentious rabble" that appeared, mixed with the other orders, in *The March to Finchley*, but nakedly by themselves in his *Gin Lane* a year later (1751, fig. 12). They were the poor, weak, dispossessed, who were angry, drunk, and violent because they were the weak and poor. Seen in one way, *Gin Lane* makes a powerful claim for those too poor (and licentious) to be protected by their government, but, seen in another way, Hogarth shows them—in a static but now deadly riot—not demanding liberty (the vote) but only turning in upon themselves, partaking of carnival in the solace of gin, damaging and killing only each other, a paradigm of what will happen in the Gordon riots, the Priestley and Bristol, and others. They can be called rioters because they are disorderly—though the indication of order in *Gin Lane* is ironic, not a militia but the distant steeple of a church, significantly St. George Bloomsbury topped with the statue of George I—closer, the cross that belonged on the church steeple is displaced to a pawnbroker's sign, the de facto authority in this street. By contrast, Wilkes's rioters in *The Times* were merchants and small shopkeepers, tradesmen, skilled and semi-skilled workers, craftsmen and mechanics, butchers beating together cleavers and bones, even aldermen—the prosperous people of Hogarth's contrasting pendant to *Gin Lane, Beer Street*.

Wilkes's crowd included the purchasers of Hogarth's prints about the poor and licentious; they were Hogarth's patrons—those we would describe today as the lower as well as upper middle class, whom Wilkes reminded that the constitution gave them liberty yet denied them an equal participation in the political process. Hogarth's characteristic distinction between his business and his art separated

purchasers, who were the market for his prints, from their subject, and not nec-
essarily to his patrons' advantage (the apprentices are preferable to the masters in
Industry and Idleness).

Just before he published *The Times, Plate 1* he made another print, *Enthusiasm
Delineated* (ca. 1761, fig. 13), a religious equivalent of *Gin Lane*, but indoors. It
shows the same rabble, within the closed structure of a Methodist meeting house,
excited and incited and driven mad by a preacher — they are devouring images of
Christ — a parody Eucharist that Wilkes would have enjoyed. Riot is, from one
direction, jollity and games, feast and dance, drinking and debauchery; from an-
other, religious enthusiasm, in particular Antinomianism (against the law), where
the two strains join. Hogarth and Wilkes shared a distrust of religion, but for Ho-
garth religion was like gin, a palliative (in the sense of *to ease without curing*). Like
gin, religion may be implosive rather than explosive, its effect only self-destructive.
Indeed, *Enthusiasm Delineated* is the religious equivalent of *Midnight Modern
Conversation*, that other interior scene, against which *The Sleeping Congregation*
of 1738 now appears to be a norm of proper churchgoing. (In *The Sleeping Con-
gregation* religion also provided relief, but in sleep.)[62] In the wake of the Burkean
and Wilkite rhetoric, however, it was easy for Hogarth, like Swift before him, to
imagine that Christ is, for each of those people, the stimulus to riot; that these
madmen will turn their energies violently outward, leaving their meeting house
and changing from the safe self-destroyers of *Gin Lane* to the dangerous incendi-
aries of *The Times, Plate 1* and the rioters who produced *The Bathos*. Both, as the
Gordon riots proved, were correct interpretations: the occupying and looting of
distilleries both escalated the rioters and destroyed them.[63]

The two subjects of the major English riots were religion and representation. Re-
ligion remained the source of anxiety that drove the riotous impulse, fueling the
strongest prejudices. But riot was about representation; the great English riots

62. See *Hogarth's Graphic Works*, cat. no. 140.

63. Hogarth did not in fact publish *Enthusiasm Delineated*; it was sufficiently liable to prosecution
for blasphemy that he suppressed it, but in 1762 he revised the image, adjusting it to accommodate a
topical scandal. He turned *Enthusiasm Delineated* into *Credulity, Superstition, and Fanaticism*, more nar-
rowly a satire of Methodists's belief in both miracles and ghosts. Sexual-based "enthusiasm" (the equation
of religious belief and sexual desire) is replaced by the safer subject of superstition, though still sexual-
based. The Christs being devoured have been replaced by the contemporary "Cock Lane Ghost", a young
woman who allegedly returned from the dead to condemn her murderer — a fraud recently exposed by
Samuel Johnson and others. For *Enthusiasm* and *Credulity*, see *Hogarth's Graphic Works*, cat. nos. 210 and
210A.

concerned representative government. Reform of the system of representation subsumed the religious riots, which were about the representation of Dissenters ("Repeal") and Roman Catholics ("Emancipation"), as opposed to "Reform", which was the extension of the franchise in general. The effective driving force, as in the Gordon riots, was the fear of popery, and it was under the fear of Emancipation that the supporters of Reform were able eventually, in the 1830s, to slip their bill through and into existence. Representation was historically the bottom line — a line that ran from the Exclusion Crisis to the Reform riots and the Suffragette riots.

3. The Gordon Riots

Facts and Fictions

The primary riot in eighteenth-century England was the one initiated by Lord George Gordon in June 1780. It was a response by the Protestant Association to the passage of the Catholic Relief Act of 1778, which slightly mitigated official discrimination of Roman Catholics; in particular, responding to the needs of the military in the American war, it absolved Catholics from taking the religious oath when joining the army. The foundation for the actions of Gordon's followers was the anti-Catholic myth, based on the fear of papal tyranny and cruelty (the Inquisition), idolatry and persecution; on the memory of the Guy Fawkes plot to blow up the Houses of Parliament, commemorated every year on 4 November; and on the belief that the Catholics started the Great Fire of 1666, enshrined in the inscription on the Fire Monument.

During the Seven Years' War, in his *Invasion* prints (1757) Hogarth projected a Franco-Catholic "invasion", carried out by priests.[64] In the foreground of Plate 1 a monk tests his axe and supervises a sledge (on which condemned heretics were drawn to execution); on it are piled a wheel, whip, fetters, pincers, and miniature gallows, as well as a statue of St. Anthony and a plan for building a monastery in Blackfriars. Popery was, throughout his career, Hogarth's code for tyranny; and this code he shared with the Gordon rioters.[65]

64. See *Hogarth's Graphic Works*, cat. nos. 202–03.

65. Another analogue for — or anticipation of — the Gordon riots was the "Jew Bill" riots of 1753–54, which followed from an equally harmless bill that naturalized Jews then resident in England. In his *Election* prints of 1754–58 Hogarth shows two models for the "Jew Bill" riots. In the first plate there is a riot going on outside the windows of the electoral enclave, and someone has thrown a brick through the window and hit one of the electors. The comedy lies in the juxtaposition of pointless or outdated issues, one being the Jew Bill, another being the Excise Bill of 1733, still a vestige of Tory propaganda, with the mob in action: the empty party slogans of "No Jews, Christianity and the Constitution" and "No Jews,

The actions of the rioters were based upon the rules of crowd ritual, by which, in Nicholas Rogers's words, they "assumed the place of authority. In their own eyes they did what the Anglican establishment should have done, immobilize the Catholic foe in their midst".[66] These extralegal forms of action, aimed at forcing repeal of the Catholic Relief Act, began by holding monthly general meetings, distributing handbills, conducting mass petitioning, holding mass demonstrations and processions. The initial riot, like the Wilkite riots, began with a formal request by the Protestant Association, a petition to the House of Commons against the Act. When the orderly procession of petitioners was broken (possibly before), the crowd attacked the lords who had voted for the Act, pulling them out of their coaches, tearing off their robes, pelting them with mud and excrement, and demolishing their carriages. This was referred to by contemporaries as "the great fall from dignity which their Lordships had suffered", an aspect of Saturnalia.[67] When the request was denied, Gordon was hailed by the crowd as another Wilkes — hero and martyr; the crowd unharnessed his horses and drew Gordon's coach, carrying him in triumph through the streets, forcing anyone encountered to wear a blue cockade and chant "No Popery" or else be roughed up.

The historical phenomenon of the Gordon riots was an advance upon the Wilkite riot in one important way: It turned symbolic into real violence,the lighting or breaking of windows, the discomfiting of the lords, and the burning and looting of buildings. Rejection of the petition prompted an attempt to break into Parliament, attacks on popish chapels ("mass houses"), and the smashing and burning of altars, altar ornaments, vestments, prayerbooks, and pews, as well as the chapels themselves. After the second meeting of Parliament on 6 June, with still no action, the riots became more general, moving out from Catholics to the political establishment, burning the houses of supporters of the bill. After some of

No Naturalization Bill, Old England and Christianity for ever" juxtaposed with the politicians accepting the Jews as part of their electoral crowd.

The fourth *Election* plate shows a different kind of riot. The first was anti-Jew Bill, this one is the counter-riot of the Jews. In the fourth plate the Jewish mob has won the election or taken over, replacing Christianity with Judaism in England — essentially the equivalent twenty-five years later of Gordon's nightmare of the papists taking over. The victory procession consists of Jewish peddlers and fiddlers in a farcical, duncical carnival scene — a displacement of the old fear that England might again become Roman Catholic. See *Hogarth's Graphic Works*, cat. nos. 198–201.

66. Nicholas Rogers, *Crowds, Culture, and Politics in Georgian Britain* (Oxford: Clarendon Press, 1998), 165.

67. Hibbert, *King Mob*, 53.

the first rioters were imprisoned, the request that they be released from Newgate was also made and refused, and this was followed by (or prompted) attacks on prisons — not only Newgate but the Fleet and Bridewell — and then on other institutions, Greenwich Hospital, the Customs House, the Navy Pay Office, the South Sea House, and the offices of the East India Company, the Inns of Court, and finally the Bank of England.

At the Bank it was Wilkes who, declaring that if trusted with power "he w[ould] not leave a rioter alive", "headed the party that drove them away". In conversation with George III, now his friend, he remarked on one of the rioters: "he loves sedition and licentiousness, which I never delighted in. In fact, Sir, he was a Wilkite, *which I never was*".[68]

One explanation for the progress was, as Lord Shelburne put it, that "the present tumult ... lay much deeper than the Bill relative to Roman Catholics". The riot went after Catholic churches but also British prisons, law courts, and the symbols of rule Hogarth had presented in one oppressive image in *Royalty, Episcopacy, and Law*, his print of 1725.[69]

Another explanation was that only after the first, orderly phase — when the requests were denied, or when the crowd lost its order — riot turned into anarchy. The latter phase was focused on festival, on the raiding of Langdale's distillery in Holborn (an excuse for the raid: it was thought to harbor a chapel). Francis Place recalled "the lower order of people stark mad with liquor, huzzaing and parading with flags", and rioters were reported as exclaiming at the "fine fun" they were having.[70] But Thomas Holcroft, in his contemporary account, *A Plain and Succinct Narrative of the Late Riots and Disturbances* (1780), described "the besotted multitude; many of whom killed themselves with drinking non-rectified spirits, and were burnt or buried in the ruins" of the distillery. Here the carnival rioters became the crowd of Hogarth's *Gin Lane* self-destructing in a drunken orgy.[71]

68. *The Letters of Samuel Johnson*, ed. Bruce Redford (Princeton: Princeton University Press, 1992), 271; James Boswell, *Life of Johnson*, ed. George Birkbeck Hill and L.F. Powell, 3 (Oxford: Clarendon Press, 1934): 430 n.4.

69. Hibbert, *King Mob*, 42. See *Hogarth's Graphic Works*, cat. no. 56.

70. British Library, Add. MS 27828, fol. 127; *Old Bailey*, 542, 591.

71. Thomas Holcroft, *A Plain and Succinct Narrative of the Late Riots and Disturbances in the Cities of London and Westminster, and Borough of Southwark* (1780), ed. Garland Harvey Smith (Atlanta: Emory University Library, 1944), 29. For the citation of Holcroft, see Ian Haywood, *Bloody Romanticism: Spectacular Violence and the Politics of Representation, 1776–1832* (New York: Palgrave Macmillan, 2006), 187. He applies the term "self-destruct" to the orgy in the distillery.

The anarchic riot is what Ian Haywood refers to in *Bloody Romanticism* as "the spectacular riot", the simple riot gotten out of control; but Haywood requires the massacring crowd, as in the riots and revolution beginning in 1789 in France, whereas in London the crowd's focus remained on property and the 300 lives lost in the process were mostly rioters.[72] As in the St. George's Fields riot, the lethal violence in the Gordon riots came from the militia that broke up the crowd and killed many so-called rioters and, afterward, from the criminal courts. Of the 62 rioters condemned to death, 25 were hanged, and 39 transported, most of them for the theft of property—a fact that recalls *The March to Finchley*'s examples of, from Hogarth's point of view, petty festive thievery, but from the penal code's, a capital crime.

Thus in tandem were the high-minded fear of popery; the excesses of fanatics; the traditional forms of the crowd ritual; the crowd phenomenon itself of expansion, boundary-breaking, and destruction; all exacerbated by the stimulation of the wine casks and plundered distilleries; and the further activity, under cover of the riots, of the pickpockets and thieves.

Samuel Johnson, writing to his friend Hester Thrale, made a Tory narrative of the riots:

> On Friday the good Protestants [with ironic emphasis on the word "good"] met in St. George's Fields at the summons of Lord George Gordon, and marching to Westminster insulted the Lords and Commons, who all bore it with great tameness. At night the outrages began by the demolition of the Mass house by Lincolns Inn.

He traces a relentless course of destruction:

> On Tuesday night they pulled down [Justice John] Fieldings house and burnt his goods in the Street. ... On Tuesday evening, leaving Fieldings ruins they went to Newgate to demand their companions who had been seized demolishing the Chapel. The Keeper could not release them but by the Mayor's permission, which he went to ask, at his return he found all the prisoners released, and Newgate in a blaze.[73]

72. Haywood, op. cit., chap. 5.
73. Letter to Hester Thrale, 9–10 June, *Letters of Samuel Johnson*, 3:267–68, 271.

And on and on. A day later he writes: "Several chapels have been destroyed, and several inoffensive Papists have been plundered, but the high sport was to burn the Jayls. This was a good rabble trick. The Debtors and the criminals were all set at liberty". And when George III finally takes control, like David-Charles II in *Absalom and Achitophel*: "Government now acts again with its proper force, and we are all again under the protection of the King and the Laws".

Both the Tory and the Whig fictions of riot were proposed in the trial of Lord George Gordon. The offense was treason (greater than felony — while not doing the damage himself, Gordon stood by, encouraging those who did), and the argument was that Gordon, very much like Absalom or Wilkes, "did ordain, prepare and levy publick war against the king ... levy war, insurrection and rebellion against our said Lord the King", in order "to effect by force an alteration of the established law". The prosecution was pointing to his "avowed unwillingness to present the petition unless accompanied by twenty thousand men".[74]

Against this, the defense (Lord Kenyon and Thomas Erskine) argued that Gordon's desire was only to back up the petition with the presence of the Protestant Association and to show Parliament how formidable the Association was, not as a military but as a moral force. The defense attempted to distinguish the petitioners from the rioters, the people of the Protestant Association ("the better sort of tradesmen ... well-dressed, decent sort of people") from the gang of rowdies, ruffians, and blackguards who made the riot — distinguishing orderly procession from riot. It asked, for example: Did the rabble attack the Bank of England as symbol — or simply because there was gold in it to be stolen? Thereafter the defense tried to show, with convincing testimony, that Gordon was "an earnest man desperately trying to control wild and ungovernable forces".[75]

Samuel Johnson's relief in the aftermath of the riots and the trial, "that a precedent should [not] be established for hanging a man for *constructive treason*", places him in the camp of the Hogarth of the 1750s and the Wilkes of the 1760s. And he suggests that, while he would not have shared their sympathy for a "champion of mischief, anarchy and confusion" (his first sense of riot),[76] he had some understanding of Lord George Gordon's overall — however untimely and unseemly — aims. Recall that the great issues of the Whigs at the outset in the 1680s and '90s

74. Quoted, Hibbert, *King Mob*, 135.
75. Hibbert, ibid, 126–27, 147. See also Rogers, *Crowds, Culture, and Politics*, 152–75.
76. Boswell, *Life of Johnson*, 4:87; and Hibbert, *King Mob*, 164.

had been Stuart absolutism, France, and Roman Catholicism — not different from Gordon's agenda. Gordon tapped into a deep strain of English iconoclasm in which Protestantism was simply a code for Liberty and popery for arbitrary power. It followed that he was a "reformer" opposing those parallel phenomena war and the slave trade, as well as capital punishment for trifling thefts, in which regard he anticipated Dickens's emphasis in *Barnaby Rudge* on the cases of Mary Jones and the Gypsy woman, hanged for petty felonies. Gordon subsequently attacked the tyranny in France, supported the French Revolution when it came, went to prison for his beliefs, and died repeating the words of the *Ça ira*. And those final years in his Newgate cell were punctuated by what we might interpret as Saturnalian-carnivalesque parties, in which "Dukes would meet Italian barbers, ladies of fashion would dance with Jewish shopkeepers, soldiers would drink with Members of Parliament, Polish noblemen with American merchants, rabbis with infidels".[77] Gordon's notorious conversion to Judaism was not that surprising — not only a memory of the Jew Bill riots of 1753 but the logical outcome of his iconoclasm, the final fulfillment of his rejection of the figuralness (the idolatry) of popery for the figure*less*ness of Judaism.

The Manipulator / Spectator

It was believed by many that the riot was directed by a shadowy Achitophel, an *eminence grise* behind Absalom-Gordon — one of "those well-dressed men" observed among the rioters; in Lord Mayor Kennet's words, "there are very great people at the bottom of this riot"; these were "the schemers of so deep and well conducted a project", the people "at the *bottom* of the riots", those "who had been *behind* the riots".[78]

Some meant by this French and American agitators. Benjamin Franklin and John Adams were, at the time, in Paris negotiating with the French; others claimed that Lord George Gordon was an American agent and the riots an American plot. On the other hand, many thought these "great people" included Kennet, as well as Frederick Bull and other aldermen whose main objective was to bring down the government in order to end the unpopular and unprofitable war with the

77. Hibbert, *King Mob*, 169.
78. Ibid., 58, 124, 130.

Colonies. Certainly, what enabled the Gordon riots was the inaction of the Lord Mayor and the aldermen and the forces of order ("the great supineness of the civil magistrates", who would not issue the orders to intervene), except for a few local attempts, before the attack on the Bank of England.[79] It is not clear whether the intention on the part of many City officials was to embarrass and unseat the ministry, or whether they were simply afraid, unprepared, and incompetent.

James Boswell, looking back from the 1790s, called it "such daring violence as is unexampled in history". But he dismissed the conspiracy theory: "I am satisfied that there was no combination of plan, either domestick or foreign; but", and here Boswell materializes Swift's body image in the raiding of Langdale's distillery — "that the mischief spread by a gradual contagion of frenzy augmented by the quantities of fermented liquors, of which the deluded populace possessed themselves in the course of their depredations".[80]

Those "well-dressed men", however, certainly included sight-seers, the curious witnesses and aestheticizers of the phenomenon of the Gordon riots. As well as the people who tried to understand the causes and motives of the riots, there were those who opened their windows or went out into the streets to appreciate its effect, and recorded their reactions. Charles Burney wrote that seen from his observatory the burning of Langdale's distillery "surpassed the appearance of Mount Vesuvius in all its fury". Others — Henry Angelo, William Hickey, Emily Warren, and Horace Walpole — went out and surveyed the after-effects — ruins like those of Hogarth's *Bathos*. As the *Annual Register* reported, "Every thing served to impress the mind with ideas of universal anarchy and approaching desolation".[81]

Even Johnson, though his evaluation was moral, not aesthetic, described the scene to Mrs. Thrale in terms Burke would have appreciated: "At night the[y] set fire to the fleet, and to the kingsbench, and I know not how many other places; and one might see the glare of conflagration fill the sky from many parts. The sight was dreadful. ... Such a time of terrour you have been happy in not seeing". And it "would fill You with amazement, it is without any modern example".[82]

79. Ibid., 91.

80. Boswell, *Life of Johnson*, 3:428, 431. Boswell's hero in the story is Akerman, the keeper of Newgate, who refuses to let the crowd in — anticipating Dickens's locksmith Gabriel Varden in *Barnaby Rudge*.

81. Burney, quoted, ibid., 114; *Annual Register* (1780), 262.

82. Letter to Hester Thrale, 9 June, *Letters of Samuel Johnson*, 3:269.

Graphic Images of Riot: Wheatley and Rowlandson

In Hogarth's *March to Finchley* we had the basic elements of riot: the crowd of rioters, the military presence, and the spectators. Two contemporary prints of the Gordon riots are allegedly reportorial, showing who was actually there (or said to be there), spread across a view of the burning of Newgate. The first (fig. 14) fills the picture space with the billowing smoke and fire rising out of Newgate, the second (fig. 15) reduces the fire and fills the picture space with the rioters; no spectators, only reportage. One is dominated by the consequences of riot, which dwarf the humans. What is noticeable in the other is the prominence of a single figure holding up a sword and a paper inscribed *Death or Liberty, & No Popery*, and suggestive of the one figure we have seen as the symbolic center directing the crowd. The emphasis of the first is on a natural phenomenon, of the other on the human agency. In neither is there a designated spectator.

Francis Wheatley's painting *The Riot in Broad Street* of 1784 (fig. 16) follows the structure of *Finchley*, including the spectators, only adding the smoke and fire. He adapts the components of Hogarth's composition, the basic scenic structure of the flanking buildings, but revises the ratio of mob to the column of troops (the forces of the City of London Militia). He has filled the middle with the troops, now victorious, moving them up from their position in the far distance, and reducing the mob to a clump on the left, outlined by the smoke and fire between them and the troops. The shift of emphasis is from Hogarth's planimetric composition to the deep-recession of the baroque, an element of the sublime compositions inspired by Burke's *Philosophical Enquiry*.

The other element was the spectators. Figures similar to Hogarth's prostitutes appear watching from safe spots in the windows of the building at the right. But they are not prostitutes; they offer no comic contrast to the Adam and Eve nursery opposite or the men and women underneath. Comedy is absent from Wheatley's sublime.

Hogarth had made comic, carnivalesque riot a graphic genre, and in the 1780s Thomas Rowlandson extravagantly expanded upon the genre in the wake of actual riots, Wilkite and Gordon. He rearranged the elements of *The March to Finchley* in his large watercolor *The English Review* (which he exhibited at the Royal Academy in 1786, figs. 17, 18): As in *Finchley*, the columns of soldiers (the "review") are in the far distance, the chaos in the foreground, though in this case in a huge

pile-up at the left of the composition. A barking dog has set off the action. (There was a dog in Wheatley's composition, but he was skulking rather than inciting the riot.) He is causing a horse to rear up, knocking over a vendor and endangering a coach, producing a cascade of civilians threatening three grenadiers on horseback — other soldiers are amorously mingling with women in a subsidiary pile-up. One of the horsemen looks over his shoulder at the encroaching disorder, while on the far right are the detached spectators of the riot: representing degrees of detachment from the riot, with a single observer, at the apex of the riot on the left, observing the troops through a telescope (rather like the connoisseur of the picturesque in Rowlandson's *Dr. Syntax* drawings).[83]

Rowlandson's *English Review* counters Wheatley's composition: Wheatley's crowd is in the left foreground, the troops a long line across the middle distance, with the fire and smoke rising between them, formally duplicating the crowd (as effect to cause), and the buildings on either side offer formal closure to the composition. In Rowlandson's *English Review* there is no architectural closure — the people at either side flow over and out of the picture space, emphasizing the riot aspect. The riot is in the left foreground, extending toward the center; whereas the troops are in the very far distance, barely visible. There is no smoke here, no destruction, but only riot. The emphasis, in other words, can be on the riot (positive) or on the consequences (negative), and in the second case the fire and smoke bear a formal resemblance to the pile-up (or cascade) of Rowlandson's rioters.

When Rowlandson shows a safe enclosure, a coach like the one in *The English Review*, it is surrounded, broken, and overthrown. In one example, *George III and Queen Charlotte Driving through Deptford* (ca. 1785, fig. 19), it contains the royal family. Like so many of Rowlandson's works, it is based on a Hogarth prototype — *Industry and Idleness*, Plate 12 (fig. 7), which showed the industrious apprentice on his way to being inaugurated Lord Mayor of London, beleaguered by the riotous crowd. In Rowlandson's drawing the royal family and the line of grenadiers are similarly obscured and overwhelmed by the impingement of the crowd, with the usual dog present, inciting to riot. "The Old Ship" sign at the right, nearest

83. John Hayes detects an echo, perhaps parodic, of Moreau le Jeune's *La Revieu du Roi, à la Plaine des Sablons*, which had been exhibited at the Salon of 1781 (Louvre; see Hayes, *Rowlandson Watercolours and Drawings* (London: Phaidon, 1972). See also Paulson, *Rowlandson: A New Interpretation* (London: Studio Vista, 1972).

the royal coach, evokes the old Ship of State and is commented on by parallel signs announcing the "Learned Pig" and "The Surprising Irish Giant".[84]

Often, however, the coaches are simply collapsing of the weight of their occupants or of their own inertia, and the occupants tumble out, as if an inevitable part of the natural process (fig. 20). (For the beleaguered coach Rowlandson expands upon Hogarth's *Night* from his *Four Times of the Day*, for the overcrowded coach, Hogarth's *Stages of Cruelty*, Plate 2.) Buildings also cannot hold their riotous contents, Rowlandson's bulging, bustling humanity (fig. 21). If the coach or house, seen from the outside, explodes, seen from the inside, it implodes. An artist of extremity, Rowlandson expands the indoor riot of the *Midnight Modern Conversation* into revelers who break out of the room — though only to vomit or pass out; as in Hogarth's print, the actual damage remains internal and inward-turned, against the drinkers and smokers.

The spectators are also present in *English Review* and *George III and Queen Charlotte*. They draw attention to the aesthetic dimension of riot and the fact that Rowlandson's practice is to a large extent based on — an almost parodic extension of — Hogarth's aesthetics in *The Analysis of Beauty*. In one of his most famous drawings, *Exhibition Stare-case* (fig. 22), he allows the cascade of his falling figures to correspond to the serpentine Line of Beauty; again, a dog sets under way the fall of the ladies and gentlemen down the staircase. In this and other drawings of serpentine staircases the tumbling people are not quite contained, indeed they exceed and shatter the formal order of the Line of Beauty — a violation of the containment Hogarth required as a curb on seditious energies.

As in the pun of its title, some people are spectators, shown "staring", rather than participating in, the scene, ogling the young women whose fall down the staircase exposes their charms. Rowlandson's drawings, more exclusively than Hogarth's, tend to be about seeing and aesthetic enjoyment — whether, as in the case of the Royal Academy's annual exhibition in *Stare-case*, or scenes of disarray, natural and human; his spectators extend from the crowd at a hanging (of pictures or of men) to the old voyeurs who evoke versions of *Susanna and the Elders* (a painting that is Rowlandson's favorite background art in his drawings).

84. Rowlandson, in this respect, is also recalling the allegory of Hogarth's *The Stage Coach, or Country Inn Yard* (1747), in which the inn is "The Old Angle [sic] In", a punning way of saying Old England. A crowd was also essentially what Hogarth showed in his *Groups of Heads* and *Characters and Caricaturas* (1730s, 1743) — which Rowlandson develops into great masses of heads gathered together and totally filling the picture space. See Paulson, *Hogarth's Graphic Works*, cat. nos. 167, 143, 144.

Insofar as the Rowlandson riot originates in human agency (as opposed to the accidental dog) the cause is drink or lust, and derives from Hogarth's account of the *commedia dell'arte* in the last pages of *The Analysis of Beauty* and the second illustrative plate (fig. 9). Rowlandson builds many of his compositions around the figures of the young lover, the young woman, and the old man (her husband or father), examples of the beautiful vs. ugly. The riot results from their "wild and loose festivity" and, in relation to husbands and other authority figures, "sedition", and these serve as the same catalyst as the errant dog: similarly aspects of natural phenomena. The public riot then (if we compare figs. 17 and 23) is reduced by Rowlandson to the private one of adultery, the cuckolding of the authority figure. In most cases the cuckolding is successful; occasionally the young lover is caught *in flagrante* by the husband, a representative standing in for the police.

"Cascade" seems to define the form riot takes for Rowlandson. These catastrophes are controlled not by the intentionality of rioters but by the laws of gravity and entropy. In Rowlandson's world the collapse of carriages and buildings is not the result of a Wilkite politics or the agency of insurgency but, when not of errant dogs or lovers, of natural processes, of the way things are. The sense, in the historical context, is of a sudden release from years of oppression, which can take the form of carnival, the crowd ritual, or mere anarchy. Even when the old cuckolded husband catches the young lover, the affect is comic; the genre is not, as it often was with Hogarth, satire but comedy.

"Cascade" also involves a reduction of Hogarth's complex interrelationships, formal and psychological, to the beautiful and the ugly (which he equated with the young and the old), the static and the riotous, the firm and the melting or crumbling, humans merging with animals or foliage (the so-called grotesque). In the Rowlandson crowd forms predominate over individuation on the way to indifferentiation (in political cartoons the "faceless masses", as in the Marxist journal *The Masses*) and the replacement of festive figures by stormy landscapes.

Riot and Revolution

In Paris in 1789 a riot that destroyed the Bastille (like Newgate), another that stormed the palace of Versailles and carried the king and queen to Paris, carried riot to uprising and revolution. In England riot, after Gordon, meant the destruction of property, of churches, prisons, and the symbols of authority. In France in

the 1790s, by contrast, while riot began with the destruction of a prison, the facts and the subsequent imagery were of hanging people from lampposts and beheading them, focused on killing rather than mussing up or humiliating MPs and magistrates (or beheading the statues of saints). The English, deriving from their Reformation iconoclasm, destroyed symbols and metonymies and synecdoches rather than people: effigies of Bute and Henry Fox were beheaded, not the men. The Italian Racchierotti referred to "the English nation composed of good-natured mild people", as opposed to the blood-thirsty French. The rumors in 1780 of victims hanging from lampposts referred to the rioters, not (as in the French Revolution) the objects of the riot.[85]

In *Representations of Revolution* (1983) I wrote: "One of the first things to notice about a revolution is its reliance on natural metaphors of storms, earthquakes, and erupting volcanoes".[86] Following the Civil Wars, Charles Leslie recalled how "three flourishing kingdoms were set all in a flame, which yet that ocean of blood could not quench", and metaphorically it is not easy to mark the point at which riot becomes revolution, phenomena which share the imagery of natural violence.[87] Obviously the difference as to fire and water is a matter of degree, as on a scale ranging from hurricane to apocalypse. Revolution is a 360, not a 180, degree rotation, though it still carries the connotations of a natural cycle.

Riot, unlike revolution, had a single aim — food, employment, fear of the Catholics; the underlying aim in England, improved representation. While riot addressed one local issue, or was simply the expression of pent-up feelings about one issue that may have broadened out into others, revolution changed virtually every substructure of the social system. Riots were repetitious, frequent and, until the Gordon riots, unsurprising; revolution was unprecedented — something hitherto unknown and unexperienced. We have examined the structure of the English riot: a progression from petition against the Catholic Relief Act to an attack on its defenders, then on the parliamentary system, then the whole legal system, and the Bank of England — a movement, propelled by its own momentum, in the direction of revolution but stopped by militia before it could expand into the over-

85. Hibbert, *King Mob*, 95, 119.

86. Paulson, *Representations of Revolution (1789–1820)* (New Haven: Yale University Press, 1983), xviii.

87. Charles Leslie, "The New Association", Part II of *A Collection of Tracts on Several Political Subjects* (1681), cited, Cannon, *Parliamentary Reform*, 24.

throw of the government. Revolution and riot shared the sequence of phases from a sense of liberty as freedom from oppression to freedom to do whatever you want, but revolution went on to more radical and deadly conclusions: from the Fall of the Bastille to the Terror, 9 Thermidor, 18 Brumaire, and the Empire. In fact, the revolutionary phases could be said to dramatize, for conservatives like Burke, the story according to Dryden and Swift.

All the works of Rowlandson I have cited pre-date the French Revolution, though they post-date the Gordon riots, and so they indicate a high water mark of riot short of revolution.[88] Their comedy is another dividing line. Few jokes are associated with the French Revolution. The pleasure and festive air of riot is evacuated in revolution, which is without ambivalence.

Rowlandson was the ultimate artist of riot, whose Hogarthian model was opened up by the Gordon riots into comic and formal extremity. If you add Hogarth's crowds (*Burning of the Rumps*, *The Skimmington*, and *Industry and Idleness*) to the iconography of the Wilkite crowd and the Gordon riots, you approach the representations of Rowlandson. The English artist of the French Revolution was James Gillray, who represented it as lampposts, guillotines, and cannibalism: the revolution murders and devours its own (figs. 24, 25).[89] Rowlandson's drawings celebrated riot; Gillray's etchings were anti-Jacobin — condemnatory, not celebratory, of the revolution. They made no reference to nature as an excuse for riot. The terms were changed with the French Revolution from festive *commedia* and cuckoldry to rape and murder.

The genealogy of riot was from the burst of sexual energy — felicitous as seen by the rioters, dangerous as characterized by Swift. For Swift riot depends on the illness of bodies politic; it begins as an infection, an abscess or boil, and becomes an act of violence, for example a rape. After 1790 one would have remembered the imagery of the sans culotte trespassing on the aristocratic family, seducing or raping the wife; in particular one would have recalled Burke's notorious image of

88. My chapter in *Representations of Revolution* on Rowlandson is, therefore, anachronistic. I wrote: "We might simply call the Rowlandsonian mode a parody sublime of overturning and collapse which reduces the eruption of volcanoes to the accidents of the aged as seen by youth" (117). I saw him as burlesquing the sublime; now I see him as a way station between the Gordon riots and the French Revolution.

89. Cf. Rowlandson's besieged coach pictures and Gillray's *The Republican Attack* (1795), in which Fox, Sheridan, and their "republican" allies are attempting to break into the royal coach, one of them firing through the window.

Queen Marie Antoinette in his *Reflections on the Revolution of France* (1790) being attacked in her bedroom as the crowd cut down her guard:

> A band of cruel ruffians and assassins, reeking with his blood, rushed into the chamber of the queen, and pierced with an hundred strokes of bayonets and poniards the bed, from whence this persecuted woman had but just time to fly almost naked, and through ways unknown to the murderers had escaped to seek refuge at the feet of a king and husband, not secure of his own life for a moment.

This scene never took place, but Burke's invention was powerful and influential: The queen's bed, pierced "with an hundred strokes of bayonets and poniards", was a surrogate for the queen herself, and, as Burke intimates, were she captured she would best play "the Roman matron" and "save herself from the last disgrace by taking her own life".[90]

Dickens's Gordon Riots: *Barnaby Rudge*

The best-known graphic images of the Gordon riots, drawn forty years after, were Hablot K. Brown's illustrations to Charles Dickens's *Barnaby Rudge* (1841). Brown (better known as "Phiz") shows explosive tangles of figures, indebted to Rowlandson's drawings of unruly crowds in the 1780s and '90s. The difference is that Phiz's form is the vignette — a picture with no border, shading off at the edges; the figures explode like a bomb; Rowlandson's figures extend to, are cut off by (and in our imaginations extend beyond), the margins. Specific scenes, such as the carriage (containing the helpless young women) seized by the crowd, recall Rowlandson's besieged carriage scenes (fig. 26). The riot at its height (fig. 27), a street scene with houses being looted, roughly recalls *The Times, Plate 1* seen through Rowlandson's eyes. Although some people are destroying things, most are doing more harm to themselves than to others, summed up in the distillery scene (fig. 28), which, in

90. Edmund Burke, *Reflections on the Revolution in France* (1790), ed. W.B. Todd (New York: Rinehart, 1959), 85–86, 91; see also Paulson, *Representations of Revolution*, 60–61.

his text, Dickens based on Holcroft's *Plain and Succinct Narrative* and memories of *Gin Lane*.[91]

The remarkable aspect of Phiz's illustrations, however, is that they define the riot by means of typology. The crowd's celebration of Lord George Gordon evokes an *Ecce Homo* composition (figs. 29 and 30, the latter by Dürer, but a well-known one by Rembrandt also comes to mind), which suggests the ambiguous role of Gordon, as subject and object, hero and scapegoat, comparable to that of Christ in Ensor's painting. The crowd threatening Gabriel Varden recalls *Christ Mocked* scenes (fig. 31). We could add that the people shown assuming mitres and robes and taking over the Maypole Inn evoke a Saturnalia with Sim Tappertit a lord of misrule. These analogies, in Phiz's drawings, are not merely playful; they base the Gordon riots on historico-religious precedents.

Gordon in an *Ecce Homo* composition, it is safe to say, does not indicate a spiritual dimension in the relentlessly materialistic world of Dickens's novel; nor does it put in question the achetypal story of the Passion; but it reveals how Gordon, shown wide eyed and simple-minded, sees himself as a Savior. The effect is, like Hogarth's, mock heroic. But Gabriel Varden, the stalwart and honest locksmith, is shown withstanding the rioters who are demanding that he open for them the gate of Newgate; unlike Gordon, he is raised by the analogy:

> The savage faces that glared at him, look where he would; the cries of those who thirsted, like wild animals for his blood; the sight of men pressing forward, and trampling down their fellows, as they strove to reach him, and struck at him above the heads of other men, with axes and with iron bars; all failed to daunt him. He looked from man to man, and face to face, and still, with quickened breath and lessening colour, cried firmly, "I will not!"
> (2:220–21)

Phiz has followed Dickens's words, adding only the pikes, and his image recalls Christ and the mob, but it is Christ confronting the mob, not the meek figure of Dürer's woodcuts (see above, fig. 2, as well as fig. 30).

Cases have been made both for and against the authority of Dickens and the independence of Phiz in the invention of the illustrations, but we know that both

91. My edition is Dickens, *Barnaby Rudge*, in *The Works of Charles Dickens*, ed. Andrew Lang (New York: Scribners, 1899), vols. 12 and 13 (labeled 1 and 2), from which I have extracted the illustrations.

Dickens and Phiz were close readers and borrowers of Hogarth's works.[92] The comic shapes of Phiz's illustrations for *Rudge* should be compared with the "dark plates" he made later for *Bleak House* (1852–53), a more sombre and atmospheric effect resembling messotint, that distinguished the comic from the "darker" scenes.[93] In *Rudge* both pre-Gordon and Gordon scenes, as delineated by Phiz, are comic; whereas in the text the first relatively "Dickensian" part is followed by a much more charged narrative of the riots, which evokes the Burkean sublime. Dickens recalls the familiar Virgilian similes, comparing the rioting mob to the sea ("for the ocean is not more fickle and uncertain, more terrible when aroused, more unreasonable, or more cruel") and to "rivers as they roll towards the sea" (2:96, 106) — and of course, metonymically, to fire. The riot is, in Dickens's words, "noise, smoke, light, darkness, frolic, anger, laughter, groans", to which are added "plunder, fear, and ruin!" To "loudest, wildest" are added the words "most destructive" (2:122).[94]

In his original plan for *Barnaby Rudge* Dickens attributed the cause of the riot, which Burke called "a paroxysm of religious phrenzy",[95] to the religious mania of Swift's *Tale of a Tub* and Hogarth's *Enthusiasm Delineated* (which he would have known as *Credulity, Superstition, and Fanaticism*). He intended to make the leaders of the riot — Dennis, Hugh, Sim Tappertit, and Barnaby — madmen escaped from Bedlam. He decided against such obvious symbolism, but he retains the overall feeling of madness.

The maddened Gordon crowd starts with Catholic chapels, then goes after prisons, courts of law, and banks, but it climaxes in distilleries, only to drink gin — for a radical escalation of liberty. As it haunts *Oliver Twist* (1836), *Gin Lane* haunts the text of *Barnaby Rudge*: "What else", says the nearly sub-human Hugh, "has kept away the cold bitter nights, and driven hunger off in starving times? What else

92. For the argument for Phiz's independence, see Michael Steig, *Dickens and Phiz* (Bloomington: Indiana University Press, 1978), chap. 1; for his dependence on Dickens, see John Harvey, *Victorian Novelists and Their Illustrators* (New York: NYU Press, 1971), chaps. 5, 6. See Steig for the influence of Hogarth on Phiz's emblematizing of Dickens's text. One could also note the parallels between the consecutive plates of a Hogarth progress and Phiz's serial illlustrations. Dickens's knowledge of Hogarth was evident, for example, in his shrewd interpretation of *Gin Lane* (review of Cruikshank's "The Drunkard's Children: A Sequel to the Battle", in *The Examiner*, 8 July 1848; and his preface to the 1867 edition of *Oliver Twist*).

93. See Harvey, *Victorian Novelists*, 151.

94. Dickens produces a medley of allusions to Hogarth when he introduces old Rudge (1:236).

95. Edmund Burke, *The Writings and Speeches of Edmund Burke*, ed. W.M. Elofson and John A. Woods, 3 (Oxford: Clarendon Press, 1996): 425.

has given me the strength and courage of a man, when men would have left me to die, a puny child?" (1:236). But for Hugh gin is no longer implosive — fueling him and the other rioters at the Maypole for their destruction of Geoffrey Haredale's house, the Warrens. In *Barnaby Rudge* inebriation gives the mob an illusion of a power which is, of course, contradicted by other laws of nature, for the illusion is inevitably followed by delusion, collapse, and self-destruction.

For Gordon, the radical Protestant, madness is equated with religious mania. Mrs. Varden, supported by her maid Miggs, is a comic example of religion serving as a cover for evil impulses. Gashford is a serious example. The normative Gabriel Varden says to his wife, referring to her religion, that "all good things perverted to evil purposes, are worse than those which are naturally bad". Dickens himself says much the same at the beginning of Chapter 45, and, in his preface, he explains that the Gordon riots teach a lesson, that "what we falsely call a religious cry, is easily raised by men who have no religion; … that it is senseless, besotted, inveterate, and unmerciful …" (2:22, 94).

The motivation of Simon Tappertit, the rebellious apprentice, evokes Swift's hydraulic model of madness:

> As certin liquors, confined in casks too cramped in their dimensions, will ferment, and fret, and chafe in their imprisonment, so the spiritual essence or soul of Mr. Tappertit would sometimes fume within that precious cask, his body, until, with great foam and froth and splutter, it would force a vent, and carry all before it. (1:45)

And the source of Tappertit's vapor, we learn, is lust for Dolly Varden.[96] Of Lord George Gordon, we are told, "struggling through his Puritan's demeanour, was something wild and ungovernable which *broke through* all restraint" (1:358).[97] And within John Chester, who appears all calm and repose, blandness, serenity, and politeness, there is something hidden but always about to burst out — once almost bursts out in the presence of Haredale, and does burst monstrously out in his

96. For Tappertit, see *Barnaby Rudge*, 1:46, 82, 86. For the elaboration of Swift's metaphor of enthusiasm as a basis for social unrest, see 1:369–72; Dickens makes it clear that Gordon is a Don Quixote figure (1:372).

97. Gordon and Barnaby, at top and at bottom of the riot, are equally mad. Gordon tells Barnaby's mother, associating himself and Barnaby, "that those who cling to the truth and support the right cause, are set down as mad" (2:58). (Phiz's illustrations underline the resemblance between the two.)

surrogate and son, Hugh.[98] Some little thing—a frisky dog, a man's desire for revenge, his sexual urge—sets going the natural forces of gravity, inertia, entropy, which (as Rowlandson showed) are then unstoppable.

The nature metaphor was activated or fully charged by the seismic riot become revolution in France in the 1790s. The hydraulic model was recovered by Burke, who starts off his *Reflections on the Revolution in France* with the metaphor of English radical dissent seen through the eyes of his literary mediator Swift: The "spirit of liberty" is a "wild gas", and once "the fixed air is plainly broke loose", he writes, "we ought to suspend our judgment until the first effervescence is a little suspended, till the liquor is cleared, and until we see something deeper than the agitation of a troubled and frothy surface".[99] William Godwin, in *Political Justice* (1793), explained that "Individuals, freed from the terrors by which they had been accustomed to be restrained ... break out [or "burst forth"] into acts of injustice".[100]

So for Dickens's imagery; for his plot Dickens returns to the Christian model of Milton and Dryden: The riot centers on another Absalom, Lord George Gordon, who is directed by an Achitophel, his "secretary" Gashford. Gordon is a figurehead manipulated by his "secretary", who is assisted, from the lower orders, by Dennis, Hugh (acting out the wishes of his father), Sim Tappertit (the conventional rebel apprentice), and Barnaby the idiot, the only undersigning fellow who advances the riot (2:64).

The first part of *Barnaby Rudge*, laid in the year 1775, presents small, private epitomes that anticipate the great public epitome five years later, in the second part, of the Gordon riots. The past lies heavily upon the present, as in the typological situations presented in Phiz's illustrations. The present of the Gordon riots is foreshadowed not only by the events of 1775, and the murder of Reuben Haredale twenty-two years earlier, as also the hanging of Hugh's mother, but by the memory of 1679–81, as also 1715 and 1745, as well as the fires of Bloody Mary and the work of the Inquisition: what Michael Wheeler has described as "those

98. Chester describes himself in the terms Swift gives to the man of illusions (the credulous vs. the curious, in "Digression concerning Madness"): "The world is a lively place enough in which we must ... be content to take froth for substance, the surface for the depth, and counterfeit for the real coin" [12:122]. But this is his mask for the other Swiftean aspect (curiosity), the anatomist's knife—the metaphor Chester uses to describe his utilization of the blunt knives of the rioters to achieve his own ends: "blunt tools are sometimes found of use, where sharper instruments would fail" (12:247).

99. Burke, *Reflections on the Revolution in France*, 11–12; cf. *Tale*, 215–16.

100. William Godwin, *Enquiry concerning Political Justice* (1793), ed. Isaac Kramnick (Harmondsworth: Penguin, 1976), 663–644.

Protestant anxieties, based on historical precedents", that were realized in 1780.[101] Typology gives the novel a structure that is synchronic as well as diachronic: as the narrative progresses in a straight line each episode is related up and down to the past and to the whole of which each episode is a part. So also with the characters: Gordon and Varden are or are not representative of Christ, though both exist in relation to the Christ type — yet, given the historical data of the 1780s, distanced by irony.

An example of Phiz's employment of the Hogarthian mode is the illustration of John Chester and his son Edward — behind the father on the wall is a picture of Abraham sacrificing Isaac (fig. 32). The foreshadowings all involve the relationship of parent and child: real parents in John and Joe Willet, old Rudge and Barnaby, Geoffrey and Emma Haredale, and John and Edward Chester (also John Chester's bastard son, the demonic Hugh); and metaphorical parents in Gabriel Varden and Sim Tappertit, master and apprentice (later journeyman). In the case of real parentage, the fathers mistreat their sons, and the children (except Barnaby, whose madness is, of course, traceable to his murderous father) in one way or another rebel.

Rowlandson's model for riot was the adulterous triangle, Dickens's nuclear crowd is the disrupted family. The family, we recall, was the nucleus in Hogarth's *March to Finchley* (fig. 2), whose dispersal and fragmentation exemplified riot. From left to right across the picture plane, from the sign of Adam and Eve to that of the Charles II brothel, we follow the breakup of families. The father is leaving his wife for the war, domesticity fragments into casual affairs and whoring, and order dissolves into disorder. The dispersal of the family is either a positive or negative, or merely comic; no judgment is passed by Hogarth.

The patricidal dimension of riot was already at the heart of *Paradise Lost* and *Absalom and Achitophel*. And if the French Revolution cast its shadow back upon the Gordon riots, those riots themselves took place in the middle of the great and successful rebellion going on in America, which in the polemics of Thomas Paine and others was a generational conflict, a son rebelling against the authority of his father. In *Barnaby Rudge* the father is to blame,[102] but the good children, though

101. Michael Wheeler, *The Old Enemies: Catholic and Protestant in Nineteenth-Century English Culture* (Cambridge: Cambridge University Press, 2006), 127; for an excellent analysis of *Rudge*, see 125–135.

102. See Paulson, *Representations of Revolution*, and Lynn Hunt, *The Family Romance of the French Revolution* (Berkeley-Los Angeles, University of California Press, 1992).

they properly defy the father's tyranny, do not rebel — or they rebel in a civil manner, going their own way; they do not attempt to overthrow the father. In *Oliver Twist*, Dickens had bad parental figures like Fagin try to remake the sons — Artful Dodger, Oliver, etc. — in their own images; in *Rudge* the fathers, losing the good sons, employ the bad sons to carry out as surrogates their own private riots, which are vendettas.

The relationship between the generational battle in 1775 and the Gordon riots in 1780 is also problematic. If the continuity were based on the mistreatment of children, the Gordon riots should serve as a justified outlet and "liberty". But the rioters are all further examples of parents mistreating or exploiting their charges, only now writ large. Chester uses the rioters, and in particular Hugh (his bastard son), for his own purposes, as he had earlier attempted to use his legitimate son Edward. Gashford uses Dennis, Hugh, Barnaby, and indeed Gordon himself. Ultimately both Chester and Gashford use them for one end — which is merely, no more than, revenge on Geoffrey Haredale.

As Dryden argued in *Absalom and Achitophel*, while the ostensible motive of rebellion is religious and political, the real motive is spoils, material aggrandizement and personal pique. Though public buildings are attacked and burned, Dickens's story is about the destruction of a private house, the Warrens, destroyed under the excuse of religious enthusiasm, but in reality an act of personal vengeance by Chester, personal pique by Gashford. All the riotous acts are personal, summed up in Dennis's motive for his anti-popery — he fears that the Catholics, on the model of the Inquisition, will replace his specialty — hanging — with burning at the stake. This is not to overlook the fact that the exploited juniors have their own personal agendas as well — Tappertit to sexually take Dolly, Dennis to safeguard his profession of hangman, Hugh to avenge himself on everybody and also take Dolly, Barnaby (naively) to get riches for his mother. Gordon himself is one of these simpletons rather than one of the actual projectors of riot.

Instead of revolutionary parricide, Dickens registers, typologically (this foreshadowing that), the trajectory of the French Revolution from the Terror into Thermidor and Brumaire and Empire; he sees the riot engendering only a continuation and intensification of the paternal relationships that preceded it.

Fifteen years after *Barnaby Rudge*, *A Tale of Two Cities* (1859) also opens in 1775, and then moves to 1780, and so to 1789–93 and the French Revolution. Even though there is no mention of the Gordon riots, they hover in the reader's memory, for this is a tale of *two* cities, Paris and London, as well as two times. The *Tale*

introduces the anti-Jacobin fiction of bloody riot (the lampposts, the guillotine), based on the facts emerging from Paris, but only as a backdrop. In the foreground is the same story as in *Rudge*.

The originary motive is again revenge, but now the revenge is natural and justified. In France an inevitable causality follows from a Marquis's running over a child to the father's killing of the Marquis, to the execution of the father, and so to the lamppost and the guillotine — all starting as, focused on, a case of personal, fanatical revenge, which is a riot motive, not a revolutionary one.

Barnaby Rudge and *A Tale of Two Cities* are examples of riot represented in a novel that is about the relationship of individuals to society as a whole. This is only partly a case of public events affecting private lives — though this does emerge in the second (1780) half of the novel; but rather of how private lives epitomize the public event. We might think of a macrocosm that is explained by a microcosm. Another term is synecdoche, a part that represents the whole, or representative — a family that is representative of or for the nation.

Dickens began writing *Barnaby Rudge* in the mid-1830s when the Reform Act riots (as well as Swing and Luddite riots) would have been very much on his mind, all of which would have been part of the experience of his first readers. The major English riots of the 1780s–1800s may have originated in religio-political disagreement, but they were increasingly about representation. Some issue was being carried out by the governor without the representation of the governed, and the riot (row, ruckus, ruction) attempted to correct or bring about this representation. The riotous group stood in for the whole populace, which also came to demand greater representation, an extension of the franchise. The formal issue is a part earning its right to speak for the whole, or the part — or the many parts — rightfully representing the wishes of the whole. So, according to the *OED* to *represent* is "to stand for or in place of", to "denote by a substitute" (no. 7); "to act for another by a deputed right by a substitute" (no. 8).

Dickens's novel dramatizes the two senses of representation: it is pictorially-descriptively a representation of the Gordon riots, but it is also about the nature of social and political representation embodied in the relationship of son to father, of family to nation. The second of these has an adjunct sense of "to serve as a specimen or example" — to exemplify (no. 9). This last sense of representation is the equivalent of the literary term synecdoche, but, it seems to me, particularly appropriate to the plot of *Barnaby Rudge*.

The Peterloo Massacre

The Swing, Luddite, and Reform Act riots were relevant to a reading of *Barnaby Rudge*, but these riots were introduced by the Peterloo massacre of 1819. Peterloo materialized the form of the riot that was implicit in the St. George's Fields riot, that the rioters are the true victims of riot. In *Barnaby Rudge* the eventual purpose of the militia — in retribution and reprisal — is a massacre of the rioters and later punishment of the ring-leaders. Dickens emphasizes the fact that the hundreds of people killed during and in the wake of the Gordon riots were the so-called rioters, self-destructing or shot down by the militia or afterward hanged in exemplary numbers.

In a print of Peterloo by George Cruikshank, the orderly columns of soldiers (recalling the distant columns of *Finchley*) are now foregrounded: they are mowing down the so-called rioters (fig. 33). Cruikshank's print recalls Paul Revere's engraving of 1770 *The Boston Massacre* (fig. 34), the most memorable image leading up to the American Revolution, showing the British troops, in a single rank, shooting the unarmed crowd of "rioting" civilians. The reality was a crowd of men and boys jeering at a British sentry guarding the Boston Customs House. It was nine o'clock on a cold winter night, snow in the streets. British soldiers arrived; there was more jeering and scuffling, and shots were fired into the crowd. Five Boston citizens were killed. These were the facts; in Revere's print there is no sign of the snowy streets and the dark sky, which in the colored prints is a cloudless blue. Revere lines up the British to evoke a firing squad; the Bostonians are being "massacred".

The scene of brute military order crushing a natural human instinct for liberty (the Whig sense of riot) was one that Goya developed into a yet more powerfully compact image in his painting *The Third of May, 1808* (Madrid, Prado), where the huddled figure of Revere's foreground becomes a Spaniard, "shapeless and pathetic" (Kenneth Clark observed) as an old sack. The "stroke of genius" Clark attributed to Goya of contrasting "the fierce repetition of the soldiers' attitudes and the steely line of their rifles, with the crumbling irregularity of their target" was already present in Revere's *Boston Massacre* and would be echoed in the horsemen of Cruikshank's *Peterloo Massacre*.[103]

103. Kenneth Clark, *Looking at Pictures* (New York: Holt, Rinehart, 1960), 127; see also Paulson, *Figure & Abstraction in Contemporary Painting* (New Brunswick: Rutgers University Press, 1990), 27.

Peterloo, the great example of a police riot, was not effective — it was suppressed — but it was mightily affective. After Peterloo the myth obtained that the police riot was the only English riot; the affect of Peterloo was conveyed in the graphic and literary representations, as in Shelley's poem "1819": "A people starved and stabbed in th'untilled field; / An army, whom liberticide and prey / Makes a two-edged sword to all who wield …" The result is "graves from which a glorious Phantom may / Burst, to illumine our tempestuous day". So a police riot is an ineffective riot, though it may be, like Peterloo, a powerfully affective riot.

Post-Gordon Riots

The two English riots that were comparable in scope and severity to the Gordon, the Priestley (or "King and Church") riots of 1792 and the Bristol (Reform Act) riots of 1831, replicated in many ways the Gordon, though in the aftermath of the French Revolution. The Priestley riots began as a response to a "Bastille Day" dinner celebrating (so the mob assumed) republican and revolutionary principles, by which was meant extension of the franchise; the Bristol riots were a reaction to the failure of Lords to pass the Reform Act (passed by Commons) and the provocative visit of one of its proponents to Bristol. (Religious dissent and nonconformity were ever associated with Reform by the Tory mind.)

The stages were similar. The wealthy merchant class of Birmingham was heavily Dissenter and, following the French Revolution, "republican", and one issue was agitation for repeal of the Test and Corporation Acts that prevented Dissenters from holding public office. The mob was incensed by their "republican" activities, in particular by the efforts of Joseph Priestley, the eminent scientist and Unitarian minister. Forged letters, allegedly found among Priestley's papers when his house was burned, projected a Republican plot, comparable to the Popish Plot of Dryden's time, aiming "to burn the churches, blow up the Parliament, cut off the head of the king and abolish all taxes", "to make Priestley king, Russell Prime Minister, and John Taylor [other republicans] Chancellor of the Exchequer".[104]

As Dissenters and reformers were leaving the hotel they were attacked by the Birmingham mob — the "bunting, beggarly, brass-making, brazen-faced, brazen-

104. Cited, R.B. Rose, "The Priestley Riots of 1791", *Past and Present*, 18 (1960): 68–88. I am relying on Rose's account of the Priestley riots.

hearted, blackguard, bustling, booby Birmingham mob", well-known for Jacobite and Church and King riots going back to 1714 and the Riot Act.[105] After pelting the diners the crowd attacked the hotel, broke windows, entered and looted the premises. From there they moved to Priestley's Unitarian New Meeting and set it afire, then did the same to the Old Meeting, and proceeded to Priestley's house, which they ransacked and burned, destroying his laboratory and scientific papers. On the second day the riot spread, attacking other Dissenter chapels and the houses of the leading reformers.

There were signs of manipulation. Anglican clergy had delivered attacks from the pulpit accusing the Dissenters of pro-French principles. But the mob went on to attack the prisons — the Town Prison and the Court of Requests lock-up — and released the prisoners, duplicating the proceedings of the Gordon rioters (and the attackers on the Bastille in Paris). More private houses were destroyed that evening and the next day, the third day of rioting. The rioters extended their activities to the country and neighboring towns, and at this point, finally, parties of Dragoons arrived from Nottingham and the rioting in Birmingham came to an end, although riots continued in the outlying areas.

The Lords' rejection of the second Reform Bill in October 1831 (after it had passed Commons by one vote) produced riots in which peers were assaulted and their windows broken. In Nottingham the duke of Newcastle's castle was burned, in Derby the gaol was destroyed, and in Bristol, in scenes recalling the Gordon riots, the Mansion House, Gaol, Customs House, and the Bishops' Palace were looted and burned. Comparisons were made with the Gordon riots: not since 1780 had Britain "exhibited such scenes".[106]

The Priestley and Bristol riots also replicated the attack on a distillery, the mob again consuming large quantities of liquor found in the cellar, which increased the intensity of the riot and, as in Langdale's distillery, proved self-destructive: "many of the rioters who were drunk, perished in the cellars, either by the flames, or suffocation by the falling of the roof".[107] In Bristol when the cellars of the Mansion House were broken into, "All ages, of both sexes, were to be seen greedily

105. Rev. J. Bartlam, in J. Johnstone, *Works of Samuel Parr* (London, 1828), 1:336.

106. *Annual Register* (1831), 295; G.L. Craik, *Sketches of Popular Tumults* (London, 1837), 55.

107. *Annual Register*, cited, George Rudé, *The Crowd in History: A Study of Popular Disturbances in France and England 1730–1848* (London: John Wiley, 1964), 142.

swallowing the intocsicating licquors, while upon the ground scores were to be found dead with drunkenness".[108] *The Times* of 3 November reported seeing "Men stretched in drunken stupor besides puncheons of rum; women in loathsome shapes, bearing the outward marks of the sex, were in the same state of beastly degradation", and noted that "A considerable number of them suffered the just retribution of their crimes, by being burnt in the fires which they themselves had kindled, or buried in the ruins of the buildings which they had pulled down". Two boys are cited who, leaping from the roof, "were, I was assured, actually seen frying in the molten lead that streamed upon the pavement". One new detail: "Without waiting to draw the corks, the necks of the bottles were broken off, and blood was not infrequently seen to flow from the lacerated mouth of many a wretched being, while he drank the maddening draught".[109]

The riots corresponded to the Gordon riots in another particular: the stories of the gentlemen seen mingling with or observing the rioters. The *New Annual Register* claimed, of the Priestley riots, without qualification: "There were certain persons among the mob, conspicuous equally for their appearance and their activity, who directed the rioters and were sometimes termed their leaders. These persons evidently were not of the lowest class, but, what is most singular is that they were not known to a single person in Birmingham".[110] As in the Gordon riots there were witnesses who deposed that they had seen "well-dressed men" acting as leaders of the mob".[111]

In the Priestley riots, one of the similarities with the Gordon riots was the incompetence of the city magistrates, but here the association of incompetence was certainly with complicity. Orders were revealed that permitted the initial ravaging of the Dissenters, and put a stop when the riot extended to the interests of "Church and King". Another telling fact—and divergence from the model of the Gordon riots—was the light consequences on the rioters following the Priestley riots. Of seventeen rioters tried, often before friendly juries, only four were found guilty, only two were hanged—and, Priestley thought, "not merely for the riots, but be-

108. *Annual Register*, (1831), 294; cited, Haywood, *Bloody Romanticism*, 218.

109. [W.H. Somerton], *A Full Report of the Trials of the Bristol Rioters* (Bristol, 1832), 134.

110. *New Annual Register* (1791), 213. For other similar reports, see T.W. Whitley, *Parliamentary Representation of the City of Coventry* (Coventry, 1894), 210–11.

111. Affidavits of James Bradney and Susannah Porteus, H.O. 42.19.13lb, cited Rose, op. cit., 79.

cause they were infamous characters in other respects".[112] There is much evidence for orders from above, for the complicity, encouragement, and silent protection of the local Tory justices of the peace. One justice is reported as telling rioters not to leave "those Presbyterian Dogs a place standing", and another referring to the licence accorded the mob to "plunder, break down and destroy"[113] — in effect, a form of lynch riot. The Priestley riots were effective in their original aim of marginalizing the Dissenting and reforming element in Birmingham.

Once again, however, there was an aesthetic dimension — the spectators, most notably, and ironically, Priestley, who watched the violence done to his own house:

> it being remarkably calm, and clear moon-light, we could see to a considerable distance, and being upon a rising ground, we distinctly heard all that passed at the house, every shout of the mob, and almost every stroke of the instruments they had provided for breaking the doors and the furniture.[114]

And at the time of the Bristol riots the papers reported both the upper-class agitators and the disinterested spectators — "two respectably dressed men were very active in giving directions" to the mob, while "numerous respectably dressed persons … took no notice of the conduct of the mob" — some "looked upon the excesses with a worse feeling than apathy", as *Blackwood*'s put it.[115] These gentlemen were, according to the Whigs, the same Tory agitators who started the Priestley riots, and according to the Tories, the radical demagogues who started the Gordon riots. There is no reason to think that many were any different from the enjoyers of the phenomenon of the Gordon and Priestley riots.

Priestley regarded the "King and Church" riots, he wrote in an open letter to the citizens of Birmingham, as directed "by the discourses of your teachers, and the exclamations of your superiors in general, drinking confusion and damnation to us".[116] Priestley himself attributed the riot to "religious bigotry", with the covering

112. Priestley to John Wilkinson, 4 Oct. 1791; quoted, Rose, op. cit., 82.

113. Rogers, *Crowds, Culture, and Politics*, 193–94, citing PRO, NO 42/19/290–93, 301–05, 309, etc.; the justices' quotations are from PRO, NO 42/19/317 and 313.

114. Vivian Bird, *The Priestley Riots, 1791, and the Lunar Society* (Birmingham: Birmingham and Midland Institute, n.d.), 30.

115. *The Bristol Riots, Their Causes, Progress and Consequences. By a Citizen* (Bristol, 1832), 111, 72; Blackwood's (March 1832), 471.

116. See PRO, HO 42/19/207; Rose, "Priestley Riots", 75–76.

myth of French revolutionary sedition only secondary to the manipulation of the Anglican clergy in Birmingham.

In Bristol the defining feature was the rioting in Queen Square, when some 10,000 people took over the square, establishing a state of carnival, as seen from the Tory right: "[I]n the centre of the Square, by the equestrian statue of William the Third, surmounted with a cap of liberty, were costly tables spread, and the revel of a plundered feast, with yell and imprecation, and wine and blood, was held to celebrate this first Sabbath of Reform — of revolution".[117] This is the scene that Haywood in *Bloody Romanticism* has compared to "the main arena for carnival acts … of crowning and decrowning" described by Mikhail Bakhtin.[118] When the crown on the statue of William III was replaced with a cap of liberty he was in Bakhtin's sense "decrowned".

The most vivid graphic image of the Bristol riots was a lithograph of 30 October 1831, *Queen Square* (fig. 35), which visualizes the scene of carnival described above. It was based on a watercolor (fig. 36) by William James Müller, a Bristol landscape artist, that evokes Wheatley's *Riot in Broad Street* but is sketchily painted — billowing smoke and fire beyond human control, riot displaced to natural forms. Queen Square has become a riot-as-landscape. The lithograph more conventionally fills in the particulars of carnival, combining memories of Hogarth's *March to Finchley* and in particular *Night* (above, fig. 8). Müller replaces the statue of Charles I in *Night* with the statue of William III in Queen Square being decrowned by one of the rioters, and the scene in the foreground further recalls the drunkenness and self-immolation of *Gin Lane*.

A second painting, as if part of a *before* and *after*, places Queen Square in the context of Peterloo (this one a collaboration with Thomas L.C. Rowbotham, fig. 37), and shows the police phase of the riot: the cavalry is dispersing the crowd, the soldiers looming and dominating the scene, raising their swords as the rioters fall to the ground and cower at their feet. In the suppression of the Bristol riots some 250 people were killed or injured, 31 rioters were capitally convicted, and four were hanged. By this time the defining riot for the English reformers was the Peterloo massacre.

117. *The Bristol Riots*, 134–35.

118. Mikhail Bakhtin, *Problems of Dostoyevsky's "Poetics"*, trans. Carl Emerson (Manchester: Manchester University Press, 1984), 128; cited Haywood, *Bloody Romanticism*, 216.

In the first painting the military is reduced to the symbolic royal statue; the revelers fill the foreground, and there are no spectators on which to anchor the viewer of the picture — nothing but riot and the fire and smoke that accompanies them as an emblem of their activity. In the second picture the troops have arrived and dominate the scene, cutting down the rioters. The smoke and fire are still present, now hovering above the prone rioters across the background: in some ways a formal equivalent of the rioting mob, a stand-in when the crowd is being replaced by the soldiers.

In the later nineteenth century John Seymour Lucas R.A. painted the Gordon riots in a large painting (now in Melbourne, fig. 38). He follows Müller's second Bristol riot, Paul Revere's *Boston Massacre*, and Cruikshank's *Peterloo*. Wheatley's composition, which already showed the victorious soldiers, has been skewed and the whole right foreground is now filled with soldiers mowing down the rioters, who are isolated in the background at the left. The Lucas painting has shifted emphasis from the activity of the rioters to the activity of the military force putting down the riot. The spatial ratio has shifted from riot to police.

That the Peterloo Massacre differed from the French riots of the 1790s — the position of Cruikshank and other satirists during the 1820s — was taken as a way of defining not only the English "riot" as against property not people, but also as a futile gesture against a tyranny more powerful than the late one in France. On the other hand, riot could no longer appear without the memory and threat of the French Revolution, and the subject now tends to be displaced onto the forces that put it down — or, we shall see, onto the fire and smoke independent of the rioters; and therefore riot tends to carry the added weight of the revolutionary memory, which may explain why in "realistic" representations of riot the police fill the picture space and riot is diminished.

As the term "police riot" suggests, the idea of a riot includes its suppression, and the violence can go either way. In the Gordon riots the emphasis was on the insurgency, Peterloo on the suppression; both aspects could be violent and destructive, but the first may be (or begin as) only a demonstration or peaceful protest, and the second may absorb the out-of-control, anarchic follow-up that was the riot.

Displacements of Riot: Turner's *Burning of the Houses of Parliament*

At the end of the eighteenth century, overshadowed by revolution, the status of riot had changed markedly from the time of Hogarth and Rowlandson. Rowlandson could still respond to the Gordon riots by carrying Hogarth's riot to comic extremes. Others responded with fear of another Gordon riot that destroys property and prisons, threatens the Bank of England; but then, in the 90s, their fears were realized with a riot that only began with the destruction of a prison and went on to overthrow the government: the fear that riot can become revolution.

James Fitzjames Stephens expressed the fear behind this elision in the 1870s: "look at our own time and country and mention any single great change ... not carried by force, that is to say, ultimately by the fear of a revolution".[119] The conventional artist, for example Seymour Lucas, when he approached the subject of riot in his Royal Academy submission for 1879 (fig. 38), relieved the tension (physically and formally) by enlarging the police, reducing the rioters, and omitting the riot altogether.

Ian Haywood has noted how difficult it became after the French Revolution "to present popular violence in a positive light" and suggests that "One solution to this problem was to relocate such violence in an 'allegorical' setting that was displaced historically, geographically, or politically".[120] The psychological pressures (to which were added the pressures of censorship) were too unbearable to be confronted except indirectly by displacement. So a storm or avalanche could "carry a more radical charge" than it had before the Gordon riots and the French Revolution. But the artist was also displacing the fear of riot by aesthetizing it; or rather by emphasizing the aesthetic aspect of *sturm und drang* that had always been present from the time of Addison and Hogarth. Riot remains, when specific riots are elided, as a natural catastrophe, and it is treated as an aesthetic experience.

The imagery of storm, earthquake, and erupting volcanoes naturally fed into landscape painting, supported by Burke's aesthetics of the sublime, as an artistic equivalent of the political revolution. The degree of particularity descends from,

119. James Fitzjames Stephens, *Liberty, Equality and Fraternity* (London, 1873), ed. R.J. White, 70; cited Cannon, *Parliamentary Reform*, xiv.

120. Haywood, *Bloody Romanticism*, 192.

in *The March to Finchley* or one of Rowlandson's stagecoach pictures, each figure representing an example of riotous behavior to a generalized mass—to "crowd" as an oceanic wave or the flames and smoke of a conflagration. A landscape painter could omit the rioters, displacing them to the fire and smoke that accompanied their actions.

Wheatley's picture of the Gordon riots and Rowlandson's *English Review* anticipated, structurally, Philippe de Loutherbourg's *Avalanche in the Alps* of 1804 (fig. 39), in which there is no riot, but filling the same space is a natural catastrophe, observed by spectators with degrees of detachment. The assumption is that one enjoyed the beauty of the Alps rather than climbing them, the excitement of an avalanche rather than being under it. The figure at the far left, at the farthest remove from the avalanche, shows astonishment but is safely out of the path of the disaster: he signified "terror" or "the exhilaration of danger".[121] Then there is his terrified dog and, closer to the disaster, a woman and man showing their individual signs of mortal terror—she fleeing, he praying for deliverance. Finally, there are two figures who are engulfed in the horror of the immediate experience. This is a schematic version of Burke's Sublime, which leaves the viewer outside the picture as secure as the observer within, a mere mediator on the human effects of the natural catastrophe. Burke's "delight" and "terror" refer not to the terrified victim but to the safe spectator who can identify with the source of the danger, sublimating terror into delight. Wheatley's *Riot in Broad Street* operated in the same way, as an aesthetic experience rather than (in the merely descriptive prints that were closer to the event) a mimetic one or, in the printed text, one being judged as good or evil. The difference—what gives Loutherbourg's painting its added valence—is the intervening experience of the Revolution in France.

We have seen that the two natural metaphors for the crowd and riot were fire and water, or the ocean, both out of human control. The artist who combined the imagery of fire and water, drawing on its association with the sublime, in the revolutionary times of the 1800s, was J.M.W. Turner. Loutherbourg's avalanche may have been innocent; Turner's avalanche, painted in 1810 (fig. 40), followed from the contemporary imagery of revolution as natural upheaval, and with no longer a detached spectator: the viewer is instead plunged, without mediation, into the middle of the scene. In his seascapes the ocean overwhelms men's puny ships, in his avalanches men's flimsy houses. Lord Sidmouth said in 1829, "We seem to be

121. Hibbert's words, *King Mob*, 126.

in a shattered boat, and in a strange and agitated sea, without pilot, chart or com-pass".[122] His words evoked cartoons like Gillray's *Britannia between Scylla and Charybdis* (1793), which shows Pitt and Britannia on the ship of state threatened by a wild ocean; but it also describes more than one Turner seascape of the 1800s, whatever Turner's personal politics, Whig or Tory.

In 1834, in the wake of the Reform Bill riots and the uprisings of the Chartist movement, especially the recent incendiaries associated with the Swing riots (the rick-burnings, Richard Carlile's *Swing, the Kent Rick Burner*, and Mary Mitford's *The Incendiary*, all of 1832), the Houses of Parliament caught fire and burned to the ground. The fire that destroyed the seat of British government led Turner to paint two of his greatest works (one now in Philadelphia, the other in Cleveland, fig. 41). The context included not only his paintings of natural disasters but the Wilkite metaphors of enlightenment and breaking out of confinement and, from the other side, the political fire in Hogarth's *Times, Plate 1*, which had been liter-alized when the mob burned public buildings in the Gordon riots. The fire boat in Turner's painting (the Philadelphia version), which recalls the fire engine in Hogarth's print, is a man-made artifact, utterly impotent in the face of the real, consuming natural force of the fire. The juxtaposition of water and fire, Thames and the burning Parliament, indicates the incompatibles; to bring them together is beyond human control, whatever one's attitude toward Reform and riotous action.

Fire was the active, destructive aspect of the sun round which Turner con-structed many of his landscapes. The French Revolution was associated by its sup-porters with "this flood of light that has burst in on the human race", and "the bright prospect of universal freedom and universal peace" which is bursting in on "a kingdom, which the darkest superstition had long overspread".[123] In William Hazlitt's words, their hopes "rose and set with the French Revolution. The light [of the Enlightenment] seems to have been extinguished for ever".[124] Hazlitt's view was summed up in "On the Feeling of Immortality in Youth": "My sun arose with the first dawn of liberty, and I did not think how soon both must set. The new

122. Cannon, *Parliamentary Reform*, 186.
123. James Mackintosh, *Vindiciae Gallicae* (1791), 345; Sir Samuel Romilly, *Thoughts on the Probable Influence of the French Revolution on Great-Britain* (1790), 203.
124. Hazlitt, *The Memoirs of Thomas Holcroft*, in *The Complete Works of William Hazlitt*, ed. P.P. Howe, 2 (London: J.M. Dent, 1933): 155.

impulse to ardour given to men's minds imparted a congenial warmth and glow to mine; … and I little dreamed that long before mine was set, the sun of liberty would turn to blood, or set once more in the night of despotism" — a passage that runs the gamut of associations of light with birth and youth ("ardour") to age, from "dawn of liberty" to setting "once more in the night of despotism", and from "warmth and glow" to "blood".[125]

On the opposite side, Burke made his first reference to the imagery of light in his *Philosophical Enquiry* where darkness is sublime and light is not: "But such a light as that of the sun, immediately exerted on the eye, as it overpowers the sense, is a very great idea. … extreme light, by overcoming the organs of sight, obliterates all objects, so as in its effects exactly to resemble darkness". This fierce glare, this power of uncontrolled energy seen as sublime, became thirty years later, in Burke's *Reflections on the Revolution in France*, the Enlightenment rays that have been intensified by the revolutionaries into "this new conquering empire of light and reason" which dissolves all "the sentiments which beautify and soften private society", and indeed (as the metaphor shifts) rudely tears off "all the decent drapery of life", first from the queen and then from society in general.[126]

Burke was reacting against the metaphor for revolution (the French) formulated by the Reverend Richard Price shortly after the fall of the Bastille:

> I see the ardor for Liberty catching and spreading. … Behold, the light you have struck out, after setting America free, reflected to France, and there kindled into a blaze that lays despotism in ashes, and warms and illuminates all Europe! Tremble all ye oppressors of the world! … You cannot now hold the world in darkness. Struggle no longer against increasing light and liberality.

Before the Revolution began he was prophesying "a progressive improvement in human affairs which will terminate in greater degrees of light and virtue and happiness than have yet been known".[127] Thomas Paine developed Price's image of the

125. Hazlitt, *Winterlow* (1850), in *Complete Works*, 17 (1933): 197.

126. Edmund Burke, *Reflections on the Revolution in France*, 73; also 92–93, 105–106, 110. See Paulson, *Literary Landscape: Turner and Constable* (New Haven: Yale University Press, 1982), 85–86.

127. Richard Price, sermon, 4 November 1789, to the Society for the Commemoration of the Glorious Revolution (i.e., of 1688) published as *A Discourse on the Love of Our Country* (1789); *Evidence for a Future Period of Improvement in the State of Mankind with Means and Duty of Promoting It* (1787), 5, 53.

Enlightenment of conflagration in the opening of Chapter 5 of *Rights of Man*, Part 2 (1792): "From a small spark, kindled in America, a flame has arisen, not to be extinguished", and Blake carries the metaphor on into his revolutionary poems with "fiery Orc", the spirit of revolution.

In Turner's paintings of the conflagration, the association of the sun (of the Enlightenment) and fire, incidentally reflected in the water of the Thames, linking fire and water, and incidentally invoking memories of Guy Fawkes (as Lord Elton and others predicted the burning would), embodies the destruction of the English government. The year after the burning of the Houses of Parliament, Turner's fellow academician James Ward published *New Trial of the Spirits* in which he declaimed: "God is not to be mocked! The vivid lightnings are gone forth! Farm house conflagration. York Minster conflagration, Senate House of Kings, Lords and Commons burnt—'I will overturn! overturn!' Ezek. XXI27. King, Church, Government, and people beware!"—words Turner could have used as a gloss for his painting.

Nineteenth-century journalists and historians, when treating riots, continued to use the nature metaphor: riots were violent disturbances, outbreaks of savage, random violence, with no meaning or purpose. More sophisticated historians delved into the structural and social causes of the riots—most obviously, slaves who rebel against their masters, women (suffragettes) who demand their rights, but also other political, economic, and cultural contexts, with a focus on particular rioters, their ostensible aims, their targets and victims, the precipitating events that caused the riot, and its development in time and its conclusion. The art of the riot, however, devolved upon the schools of realistic painting rendering the events as faithfully as Jan Verhas's *Review of Schoolchildren in 1878* set against Ensor's *Entry of Christ into Brussels in 1889*. Photography made such representations as Verhas's less forceful if not irrelevant.

The emblem of the hydra was on one side of the historical divide, the image of the tempest or conflagration on the other—the fiction of agency, something resembling the actual riot, in the middle. Turner avoids the direct representation of history and displaces the force of the riot onto natural catastrophe—without the need for specific reference, retaining the memories of the Gordon riots and the French Revolution. In his seascapes he displaces riot onto wild oceans, and then he displaces the series of riots from Peterloo to the Reform Act and the Chartist upheavals of the 1830s onto the fact of the burning of the Houses of Parliament; although he knows that the last was not the result of an incendiary, the realization

of Guy Fawkes's dreams, but an accident, he makes it seem a manifestation—drawing upon the imagery of earlier riots—of a retributive Nature.

The Artist as Rioter

Following political revolution was the theory and practice of the art that represented revolution. Joel Barlow, speaking of both the American and French revolutions, referred to "the revolution that has been brought about in the whole of the art [of painting] within the last thirty years by [the artist's] having broke thro' the ancient shackles and modernized the art".[128]

The stories of Turner having himself lashed to a mast in the midst of a storm suggest something of his self-association with the natural forces, and especially with the sun, the ultimate source of fire. In his late painting *The Angel Standing in the Sun* (1846, fig. 42), he superscribes the sun with the figure of an angel, described in the Royal Academy catalogue as the avenging Angel of Revelation. He had been described three years earlier by John Ruskin, in *Modern Painters* (1843), as "standing like the great angel of the Apocalypse, clothed with a cloud, and with a rainbow upon his head, and with the sun and stars given into his hand".[129] The angel is quite literally Turner himself, superimposed on the sun. All the revolutionary overtones of the sun and fire are subsumed for Turner under this personal, artistic significance.

Turner paints sea and fire instead of figures participating in a riot; the true riot, for him and other artists of the age of police riots, is uncontrollable nature and, then, the turbulent artist who represents it. To the artist of riot nature is another vigilante action, the extralegal form that trumps in art the laws and edicts of the ruling order in politics. And, as Turner shows, in some cases the artist sees himself as a vigilante—as the sun or the conflagration that burns away the seat of authority. Turner displaced the riots of the 1830s onto storms at sea, sinking ships, and in particular the conflagration that destroyed the Houses of Parliament, and by this time he was associating the untrammeled power of nature against flimsy man-

128. Yvon Bizardel, *American Painters in Paris* (New York, 1960), 77.

129. John Ruskin, *Works of John Ruskin*, ed. E.T. Cook and A.D.O. Wedderburn (London: G. Allen, 1903–12), 3:254n.

made structures, of government and art, with the power of the painter who represents it.

Some artists, like Turner, would appear to have placed themselves inside the eye of the storm they were representing. The problem was set forth by Edmund Wilson in *The Wound and the Bow*, where he showed Dickens preaching against the mob but clearly putting all his energy into the representation of the fire and destruction, especially of the prison (a memory of his father's experience of prison, an insight that would equally apply to Hogarth): "the historical episode, the contemporary moral, and the author's emotional pattern do not always coincide very well", Wilson comments, of the storming and burning of Newgate: "The satisfaction he obviously feels in demolishing the sinister old prison, which, rebuilt, had oppressed him in childhood, completely obliterates the effect of his right-minded references in his preface to 'those shameful tumults'".[130]

However much creative energy went into the representation of the destruction of the Warrens, Newgate, and the distillery, Dickens gives no sense that this iconoclasm is good: it is an act stimulated and carried out by the rioters with motives of vengeance and profit. But while in the novel he associates the mob with devils, savages, animals, the insane and diseased (as well as the uncontrollable sea), in a letter to his friend John Forster, he described his experience of writing *Barnaby Rudge*: "I have just burnt into Newgate, and am going in the next number to tear the prisoners out by the hair of their heads". "I have let all the prisoners out of Newgate, burnt down Lord Mansfield's, and played the very devil. Another number will finish the fires. ..." And in another letter, referring to Gordon: "As to the riot, I am going to try if I can't make a better one than he did".[131] A writer, one thinks, always enjoys depicting a rebellion—a *Paradise Lost* over a *Paradise Regained*. Perhaps, as many critics have noticed, Dickens takes the Tory fiction for his value judgments, but his own energy goes into the descriptions of iconoclasm.

The artist had two basic positions to choose between: the parallel action of the riot and the artist to break open and burn and level the social edifices of order or to suffer with the peaceful protestors who are fired upon and massacred by the representatives of law and order. The first was an extension or projection of the

130. Wilson, *The Wound and the Bow* (1941), 18; quoted, Philip Collins, *Dickens and Crime* (New York: St. Martin's Press, 1994), 44.

131. John Forster, *Life of Charles Dickens* (New York: Scribners, 1900), 1:163; to Ollier, 3 June 1841, *The Letters of Charles Dickens*, ed. Walter Dexter (London: Nonesuch Press, 1938), 1:324; quoted, Collins, *Dickens and Crime*, 45.

"world turned upside down" of carnival and Saturnalia and offered the kind of pleasure Dickens describes and Turner probably felt. The second provided a basis for the rhetoric of helpless outrage. Both were satiric forms, one insurgent — the satire of Rabelais and his avatar Panurge, who discomfits society, sometimes to the point of murder; and the other defensive — the satire of Juvenal (*difficile est saturam non scribere*), seen from the perspective of the victim, the last Roman in an un-Roman Rome, the parent whose daughter has been ravished by the emperor.

4. Literary Riots

Sir Walter Scott's *Heart of Midlothian*

In the nineteenth century the official (the R.A.) art maximized the British authority, minimizing the riot—or displaced it to harmless comic Rowlandsonian scenes of revelry. The other response, of artists like Turner, was to omit any reference to riot but displace the imagery of riot from the French Revolution onto natural phenomena (recalling at the same time the Whig rhetoric of liberty). These were both graphic representations. The novel offered a space in which to describe riots without metaphor or displacement, in representations that were more realistic and at the same time more nuanced.

The Porteous Riots, which took place in Edinburgh in 1736, consisted of two distinct riots: the so-called "riot" that was seen to accompany the hanging of Andrew Wilson and the crowd ritual, the extralegal lynching of Captain John Porteous. Sir Walter Scott opens his novel *The Heart of Midlothian* (1818) with a representation of these riots.

The first followed the execution of a sympathetic smuggler, Andrew Wilson, when there appeared to be a riot—or at least signs of unrest interpreted by Captain Porteous as a riot. Captain Porteous, the officer of the City Guard, with "the charge of preserving public order, repressing riots and street robberies, acting, in short, as an armed police",[132] was an irascible sort with a personal grudge against Wilson, abusing him cruelly as he conducted him to the scaffold.

Once the execution was carried out, Scott tells us, "Many stones were thrown at Porteous and his guards; some mischief was done: and the mob continued to press forward with whoops, shrieks, howls, and exclamations". One member of the crowd ascended the scaffold, perhaps to recover the body (another aspect of

132. Sir Walter Scott, *The Heart of Midlothian* (1818), *The Waverley Novels*, 11 (Edinburgh: A&C Black, 1878), chap. 3, p. 58.

the crowd ritual, saving the body from the "resurrection men" who would sell it for dissection).

> Captain Porteous, was wrought, by this appearance of insurrection against his authority, into a rage so headlong as made him forget, that, the sentence having been fully executed, it was his duty not to engage in hostility with the misguided multitude, but to draw off his men as fast as possible. He sprung from the scaffold, snatched a musket from one of his soldiers, commanded the party to give fire, and, as several eye-witnesses concurred in swearing, set them the example, by discharging his piece, and shooting a man dead on the spot. (3.66)

In Porteous's own words, perceiving "the turbulence of the mob", "a formidable riot", he fired on the crowd — killing a dozen people. Others perceived the crowd as only "a trifling disturbance, such as always used to take place on the like occasions", that is, at all hangings (3.68), and the relatives of the victims called Porteous's response "a wanton and unprovoked massacre". As the cause of a "massacre", Porteous was called to account, and a court capitally convicted him of the crime. Nevertheless, the government in Westminster, representing "the general maintenance of authority", pardoned him, declaring that "Captain Porteous was in the exercise of a trust delegated to him by the lawful civil authority; that he has been assaulted by the populace, and several of his men hurt; and that, in finally repelling force by force, his conduct could be fairly imputed to no other motive than self-defence in the discharge of his duty" (4.74). News of the reprieve reached the crowd around the gallows awaiting the arrival of the condemned.

The first Porteous riot was a "police riot". The lesson we learn is that it is the police who determine whether a demonstration becomes a riot — and who turn what they designate a riot into a massacre. The second riot, following Porteous's reprieve, carefully orchestrated by "Madge Wildfire", one of the many disguised (as women, etc.) rioters, proceeded from West Port to Cowgate Port to the High Street and on to the Tolbooth Prison, retaining what witnesses reported as "police attention" to the people they encountered, "order and gravity", "a show of justice and moderation", and strict adherence to the forms, including the presence of a clergyman. They did not string Porteous up to a tree but would "have him die where a murderer should die, on the common gibbet" (6.111, 7.119–20). The inexcess part of the progress that accompanied the justice of the lynching was the

storming of the Tolbooth Prison, which involved, besides seizing Porteous, the release of all the other prisoners. But this was secondary to the lynching of Porteous. Indeed, the ultimate crowd ritual, a correction of ruling class law, as this example shows, is a lynching.

The lynch riot could be seen as a popular alternative — or as a correction — to an authority that ascended from Porteous to the constabulary and the soldiers in Edinburgh Castle up to the duke of Newcastle in London, including the "young nobles and gentry", the ruling class reprobates of Edinburgh who had been able to debauch and riot with impunity because they had been protected by Porteous. Porteous himself was merely a scapegoat: initially for Wilson, legally condemned, but then for the Porteous who was condemned by the court and yet reprieved by Westminster, and finally for the government in Westminster.

The lynching of Porteous is described by Scott from the perspective of Reuben Butler, the clergyman who is forced to accompany the procession/mob until the hanging takes place. Butler describes an experience "of a nature to double his horror, and to add wings to his flight ... to carry his horror and fear beyond the walls of Edinburgh" (7.129). When Porteous did not appear for his execution, Scott writes, invoking the metaphor of the ocean, essential for the description of riots, "the hitherto silent expectation of the people became changed into that deep and agitating murmur, which is sent by the ocean before the tempest begins to howl ... like the agitation of the waters, called by sailors the ground-swell" (4.75).

There remains the question of the relationship between the Porteous riot and the story of Effie Deans, to which it serves as prologue. For Reuben Butler "the frightful scene which he had witnessed" coincides with "the melancholy news of Effie Deans's situation". Into the public event of Porteous's lynching is set the private one of Effie's arrest for the killing of her infant. The heart of Midlothian of the novel's title refers to both the Tolbooth Prison and Jeanie Deans and to the public case of Porteous and the private one of Jeanie and her sister — the legal cases of Andrew Wilson and Effie Deans and the moral case of Jeanie, who must choose not to lie for her sister.[133]

The Porteous riots open Scott's novel, and we can infer that Porteous and Effie, on their different levels, share the qualities of heedlessness — he shoots before he

133. Of the possibility that the Tolbooth is the authorial center of the narrative, see James Chandler, *England in 1819: The Politics of Literary Culture and the Case of Romantic Historicism* (Chicago: University of Chicago Press, 1998), 306.

considers, she does sexually the equivalent, and they suffer equally dire consequences, legally and extralegally, with the same hope focused on a reprieve. Scott is relating the great world of eighteenth-century Scotland to the private, domestic world of Effie and Jeanie Deans, and both touch at the apex in England of the court in Westminster, with the monarch's reprieve. The public action of the crowd to right the law finds its private equivalence in the pilgrimage to Westminster of Effie's sister Jeanie. The larger issue is representative government seen from the perspective of 1818. The representative subject, in the ideal world of the 1730s, can gain an audience with the queen and be heard. When Jeanie's case is presented to Queen Caroline, it is in terms of "the fate of an unfortunate young woman" as "highly useful in conciliating the unfortunate irritation which at present subsists among his Majesty's good subjects in Scotland"; and the question posed to the queen by Jeanie's intermediary, the duke of Argyle, is whether "the discontents in Scotland [can be dealt with] as irritations to be conciliated, rather than suppressed", with the granting of Jeanie's petition an emollient (37.204–05). The extralegal voice of the riot is corrected by the plea of the representative citizen.

Scott's novel looks ahead in three respects: the delineation of the police riot, of lynching as a crowd ritual, and, anticipating *Barnaby Rudge*, the displacement of the riot onto something personal and private and, here, beginning with sexual transgression. So the novelistic representation of riot calls for a structure in which the representative is related to the whole, the individual to the government (Jeanie Deans to the queen), raising the question of who properly or improperly represents the Body Politic.

The same year Scott published *The Heart of Midlothian* saw the publication of Jane Austen's *Northanger Abbey* (though written earlier). An aesthetic experience was by the time Austen wrote *Northanger Abbey*, in the decade of the French Revolution, one fashionable response to riot. So it was for such Gothic enthusiasts as Catherine Morland (parodied in Henry Tilney's version of the St. George's Fields and Gordon riots) something to read about — "something very shocking indeed … more horrible than any thing we have met with yet … the Bank attacked, the Tower threatened, the streets of London flowing with blood …"[134] The point is that this is an imaginary, a parody riot. The moral evil in *Northanger Abbey* lay elsewhere, not in Gothic fantasies but in the more mundane customs of courtship

134. *Northanger Abbey*, in *The Oxford Illustrated Jane Austen*, ed. R.W. Chapman, 6, Pt. 1 (London: Oxford University Press, 1959), 112–13. See Paulson, *Representations of Revolution*, 216.

and marriage. And the spectatorship of the riotous experience, as with Henry Tilney and Catherine Morland, is founded in courtship and a sexual seduction. Though the riot in *Northanger Abbey* is imaginary and a fleeting reference, it bears the same relationship to the Catherine-Tilney plot as the Porteous riots do to the story of Reuben Butler and the Deans sisters, situating the subject in the political and social battles of its time; situating the homely, domestic drama in the larger, more spectacular national drama.

Charlotte Brontë's Shirley

Charlotte Brontë's *Shirley* is a novel of 1849 that describes a Luddite riot of 1811. The Luddite riots in Yorkshire—over the introduction of machines that threatened workers' livelihoods—led to the destruction of the machines as well as other objects of oppression such as workhouses and tithe barns. These supply the political context for a novel about two young women in love with the same man, Robert Moore, the owner of a mill that is installing mechanical looms. There are two examples, or phases, of riot: in the first rioters waylay the frames that are being delivered to Moore's mill and destroy them; the second is a full mounted attack on the mill by hundreds of rioters. The first succeeds, the second, larger enterprise fails because of Moore's careful preparation and foresight. This is a riot manipulated by agitators, who are grotesque, drunken, and peg-legged Dissenter and Antinomian "madmen"; the author's description of the chief suspect recalls the typical Swiftian Dissenter, "a tailor by trade", his voice "snuffling", speaking in biblical terms of apocalypse.[135] The manager Moore's only fault is a certain unfriendliness and coldness, as well as his status as a foreigner.

We do not experience either action directly. The first is described by one of Moore's men: It is, he says, led by a "captain [who] ... wore a mask; the rest only had their faces blacked", characteristic of the subculture counter-theater. The description of the chief riot (Chapter 19) is informed by the author's obvious sympathy, but it is seen from the particular perspective of the two young women, Shirley and Caroline, who are spectators from afar.[136] To them the rioters are merely

135. Charlotte Brontë, *Shirley* (1849; London: J.M. Dent, Everyman's Library, 1962), 100, 104.

136. For other, contrary views of the Luddites (e.g., Byron's), see Haywood, *Bloody Romanticism*, 200–05.

sounds — the shattering of glass and the "rioters' yell ... a rioter's yell"; and to sup
plement their experience the author turns to the reader: "You never heard that
sound, perhaps, reader? So much the better for your ears — perhaps for your heart;
since, if it rends the air in hate to yourself, or to the men or principles you approve,
the interests to which you wish well, Wrath wakens to the cry of hate" (171–72).

Shirley and Caroline are influenced by, in various degrees, their love of Robert
Moore and (for Shirley at least) the wish to play a role in local politics. But the
fact that they do not get closer than they do to the fracas renders the affect of their
spectatorship aesthetic, one distinguished by the distance from danger and the
appreciation of the sublime effect: "[S]omething terrible, a still-renewing tumult,
was obvious ... Both the girls felt their faces glow and their pulses throb ... they
could not have taken their eyes from the dim, terrible scene — from the mass of
cloud, of smoke — the musket-lighning — for the world" (272–73). The nexus of
apparent concern is Robert Moore, secondarily his mill, but in fact the excitement
of the scene witnessed from a safe distance.

The structure of the riot is laid out: First, the young women hear the sound of
hundreds of tramping feet, marching in order, as the "mob" passes the Rectory.
The rioters stop at the Rectory to contemplate the murder of the Rector Mr. Hel-
stone — but, characteristically, are scared off by the dog. Shirley (aka "Captain
Shirley") projects a "counter-riot" with her (or rather Mr. Hilstone's) pistol, though
the rioters have left before she can fire a shot, and her "counter-riot" does not ma-
terialize. The scene, however, is a prelude to the action at the mill. It describes
how the rioters operate and these ladies react, as the riot itself is made distinctive
only by the perspective from which these particular spectators view it, and this is
a romantic perspective.

The rioters proceed to the mill, break down the gates, smash the windows, and
are repulsed. Moore (unlike some other mill-owners of the region) is prepared
and has redcoats and fire arms ready and waiting. But this is no police riot: Moore
cares for the wounded, does not pursue the rioters, only the ring-leaders (the
agitators). These he does pursue at a later time, disappearing for a long stretch be-
fore returning with the last of them, who are tried, convicted, and transported.
No hangings. But there is a final — a third stage — of the riot: one of the original
agitators from the first riot, when the frames were destroyed, now ambushes
Moore and avenges the convicted agitators. But Moore survives the bullet, does
not press charges, and the wretched man is allowed to sink into delirium tremens
and madness.

The riot, which comes to a head in a single chapter, is more a shadow across the coming-of-age of the two young ladies — and also of Moore — than a thing in itself. It is in the novel to characterize Moore and Shirley and Caroline — secondarily Mr. Hilstone and Mr. York as they respond in their opposite ways. Riot is essentially part of the narrative of Robert Moore, focusing his good and bad qualities on the "hate and vengeance" he provokes. There is no representative quality in the Shirley-Caroline-Moore plot that sheds significant light on the nature of the riots. Very different was the displacement of riot in *Barnaby Rudge* and *Heart of Midlothian* from macrocosm to microcosm, down to the level of individual psychology.

Riot and Rape in British India: E.M. Forster and Paul Scott

In England in the twentieth century the sense of riot depended on whether seen by the right or the left — from the right, Swift's madness, and from the left the Peterloo sense of a peaceful demonstration bloodily suppressed. The notorious example was the massacre in British India at Amritsar (1919). On 10 April 1919 the arrest of two Indian leaders in Amritsar led to a riot of some 40,000 people who pillaged and burned buildings in the city, killing five white men. General Reginald Dyer took command of the city, and on 13 April became aware of a festival celebrating the first day of harvest, which brought out both Sikhs and Hindus. There was a great gathering in Jallianwala Bagh, which allegedly included a small group of political agitators, somewhere within the crowd of several thousand celebrating the festival. Dyer had the Riot Act read but it could not possibly be heard, and he opened fire indiscriminately on the crowd. Official estimates put the death toll at 379 and at least 1,200 wounded, and popular estimates were much higher. Dyer admitted no error, was hailed a hero in the immediate aftermath, and while he was eventually reprimanded, he was never punished.[137] In effect, Dyer called a riot what was in fact an Indian fertility festival. Gandhi's response was the peaceful march, which positioned the counter-revolutionary armies of the Raj as the rioters against the King's Peace.

137. See Alex von Tunzelmann, *Indian Summer: The Secret History of the End of an Empire* (New York: Henry Holt, 2007), 41–43.

In *A Passage to India* (1924), E.M. Forster does not describe Amritsar, though its memory shadows the background of the action, as the Porteous riots did in *Heart of Midlothian*, but he displaces the memory onto a description of an innocent Hindu celebration of the sort that General Dyer's troops fired into. Forster's point is that India, seen from the perspective of the Raj (e.g., General Dyer), is riot; seen through the eyes of British law, riot equals twelve or more people assembling unlawfully and failing to disperse when so ordered.

In Part III, "Temple", Professor Godbole is in the midst of another Hindu festival, celebrating the birth of God: God, he chants, is "my father and mother and everybody", and everybody and everything is here (though "placed wrong"), which Forster describes as "the toiling riot, whom some call the real India".[138] "The assembly", he adds, "was in a tender, happy state unknown to an English crowd, it seethed like a beneficent potion". There is music, but it is "untrammeled", and all the "braying braying crooning melted into a single mass".

In this representation of "riot" as festival, "India was (as we call it)", writes Forster the Englishman, "a frustration of reason and form", a "jumble" of mistakes (elsewhere, a "muddle", "the divine mess", "benign confusion"), a mix in which Eastern and Western objects are undifferentiated, in which the Hindu myth of the birth of Sri Krishna is conflated with the Christian Nativity (Herod is present also): — "it made no difference"; "God si [sic] Love". The celebration is characterized by joy and laughter — "a most beautiful and radiant expression" is on their faces, showing that "the divine sense of human coincided with their own" — a sense of "fun" (289–90). This is riot in its positive sense, opposed to Lent and British Protestant Christianity, which is represented by the police, army, and Raj: "By sacrificing good taste, this worship achieved what Christianity had shirked: the inclusion of merriment"; in the Christian Raj "practical jokes are banned". (Recall the filching of milk and gin in *The March to Finchley*, which regarded in the Indian way were practical jokes rather than felonies.)

This festival, I believe Forster is saying, was the kind of riot that was "dispersed" by General Dyer at Amritsar. The Amritsar massacre itself does not appear in *Passage to India*, but the public catastrophe (the macrocosm of massacre riot) is displaced to the private case of Adela Quested's "rape" and the violent British response to it. The rape was imaginary, as was also the Amritsar riot (only designated riot by General Dyer), but it was designated rape by an English lady and so

138. E.M. Forster, *A Passage to India* (1924; New York: Harcourt, Brace, 1957), 284–85.

by all the English colony, and the "rapist", the Indian Dr. Aziz, was assumed guilty. In the thematics of the novel, it is another case of the misperception between East and West that ends with the friends Fielding and Dr. Aziz, representations of British and Hindu India at their best, riding off in different directions, unable ever to join. In *Passage to India* Forster moves riot from a political to a psychological nexus, from the model of representative government to the acknowledgement that one no longer, in this age, sees the difference between collective and personal guilt.

Forty years later, in Paul Scott's *Raj Quartet* (1966–75), rape also serves as the subject of displacement for the British massacre riot, which always implicitly is Amritsar and behind it, explaining something of General Dyer's reaction, memories of the treatment of British women in the Sepoy Mutiny. The sense of riot was always associated by the British with the sexual attack of black Indians on white British women. Here it is a British girl, Daphne Manners, raped by two or more Indian men followed by the massacre-minded response of the British. She was raped, but the law focuses on the wrong man, the innocent Hari Kumar, and grievously punishes him. (In particular the reaction of Ronald Merrick, the district superintendent of police, who is engaged to Daphne, is savage, sadistic, and sexually degrading.)

On the first page of the first volume of *The Raj Quartet, The Jewel in the Crown* (1966), Scott writes: "This is the story of a rape", but it is set in 1942 and opens with the macrocosm, a riot following the arrest of Mahatma Gandhi (who has declared himself against British rule, implicitly inviting a Japanese takeover), involving another British woman, closer to Forster's Mrs. Moore. The elderly Miss Crane is attacked by a mob on the road (she recalls "the troubles of 1919" [50]), slapped repeatedly by an Indian, and pushed into a ditch, but it is her Indian companion and guardian, Mr. Chadhuri, who is killed. He gives himself to the mob to save Miss Crane (as the Muslim Ahmed does in the riot at "Independence" that ends the four volumes). The British woman survives (physically, though ultimately not psychologically), but the victim is the Indian.

The rape of Daphne Manners follows close upon — in Indian and British minds is conflated with — the riot experienced by Miss Crane, and the official response is quick and excessive. As in the case in Amritsar, the governor turns control over to the military —

> things had been almost as bad as in the days of General Dyer in Amritsar in 1919. There had not been any indiscriminate shooting of unarmed civil-

ians, but there had been, apart from controlled shootings and consequent deaths, the forcible feeding with beef — if the story were to be believed — of six Hindu youths who were suspected or guilty of the rape [Daphne's] in the Bibighar Gardens.

And there were rumors that the boys had also been whipped, and they disappeared into prison without trial. In the town where Miss Crane was assaulted "there had been many charges by mounted police, and firing by the military to disperse crowds and punish looters and fire-raisers" (62).

Mr. Chadhuri's assumption, on the spot, was that this is an ordinary riot, which may begin as a protest supporting Gandhi but whose "main preoccupation was the prospect of loot" — and when he is knocked down, the rioters go through his pockets.

> The size of the crowd depended on three things: the nature of the distur-
> bance in the town which dictated the likely quantity of loot to be expected;
> the general temper of the surrounding villages and the number of men in
> each of them who had time and inclination to take the opportunity of filling
> their pockets; and finally the degree of control that the village headmen
> and rural police were able to exercise. (50)

These are the usual elements of the looting riot: the crowd's natural expansion into looting, the influence for good or evil of the village leaders, and the restraining force of the police. The crowd that kills Mr. Chadhuri at first, faced with Miss Crane's car, moves back "to give way, but then they cohered again into a solid mass. They must have seen her white face. A man in front began to wave his arms, commanding them to stop". Chadhuri shouts to "Keep going", but "She couldn't drive into a mass of living creatures" (56). They overturn her car.

Before the crowd slips into violence, the rioters, chanting here "Quit India! Quit India", recall the Indians in Forster's novel chanting "Essmiss Esmoore". Like the Hindus in Part III of *Passage* they are festive, notably laughing. With Miss Crane's attempt to defend herself, and while Mr. Chadhuri cries "Devils! Devils!", "they laughed louder and struck postures of mock defence and defiance, jumped about grinning, like performing monkeys" (58–59).

For the British in India the massacre of Amritsar was the defining event. Gandhi's decision that India must be independent supposedly followed from that

traumatic incident. Its presence is felt in every novel about India, whether explicitly or implicitly. Forster and Scott do not show it; instead they displace the public phenomenon onto a private situation that has the same structure: an act that has the elements of a riot (wild and loose festivity, a sexual dimension), a misunderstanding of the act, and a violent and paranoid response that produces a true riot situation. *This* is how you talk about Amritsar, particularly if you are an Englishman: indirectly, displacing it from the public to the private, something that mimics the structure of a riot, that you believe contains or represents the heart and soul of the riot.

Rape, though perhaps for both Forster and Scott it had a literary genealogy that went back to the "pursued maiden" described by Leslie Fiedler,[139] was Indian-specific and distinct from the rape that precipitated and centered many eighteenth- and nineteenth-century English novels: *Clarissa*, where the heroine was raped by a libertine, or its comic counter in *Shamela*. In countries of mixed races like British India a black man attacking a white woman was the epitome of rebellion, taking the white man's woman and, in effect, his manhood. In *Passage to India* and in Scott's *Raj Quartet*, respectively, first there is the rape and then the riot, first there is the riot and then the rape. In the displacement from riot to rape, rape is a synecdoche, a part for the whole, the defining characeristic of the riot.

Forster and Scott chose not to represent the horrible (unrepresentable) massacre of Amritsar in their novels, but they represented instead an ironic displacement of Amritsar (that is, the police or massacre riot) onto the Hindu fertility festival, the equivalent — or better, the truth — of "riot" (which had been rendered a lie by Gen. Dyer). They then located the source of the riot in a private sexual desire — fairly obvious in the festive (fertility-based) riot, but according to Swift and others true of the seditious riot as well, or any riot. Sex becomes, or is replaced by, violence: a microcosm of Amritsar, a misunderstood and disastrous mingling of races, a lynching that satisfies sexual needs.

The "riots" in India that followed Independence in 1947 went beyond a conventional sense of riot — from massacres to pogroms and genocide. The Hindu majority killed the minority, alien, and fleeing (to Pakistan) Muslims. Here the members of one religion pour out onto the street and attack the churches and homes of another religion, randomly murdering people. If they were against the constituted authority (against Church of England in London, Muslims in Pakistan)

139. Leslie Fiedler, *Love and Death in the American Novel* (New York: Criterion, 1966).

these forays might have been riots; they were in India, and though they were ex-tralegal, they spoke for the religious majority — another form of crowd ritual, an organized form of lynching.

In the final volume of Scott's *Raj Quartet*, *A Division of Spoils* (1975), the terrible events of 1947 are epitomized by an ambush. A train is stopped, compartments with Muslims, previously marked with chalk, are broken into and men, women, and children dragged out and killed. Scott describes a scene of the dead along the railroad tracks in the same terms Forster had used for his festival/riot: "men, women, youths, young girls, babies, in death looking all the same, like dummies stuffed for some kind of strange fertility festival".[140] The other side of Forster's Indian undifferentiation, the positive fertility ritual, is negative, anarchy: "But it was all so senseless. Such a damned bloody senseless mess ... the mess the Raj had never been able to sort out" (606).

The English are not harmed, only the natives, but Scott describes it as a displace-ment (of the sort we saw in the Gordon riots) of the hatred of the Raj: "It was the kind of situation that had always been bubbling under the surface trying to break out, the kind that the Raj had had to try to control. Now the worst had happened" (609). The bag had burst. The Independence riots carry us into the twentieth, in-deed the twenty-first century. Pogroms are the extreme of vigilante action, taken from the position of power, of the state against minorities, if only in the locale or neighborhood, but often, as in India, over large areas.

The American Lynching: James Baldwin's "Going to Meet the Man"

Across the ocean in the Colonies, the American riot, from its beginning in the Boston Tea Party, was based on a form of the British crowd ritual — "the people have the right to take matters into their own hands" — that carried an unusual au-thority. The assumption being that Americans, unlike Englishmen, should be free to assemble without regard to size or cause, there was no Riot Act in America. (Other laws applied: disorderly conduct, arson, criminal trespass, etc.) Most ex-tralegal public action was vigilante action, all-American like the Boston Tea Party or the tar-and-feathering of Tories, and the police usually stood back or were com-

140. Paul Scott, *A Division of Spoils*, vol. 4 of *The Raj Quartet* (1965; New York: Avon, 1979), 606.

plicit.[141] In the nineteenth century the equivalents of the colonial riots were slave-related, on one side the Nat Turner uprising, slaves against masters (1831), and on the other the New York Draft Riots of 1863, which, beginning as reaction against the Civil War draft, led to the ransacking and burning of buildings, including many homes and an orphanage for black children, and the lynching of black men (whom the mob blamed for the draft), and concluded with the bloody suppression by the military using artillery and fixed bayonets.

The lynch riots that followed the Civil War, seen from the left, presented images of horrifying injustice, from the right the heroic Ku Klux Klan emblazoned in D.W. Griffiths's film *Birth of a Nation* (1915), with the counter-riot police the abhorred Northern carpetbaggers. Police remained one element, supposedly counter though often acquiescent, looking the other way or too weak to act effectively. Riot and police were to become interchangeable elements of the social scene.

One of the literary topoi of the twentieth century was the riot that lynched, ordinarily an innocent man. In the 1900s, as Dos Passos noted in *U.S.A.*, "they lynched the pacifists and the proGermans and the wobblies and the reds and the bolsheviks" — anyone guilty of being un-American.[142] An innocent white man is lynched in William Faulkner's *Sanctuary* (1932) and in Walter van Tilburg Clark's *The Ox-Bow Incident* (1940). But the paradigmatic lynchings were of black men. In Faulkner's short story "Dry September" (1931) and his novel *Light in August* (1932) it is a black accused of raping a white woman, and in James Baldwin's "Going to Meet the Man" (1965) it is a conflation of riot, rape, and lynching that operates in much the way of Scott's Indian plot.[143]

A man is in bed with his wife, unable to "get it up" (his words). He thinks that if she were "a nigger girl", he could ask her to fellate him, and the "image of a black girl caused a distant excitement in him", but something else seems to be on his mind: two events witnessed by this man, one on the day before, the other from his childhood. The first is a "riot" (so designated by the sheriff) and its consequence, and the second is a lynching.

141. This vigilante action ("This isn't the law: this is a citizens' committee") is defined by Mac in *In Dubious Battle*: "Why they're the dirtiest guys in any town. They're the same ones that burned the houses of old German people during the war. They're the same ones that lynch Negroes. They like to be cruel. They like to hurt people, and they always give it a nice name, patriotism or protecting the constitution" (John Steinbeck, *In Dubious Battle* [1936, Penguin Edition, 2006], 91, 131).

142. John Dos Passos, *U.S.A.* (1930–37, Modern Library, n.d.), 1:95.

143. See Jacqueline Goldsby, *A Spectacular Secret: Lynching in American Life and Literature* (Chicago: University of Chicago Press, 2006).

The first is a police riot: A group of blacks, the narrator relates, "start blocking traffic around the court house so couldn't nothing or nobody get through, and Big Jim C. [the sheriff] told them to disperse and they wouldn't move, they just kep up that singing".[144] In particular, they will not stop singing. The sheriff and his associates beat the "ring-leader" and a couple of others, take them to the police station, and the narrator, a deputy, mercilessly beats a black boy, crying repeatedly, "You make them stop that singing" — the festive element ("wild and loose festivity") he cannot stand; and then he "began to hurt all over with that peculiar excitement which refused to be released", and soon "he felt himself violently stiffen" — words which evoke the opening of the story, in bed with his wife.

This riot recovers the memory of an earlier incident, the lynching to which his father took him when he was a child, and this proves to be the source of his physical reaction to his treatment of the black boy who led the riot. The happy result of this memory is, in his bedroom, the erection he had lacked at the beginning of the story and a satisfactory sex act with his wife: "Something bubbled up in him, his nature again returned to him", and this is the result of thoughts of the black boy in the cell, the black man hanging over the fire, and the castrating knife in the hand of a white man.

Baldwin's story is an elaboration of John Steinbeck's story "The Vigilante", in *The Long Valley* (1938). Following his participation in a lynching, a character named Mike, similarly impotent in bed, is accused by his wife of having been with another woman. He thinks: "By God, she was right. That's exactly how I do feel". What was implicit in Steinbeck's story of the 1930s is in the 1950s painfully explicit. In Baldwin's story there is the white man's psychology, the boy focused on the size of the victim's genitals — "huge, huge, much bigger than his father's, ... the largest thing he had ever seen till then, and the blackest". The black body is both sexualized (the man with the knife "stretched them, cradled them, caressed them" before cutting) and aestheticized: "He watched the hanging, gleaming body, the most beautiful and terrible object he had ever seen till then", and wished "that he had been that man" who wields the knife (247–48). He returns us to the conflation of beauty and sex in Hogarth's *Analysis of Beauty*. But the genuine aesthetic experience is compromised; in the very title of the story, he goes to meet, not to see, the man; the encounter is more intimate than aesthetic. Finally, like the current riot

144. James Baldwin, "Going to Meet the Man", in *Going to Meet the Man* (1955; New York: Vintage, 1995), 232.

("stop that singing"), the lynching is a festive occasion: the boy "began to feel a joy he had never felt before", "a wave of laughter swept the crowd", and the occasion ends in a picnic, all but the singing.

The sexual urgency at the bottom of the riot enters from an essential nucleus, the fear of the black man's having sex with a white woman, the white man's guilt at having sex with a black woman; but the congruence is significant, one that was evident in the literature of the crowd and the riot from the beginning. In Baldwin's story, as it "bubbled up", "He moaned. He wanted to let whatever was in him out; but it wouldn't come out" (230).

In Baldwin's essay, "Notes of a Native Son" in the book of the same name (1955), the race riot is seen from the other side, from the perspective of the black son and his father. The death of the father is played off against the coincidence of the race riots in Detroit and Harlem: the father riven by bitterness and hatred is the microcosm that, in this case, indicates the disquiet which generates the rioting of the blacks in random violence, "one of the bloodiest race riots of the century".[145] The son reflects on "how powerful and overflowing this bitterness could be and to realize that this bitterness now was mine" (65). This brings out the rioter in him: "Between pity and guilt and fear I began to feel that there was another me trapped in my skull like a jack-in-the-box who might escape my control at any moment and fill the air with screaming" (76). And he joins, a few pages later, the riot itself, which accords with his imagery of repletion — "like the effect of a lit match in a tin of gasoline. The mob gathered before the doors of the Hotel Braddock simply began to swell and to spread in every direction, and Harlem exploded" (81). The microcosm of the deputy sheriff's orgasm, in the larger world, is reflected in Harlem's riot.

The American Strike: Steinbeck's *In Dubious Battle*

When does a crowd ritual become un-American? When it is a strike, picketing, or a protest-march — when it is seen as a riot by the Tories who followed the jeering at a British sentry with the Boston Massacre, which graduated from protest to uprising to revolution. The characteristic American riot of the 1930s was the strike. A strike was a negative riot, Gandhi's "passive resistance" — in fact a withdrawal

145. James Baldwin, *Collected Essays* (New York: Library of America, 1998), 63.

from violence and from action which, for example, prevents the apples from being picked and leaves them to rot on the tree; which, however, unlike the Gandhi hunger strike, expects retaliation: management replacing the strikers with scabs, an act that will bring back the strikers as pickets and cause management to call out the police, and the result is a police riot.

Between the 1880s and 1900s there were more than 37,000 labor strikes, many of them bloody. Attempts to unionize were met with clubbings, shootings, imprisonments, and executions at the hands first of the company strike-breakers and then of the police, National Guardsmen, and the U.S. Army. In these armed conflicts — in the Homestead and Pullman strikes of the 1890s, at Ludlow in 1914 — dozens of workers were killed, and, from the perspective of the right, "company" came to equal "America".

Steinbeck's novel *In Dubious Battle* (1936) is virtually a how-to manual for strike-making: in effect, an analysis of the strike-as-riot, a practical example of crowd ritual and how to conduct it that follows from, and refers to, the facts of the San Francisco Longshoremen strike of 1934, a typical police riot, where on 3 July (known as "Bloody Thursday"), the police killed two protesters and wounded seventy others. Steinbeck imagines a strike of migrant apple-pickers south of San Francisco. The owners, the California Growers' Association, peremptorily cuts wages, the pickers strike, but the Growers' Association controls the government and the state police, who are brutal in their response to the strikers, and the strike is ineffective. Seen from the left, the scene is a murderous police riot, from the right (as it was in Brontë's *Shirley*) a plot by Commies and radicals.

Steinbeck, however, portrays the strike not from the perspective of the pickers but from that of the organizer, Mac, who is further seen through the eyes of an impressionable young man, Jim, a Depression outsider who wants to join the Communist Party and becomes Mac's friend. The novel follows Mac's indoctrination of Jim, a realpolitik of the strike: get among the workers, smoke and share your tobacco, don't argue with a cop except at night, use whatever material is at hand, don't waste your time on old guys. "You win a strike two ways", Mac says, not because you win the strike but "because the men put up a steady fight, and because public sentiment comes over to your side": affect over effect.

Steinbeck's sympathy is with the strikers, but his interest in the manipulations of the organizer — better defined as an agitator — confers a certain detachment on the phenomenon. In terms of gain and loss, the organizer and the owners, polarized, equally destroy the workers-strikers, who are struggling only for bread; Mac

imposes a strike on them, his only objective being to raise their consciousness, whatever the cost to their survival, and so to recruit for the union and the Party. And Mac himself is only on assignment from the higher-ups such as Harry Bridges and ultimately Moscow: these are, as people of the right were assuming, radicals, and Commies, and Mac demonstrates the exploitation of the police riots by the Communists.[146]

The stages are schematic: organize, distribute handbills, strike, and picket — win over or beat up the scabs — then, with the arrival of deputies (often vigilantes), comes the production of a martyr (Joy, Al Anderson, even old Dan — "The old buzzard was worth something after all", says Mac [79]). At the end when Jim is killed, while Mac is affected by his student's (his friend's) death, he immediately turns him into another symbolic martyr who will stimulate the strikers to further action and, better, organization — "for every man they kill ten new ones come over to us" (253). In consequence, it's good that men like Jim are killed — and yet, as Mac says, "You see a guy hurt, . . . an' you think, what the hell's the use of it, an' then you think of the millions starving, and it's all right again. It's worth it. But it keeps you jumping between pictures", between the part and the whole.

The treatment of the pickers by the police is mostly off-stage, while the strikers' treatment of the scabs is front and center, seen by Jim the distanced, if not detached, spectator: "Jim looked without emotion at the ten moaning men on the ground, their faces kicked shapeless. Here a lip was torn away, exposing bloody teeth and gums; one man cried like a child because his arm was bent sharply backward, broken at the elbow" (142). The unintended consequences of Mac's program are also extreme: He has persuaded Al, the lunch wagon proprietor, to help, and Al's father has permitted them to camp on his farm. The Growers' vigilantes burn the lunch wagon, break Al's leg and ribs, smash his head, and burn his father's barn and apple crop.

Steinbeck's verdict on Mac, if not on the strikers, begins with his title and epigraph from Milton's *Paradise Lost*, where Satan and his angels engage God "in dubious battle". Satan speaks:

> Innumerable force of Spirits armed,
> That durst dislike his reign, and, me preferring,

146. Thirty years later, laid in the same territory, Ken Kesey's *Sometimes a Great Notion* (1964) presents a strike in which the hero is the strike-breaker, the story a family's battle against the labor union.

His utmost power with adverse power opposed
In dubious battle on the plains of Heaven
And shook his throne. What though the field be lost?
All is not lost — the unconquerable will,
And study of revenge, immortal hate,
And courage never to submit or yield:
And what is else not to be overcome? (l. 101–09)

The analogous speaker can only be Mac, as in his words to Jim:

> "No, I don't think we have a chance to win it. This valley's organized [he means by the Growers' Association]. They'll start shooting, and they'll get away with it. We haven't a chance. I figure these guys here'll probably start deserting as soon as much trouble starts. But you don't want to worry about that, Jim. The thing will carry on and on. It'll spread, and some day — it'll work. Some day we'll win. We've got to believe that". (121)

Satan's lines have to be read as mock-heroic, Mac's as seriously undercut by the action. The reading projected by the epigraph (given its date, a nod at Joyce's *Ulysses* and Eliot's *Waste Land*) is not that different from the Tory reading of riot in the eighteenth century and its employment of typology — the War in Heaven to a strike in 1930s California; and so Satan (Mac) seduces the strikers into attacking God (His equivalent, the California Growers' Association).[147]

It is obvious how the pattern fits Steinbeck's novel — the final figure, of Dryden's Absalom, is in his scenario the man named London (after Jack London?), the good, naive striker, the natural leader, Mac's "man". *Dubious* must refer to the ambiguity of the situation and the outcome: the destruction of the fallen angels, despite Satan's and Mac's hopeful predictions (unless Steinbeck is reflecting the old Romantic reading of Satan as the hero of *Paradise Lost*). The parallel between the power of the Growers' Association and the power of God, who in Milton's story has the final word, finds its equivalent in the words of Jim and London to Mac: "But we can't fight guns and gas with our hands" (242–43).

147. Eliot cast a shadow across much fiction of the '30s. As the strike enters its final phase, Jim sees a woman "combing her hair" (repeated three times) and remembers an image of the Virgin Mary in a church, which recalls Eliot's epiphany of the Dantesque woman in "La Figlia che Piange".

The good characters are Dan, London, and the other workers, who are manipulated by the organizers and exploited by the Association. But there is another figure who complements the voices of Jim and Mac and, in particular, Mac's pseudo-detachment: Doc Burton stands outside the politics and the organization, the discourse of revolution and Communism. When Jim says of the strike's failure, "The worse it is, the more effect it'll have", Doc replies: "It all seems meaningless to me, brutal and meaningless" — or, as the title says, *dubious*.

Doc Burton is a physician who keeps the encampment, the "home" the strikers construct for themselves, healthy and clean — from his point of view to care for the pickers' bodies, from Mac's to prevent the Growers from exploiting health laws to close the encampment. Through Doc, Steinbeck attempts to redefine the riot crowd, which in the terms of Mac and the Communist Party is the unruly crowd of Dryden's Tory fiction. Doc's idea of a "group-man", or "phalanx" (a massed, compact body of infantrymen united in a common purpose), replaces the crowd (throng, crush, rout, horde, or mob, with implications of disorder, destruction, or violence) with a biological body, an entity like an amoeba, without a leader (Mac) but its own telos. This is a body vs. a part, nucleus, or synecdoche (or cell or an "elite"), which designates the source of riot as a healthy organism doing the natural thing according to the Laws of Nature — not Swift's diseased organism, a boil waiting to be lanced. It naturally responds to constraint, advances and expands, without any Achitophel and Absalom, a Mac and Jim, to guide it.

Doc's image is of the Body Politic: "When you cut your finger, and streptococci get in the wound, there's a swelling and a soreness. That swelling is the fight your body puts up, the pain is the battle. You can't tell which one is going to win, but the wound is the first battleground. If the cells lose the first fight the streptococci invade, and the fight goes on up the arm" (113). But Doc's Marxist body, different from Swift's, is attacked from the outside, not the inside, by a germ and not a sexual desire (though Mac acknowledges that he keeps his economics in his bedroom [59]). The body has a good chance, Doc believes, *as body* of defending itself. He sees infection as invested capital, but the wound is the strike.

In support of Doc's thesis, the one positive quality that emerges as we follow the strikers is their sense of comradeship, of oneness and a sort of joy among many different men. Jim's final justification for his role as Mac's acolyte and a fellow striker is that "I used to be lonely, and I'm not any more"; whereas Doc, the outsider, admits that he is "lonely ... I'm awfully lonely. I'm working alone, towards nothing" (199–200). And yet in a later dialogue Jim asks whether anybody knows "How a

bunch o' guys'll act?" "No", says Mac, "I've saw a bunch of guys run like rabbits when a truck back-fired. Other times, seems like nothin' can scare 'em" (210–11). And within the strike there are exceptions like Burke, a betrayer among the rebel angels.

And Doc is above the "battle"; Mac identifies him as an aesthete and Jim refers to Doc's "high-falutin' ideas". "Beautiful creatures", says Doc, referring to Mr. Anderson's pointers; "they give me a sensual pleasure, almost sexual". Mac replies: "Here's a couple of fine dogs, good hunting dogs, but they're not dogs to Doc, they're feelings. They're dogs, to me. And these guys sleeping here are men, with stomachs; but they're not men to Doc, they're a kind of collective Colossus" (115). (The pointers are burned to death along with Mr. Anderson's crop and barn, the result of Mac's strike.)

Mac has a more realistic version of Doc's phalanx. In fact, "a mob with something it wants to do is just about as efficient as trained soldiers", Mac says,

> but tricky. They'll knock that barricade, but then what? They'll want to do something else before they cool off. … It is a big animal. It's different from the men in it. And it's stronger than all the men put together. It doesn't want the same things men want — it's like Doc said — and we don't know what it'll do.

Its biological motivation, he says, is the smell of blood. "A smell of blood seems to steam 'em up. Let 'em kill somethin', even a cat, an' they'll want to go right on killin'". On lynching, Mac remarks: "I saw a nigger lynched one time. They took him about a quarter of a mile to railroad over-pass. On th' way out that crowd killed a little dog, stoned it to death. Ever'body just picked up rocks. The air was just full of killin'. Then they wasn't satisfied to hang the nigger. They had to burn 'im an' shoot 'im, too" (239, 249, 211). Apparently so long as it is directed by Mac or another professional agitator the bloodlust can be controlled.

In Dubious Battle is a conventional novel, both *bildungsroman* (Jim in the ways of strike agitation) and how-to manual (all you ever wanted to know about a strike). While Dickens's family in *Barnaby Rudge* was a miniature of the Gordon riots, Steinbeck's "family" is a "revolutionary cadre", a nucleus around which an expanding organization is built, and so the cause of the riot. The macrocosm strike is portrayed in all its detail, but Steinbeck's focus is on the agitators Mac and Jim, and their relationship, while on one level *bildungsroman*, on another is male bond-

ing with a homoerotic dimension; both metaphorically and sexually Jim's trans-formation is portrayed as a "rape", or rather a seduction that leads to Jim's death. As a nucleus their relationship is to the strike as the narrator's sexual confusion is to the riot of "Going to Meet the Man".

The novel is a much more complex nexus for the analysis of riot than the graphic image, not excluding the photograph. The mode of photography and cinematog-raphy is the shocking gestalt: the footage of blacks emerging from stores carrying TVs, police wielding nightsticks, a policeman dragging a woman along a street, and of course the fire hoses and police dogs. The cartoonist's mode in the 1930s was allegory. In political cartoons of the right a huge thuggish hulk in overalls was labeled "Strike" (or given the face of John L. Lewis). In *The Masses* and *The New Masses* the huge looming figure was the employer, the difference being that he had a pot belly, a top hat, and a suit decorated with dollar signs. In the comicstrip, Little Orphan Annie, in the '20s, picketed a restaurant from which she had been fired, but in the '30s she turned against strikers, whose organizers drove big cars and (beyond the law and by the Grace of God) are crushed under an elephant's foot — or disappeared under Punjab's capacious cape. A drawing by William Grop-per (1930s) shows the striker being tied hand and foot and beaten and bludgeoned by figures labeled "Strike-breaking" and "Union-busting", while in the foreground a figure with a Sherlock Holmes hat and a magnifying glass is examining an insect, his back turned to the strike-breaking.[148]

In a Pulitzer Prize cartoon by Ross A. Lewis in the *Milwaukee Journal* (1935, fig. 43), rather like Turner's angel in *Angel Standing in the Sun*, a huge figure of Vio-lence, a thug carrying a brick in one hand and bombs in the other, has one foot next to a factory ("Industry"), the other next to a group of tiny men, "Strikers".[149] The title is "Sure, I'll work for both sides". Drawn with conte crayon, evoking the style of the *Masses* cartoons (Lewis studied under Boardman Robinson), it could serve as an emblematic illustration for *In Dubious Battle*, but without the novel's subtle analysis of motives and causes.[150]

148. See *The Image of America in Caricature & Cartoon* (Fort Worth: Amon Carter Museum, 1976), fig. 154.

149. Gerald W. Johnson, *The Lines are Drawn: American Life since the First World War as reflected in the Pulitzer Prize Cartoons* (New York: Lippincott, 1958), 97.

150. The graphic image of lynching was equally powerful, and simple, the most famous being Ed-mund Duffy's Pulitzer Prize cartoon, "California Points with Pride" (*Baltimore Sun*, 1934), which shows the governor of the state gesturing toward two bodies hanging above him from the branch of a tree (John-son, op. cit., 91).

The Hollywood Riot: West's *Day of the Locust*

Steinbeck said of *In Dubious Battle* that his intention was to write not fact or re-
alism but fantasy: "I still think that most 'realistic' writing is farther from the real
than most honest fantasy".[151] Steinbeck's "fantasy" might refer to his title and epi-
graph from *Paradise Lost*, where Satan and his angels engage God "in dubious
battle". It might merely be that Steinbeck "imagined" the apple-pickers' strike
rather than reported the longshoremen's. But whatever he may have meant by this,
his novel asks to be contrasted with Nathanael West's *The Day of the Locust* (1939),
a work that deals with — or some would say avoids — the issues of the 1930s with
a fantasy reminiscent of Hawthorne.

The closest West got to a strike was in 1935 when he and some other writers
marched in a picket line, singing "The International", outside Orbach's in New
York. But even picketing was potentially a police riot. West's group was attacked
by the police and arrested, though shortly released by a sensible judge. Edward
Dahlberg, one of the picketers, noted that among the others "there was a certain
amount of exhilaration: singing, fun and games. West took no part in any of it" —
this was not his sort of riot. It was "spiritual, not material, poverty" that interested
West.[152]

The 1930s was the time of the Great Depression. In April 1932 the peaceful
protest of the Bonus Marchers' encampment ("Hooverville"), judged to be threat-
ening the nation's capital, caused the army, led by General MacArthur and Major
Patton, to fire on the men, to attack its own veterans with cavalry and tanks. The
hunger marches and strikes were accompanied by individual acts of riot, bank
robberies. One American wrote a letter to *The Indianapolis Star* in 1934: "Dillinger
did not rob poor people. He robbed those who became rich by robbing the
poor".[153] A bank robbery was, seen one way, a small riot, but in another an act
parallel to the legal heists of the banks and bankers — an analogy made by F.D.R.
in one of his 1936 re-election speeches.

151. Quoted, Warren French, introduction to Steinbeck, *In Dubious Battle*, xiii. French thinks his
words suggest "that his intention was to imagine a possibility rather than reflect a reality, moving already
toward the cautionary mode that he would adopt in *The Grapes of Wrath*".

152. Jay Martin, *Nathanael West: The Art of His Life* (New York: Carroll & Graf, 1970), 258–59.

153. Elliott J. Gorn, *Dillinger's Wild Ride: The Year that Made America's Public Enemy Number One*
(New York: Oxford University Press, 2009); cited, Frank Rich, "Bernie Madoff is no John Dillinger", *New
York Sunday Times*, 5 July 2009, "Week in Review", 8.

The popular response to the Depression can be gauged by Hollywood movies. In the wake of the Wall Street Crash there were two kinds of movies: the gangsters in *Little Caesar* (1930), *Public Enemy* (1931), and *Scarface* (1932) were evil; their lives were, in fact, parallel to those of the bankers and capitalists, a success story leading to hubris and downfall. The bank robbers all met bad ends. But in the later '30s they were fantasized as heroic righters of wrong: in immensely popular movies, Robin Hood (1938) and Zorro (1940), in comic books Superman and Batman (both 1939).[154] In one sense Robin and Zorro, the solitary rioter who survives and wins out in the end, were a continuation of the escapist movies that depicted luxurious apartments and rich heroes in tuxedos and heroines on vast dance floors; in another, respectable versions of Dillinger". This is the context West evokes in his Hollywood riot.

The people Steinbeck describes came to California to be pickers and share-croppers, their motive hunger and survival. In *Day of the Locust* West ignores the facts of these contemporary migrations and shows middle-class retirees and es-capees traveling to Hollywood in pursuit of illusions and excitement. Money does-n't seem to be an issue; they can afford to go west to the City of Dreams. The Hollywood counter-Depression escapist movies, comedies of the rich and the vast Busby Berkeley panoramas of scantily clad dancers, were the given. These people seek happiness but instead find boredom and therefore resentment and anger. Their riot is not out of want but ennui and disillusionment with what they sought and expected.

The literary source for West's phantasmagoric riot is something like Pope's *Dunciad*; insofar as it is based on actuality, it is a Hollywood premiere, a crowd focused on a "star", another crowd ritual recalling the English Lord Mayor's Day or a Ty-burn "fair" that Hogarth paralleled in *Industry and Idleness*, Plates 11 and 12. "Here comes Gary Cooper", says one, and "this is a riot you're in", says another. Individ-ually it is the desire to get a souvenir from the star, but collectively it is simply to "grab and rend". The result is "bedlam". West claimed of *Day of the Locust* that "the people who supposedly worshiped the glamorous stars, really wanted to kill them, murder them [since] they were jealous of them ... They want to kill them, they hate them, they'd like to tear them to pieces. If they could shred their flesh as much

154. Of course, Robin Hood and Zorro had been heroes of popular Douglas Fairbanks films in the '20s (1920, 1921), but the timing of their revival was significant.

as their clothes, they would".[155] The cathected object, as in *Industry and Idleness*, is both hero and scapegoat, like Christ in Ensor's painting.

The moment the individuals, otherwise innocent, become part of the crowd, "they turned arrogant and pugnacious. It was a mistake to think them harmless curiosity seekers. They were savage and bitter", and Tod Hackett, the narrator, adds, "especially the middle-aged and the old, who had been made so by boredom and disappointment". "Their boredom becomes more and more terrible. They realize that they've been tricked and burn with resentment", and the riot follows.

The desire of these people who have come west to Hollywood is displaced onto "movie stars" and "celebrities", and when the outlet is blocked it seeks relief in explosive energy, sexual activity, destruction, and death. In the characteristic scene of riot the crowd, once activated, compared once again to an ocean, is a "dense mass" that "surges forward wherever the police line is weakest", and "As soon as that part was rammed back, the bulge would pop out somewhere else". The action of the crowd on the unfortunate Homer Simpson (and on Tod Hackett, carried along in its wake) is also that of the ocean's meaningless surge. And the metaphor of water is supplemented by the other natural image for riot, the fire of Tod Hackett's painting, "The Burning of Los Angeles".

The role of Homer — one of those "middle-aged" people who came to California and has finally decided to escape it and return to Waynesville, which he (like all the others) left to seek escape in Hollywood — is to offer the crowd a scapegoat who replaces Gary Cooper. The innocent Homer is baited by the child-star Adore. Losing control Homer tramples him, and (seen as a pervert, a parallel to the men who, in the rush, fondle or rape women) is attacked by the mob and carried off to his death, a lynching.

The riot is the action of the macrocosm; in the microcosm the search for escape is particularized in Tod's lustful pursuit of Faye Greener into the Hollywood set for the "battle of Waterloo", and later in the men at the premiere who are groping girls. The crowd's fiction of Homer's pederasty and the reality of the girl attacked by two men, carried away by the second, implies that this — an opportunity for "hugging" and "embracing", for attacking young women — is the nucleus of the riot.

So also in Tod's painting: "the naked girl in the foreground being chased" by men who will rape her, and by women who throw rocks at her, is clearly intended for Faye Greener, the object of his own desire. And the rape in the painting is

155. Henriette Martin, quoted, Jay Martin, *Nathanael West*, 304.

materialized for Tod by the cowboy Earle Shoop's pursuit and rape of the real Faye following his knocking out of his rival, the Mexican Miguel. The fight-to-the-death of two gamecocks frames these episodes: in the first Miguel shows Tod the cocks, followed by Shoop's attack on Miguel and his rape of Faye, and the second materializes the cockfight, followed by the dwarf Abe Kusick's attack on Shoop's testicles and Miguel's bedding Faye. Thereafter, Tod summons up his own fantasy of raping Faye. (The other "rapes" were probably consensual, but it is as rapes that they excite Tod.)

Faye herself, while in the painting her body flees the rapist, "is running with her eyes closed and a strange half-smile on her lips" — "she is enjoying the release that wild flight gives" as much as the terror of the pursuit and is compared to a game bird in flight (321). In another simile, she is placed in the ocean, the ocean that will engulf Homer, "riding a tremendous sea. Wave after wave reared its ton on ton of solid water and crashed down", but she is "like a cork. No matter how rough the sea got, she would go dancing over the same waves that sank iron ships and tore away piers of reinforced concrete" (404). For Faye, unlike Tod, the riot remains festive.

Religion is also present, another motive, parallel with the sexual urge. West's analogy, comparable to Dickens's, is between the illusions of the cinema and revivalist religion; at the cinema riot, the "excited, screaming fans", evoke Swift's religious enthusiasts — the news broadcaster who describes the scene is related to the revivalist preacher "whipping up his congregation", both "toward the ecstasy of fits". With of course the underlying sexual motivation. West's Hollywood is the 1930s equivalent of alcohol and religion for Swift and Hogarth: it is another way of coping with the impossible situation of the Depression, and another case of "the sublime felicity of being a fool among knaves".

West's novel is about detachment and immersion — about art and experience. His riot is doubly fictional, as both imaginary (symbolic) event and painting of the event, a scene reproduced by the artist, Tod Hackett, which he calls "The Burning of Los Angeles". It is an ekphrasis of Ensor's *Entry of Christ*. John Russell, among others, thought "the Ensor painting served as the inspiration for 'The Burning of Los Angeles", and he may have been right.[156]

156. John Russell, *New York Times*, 12 October 1987. Josephine Herbst also saw the likeness, and Jay Martin emphasizes the connection (op. cit., 316).

There are two riots and Tod's representation of a riot: First, the novel opens (chap. 1) with Tod Hackett experiencing Hollywood reality, as if he were facing Ensor's canvas, which is in fact an ekphrasis of Ensor's drawing *Les Cuirassiers à Waterloo* (1891):[157] "an army of cavalry and foot" of the French and British army at the battle of Waterloo "moved like a mob; its lines broken, as though fleeing from some terrible defeat" (259). This "bobbing disorder" is actors playing the soldiers and followed by a little fat man in a cork hat of the real world, "shaking his fist and cursing", as he tries to direct them to the correct stage to perform upon. The same mob returns in Chapter 18, where Tod is lustfully pursuing Faye Greener onto the set. What he first encounters is the ruins of previous movies, an anticipation of the consequence of the riot about to happen. For Tod this bathos signifies the melange of dreams, a "Sargasso of the imagination", that drive the lives of the poor folk who have come to Hollywood to die — the people of his painting. Second, the actual, human riot takes place at a world premiere of a movie (chap. 27). And finally, this riot is the realization of Tod's painting, on which he has been working throughout the novel — recently he "had worked on it continually" in order (his own way of coping) to escape thinking about the lovely but brainless Faye; in other words, for Tod painting a riot serves him as the same outlet as the riot itself for the "people who come to California to die". Tod, a costume designer in Hollywood, was trained at the Yale School of Fine Arts, where his models were Winslow Homer and Thomas Ryder,[158] and where he painted such subjects as "a fat red barn, old stone wall or sturdy Nantucket fisherman". But when he gets to Hollywood he finds Winslow Homer is no longer an adequate model. For the fantastic illusions and disillusions of Hollywood he begins relying on Goya, Hogarth, and Daumier, but then turns, as his thoughts go from the people to the ruins of their illusions, to Salvator Rosa, Francesco Guardi, Monsu Desiderio, and Alessandro Magnasco, "the painters of Decay and Mystery" — of "bridges which bridged nothing, sculpture in trees, palaces that seemed of marble until a whole stone portico began to flap in the light breeze", like those Hollywood sets.

The paintings Tod evokes (though West stops short at this point) are the infernos of Bosch and Brueghel: "Across the top, parallel with the frame, he had drawn the burning city, a great bonfire of architectural styles, ranging from Egyptian to Cape

157. Antwerp, Koninklijk Museum of Fine Arts; noted, Martin, op. cit., 316.
158. Significantly not Albert Pinkham Ryder, whose paintings might have prepared Tod for Hollywood.

Cod Colonial". In his representation, preceding the conflagration, in the middle distance Tod paints a "mob carrying baseball bats and torches", their faces those of "the people who come to California to die, the cultists of all sorts, economic as well as religious, … those poor devils who can only be stirred by the promise of miracles and then only to violence". Their leader is the preacher—they are "marching behind his banner in a great united front of screwballs and screwboxes to purify the land", much as we saw in *Entry of Christ into Brussels*. In the lower foreground, fleeing "the crusading mob", are the characters of the novel, including Faye and Homer, and Tod himself, shown picking up a stone "to throw before continuing his flight" (720).[159] Tod has given up the paint brush in exchange for the stone. The painting is another illusion.

This is riot as apocalypse (or, we might say, fantasy), the projected end of Hollywood: An earlier title for the novel was "The Wrath to Come", and in an earlier draft it had been narrated by another character, Claude Estee, a voice prophesying doom.[160] The painters Tod Hackett finally turns to, as he organizes his painting, are painters of decay, not of riot, and the final title (recalling Exodus 10:3–6, 13–15, and Revelations 9:3–9) is eschatological. Far removed from the social crisis of California strikes and hunger marches, and in fact contributing to West's imagining of apocalypse, must have been the war impending in Europe as he finished the novel.

Tod is initially distanced from Hollywood by his East Coast origins and his artistic temperament, adding an aesthetic dimension to West's representation of riot. Not only a spectator of the scene and the riot, beautiful or sublime, Tod also paints it—at the moment he is making sketches of the disorder he will paint in the future. In Jay Martin's interpretation of the novel (in his *Nathanael West: The Art of His Life*), "it is his artistic perception alone that stands against the disintegration of his person and the degradation of the society about him". Therefore, Martin believes, "the coherence of the design of 'The Burning of Los Angeles'"is somehow going to redeem Hollywood, in this like the larger work of art, West's novel. Martin's argument is that the novel is "retrospective, narrated after the riot which proves Tod an accurate prophet", to which he adds: "The picture, which during the

159. For an analysis of the mob scene as satire, see Kernan, *The Plot of Satire*, 66–80.
160. Martin, *Nathanael West*, 313.

time of the novel he is said to be planning, is really completed. It is a great painting. Society has dissolved into chaos, but art remains".[161]

In fact, in the midst of the riot Tod withdraws into thoughts of his painting, at this point only sketched out in charcoal on the canvas, and imagines filling in the details of the "riot". But, significantly, he has to let go of the painting, return to the real riot, in which he is immersed, and he ends uttering real screams echoing the siren of the ambulance coming to rescue him. The painting remains in his imagination. There is no indication that it is going to be painted. Tod Hackett is a feeble, twentieth-century would-be artist. His art is overwhelmed by the reality, not of a labor riot or a lynching, but only of a Hollywood premiere.

The Police Riot: Mailer's Siege of Chicago

A typical American police riot is described in John Steinbeck's *In Dubious Battle*, seen, as so often, from the perspective — the detachment — of an outside observer:

> a guy in the middle of the park talking. I climbed up on the pedestal of that statue of Senator Morgan so I could see better. And then I heard the sirens. I was watching the riot squad come in from the other side. Well, a squad came up from behind, too. Cop slugged me from behind, right in the back of the neck. When I came to I was already booked for vagrancy.[162]

The peaceful marchers and demonstrations of the 1960s, such as the various civil rights marches in the South, the protests against the Vietnam War, were not riots. They became riots when the authorities designated them riots and perpetrated a counter-riot. "Riot" was connected with the events taking place in Selma, Alabama, and other locations where attack dogs were released by the sheriffs on peaceful demonstrators, abetted by deputy sheriffs with clubs and shotguns. In April 1968 "riots" followed the assassination of Martin Luther King, with fire and looting, and in Chicago Mayor Daley ordered the police, "Shoot to kill", providing the context for the next anticipated riot, which was on the streets outside the Democratic national convention of August 1968.

161. Martin, op.cit., 314.
162. Steinbeck, *In Dubious Battle*, 7.

Of that riot, the National Commission on the Causes and Prevention of Violence concluded: "On the part of the police there was enough wild club swinging, enough cries of hatred, enough gratuitous beating to make the conclusion inescapable that individual policemen, and lots of them, committed violent acts far in excess of the requisite force for crowd dispersal or arrest".[163] Eight protesters were charged with conspiracy to incite riot, and a five-month trial followed. But while the Commission reported that the police had acted with "unrestrained and indiscriminate" violence, the police offered a different view, claiming that the officers were "the only thing that stood between Marxist street thugs and public order", "feeling outnumbered by the demonstrators hurling bottles, rocks and other objects (even a yellow sawhorse) at them; seeing a highball glass containing feces dropping from a window of a Michigan Avenue hotel onto the head of an officer and cracking his light blue helmet like an eggshell".[164]

In *Miami and the Siege of Chicago* (1968) Norman Mailer identifies himself throughout as "the reporter". He does not noticeably distort the facts of the riots: that the cause of the riot was Chicago's refusal to issue permits for the protesters' festival in the parks. Although Mailer's sympathies are clearly with the anti-war protesters at the Democratic Convention, he maintains aesthetic detachment. There is no hero, and while the protest demonstrations are plainly a police riot, made so by the decree of Mayor Daley, they do not become massacre riots. Mailer refers to "the Massacre of Michigan Avenue", but immediately adds that it was "an extraordinary event: a massacre, equal on balance to some of the old Indian raids, yet no one was killed".[165] The primary weapon used by the police is tear gas, painful but harmless, and its purpose is to clear parks for which the crowd lacks permits to occupy past closing hours; to clear the streets when, though they have a permit to assemble, they have been refused one to march.

As in Steinbeck's account of a strike, the "police riot" is helped along by the provocation of the rioters. Some "had come to Chicago ready to fight the police", whom they call pigs, and inside the parks "they were going to force the police to drive them out" (133, 145). The relation of rioters and police by this time has be-

163. The Walker Report, *Rights in Conflict* (New York: Bantom, 1968), 5.

164. Monica Davey, "41 Years Later in Chicago, Police and Demonstrators Still Clash, but With Words", *New York Times*, 29 June 2009, A11.

165. Norman Mailer, *Miami and the Siege of Chicago* (1968, reprint, *NYRB*, 2008), 159.

come symbiotic. The retaliatory action of the police, especially the tear gas, incites the crowd to riot in the further sense of pillage. The crowd now roams through the streets breaking windows,

> setting trash cans on fire, and demolishing at least a dozen patrol cars which happened to cruise down the wrong street at the wrong time. ... Perhaps the tear gas was a kind of catharsis for some of them, a letting of tears, a purging of old middle-class weakness. Some were turning from college boys to revolutionaries. It seems as if the more they were beaten and tear-gassed, the more they rallied back. (153–54)

While one group is the New Left, representing a politics of confrontation on the issue of the Vietnam War and civil rights, the group that gets his attention is the so-called Yippies:

> devoted to a politics of ecstasy ... programmatic about drug-taking Dionysiacs, propagandists by example, mystical in focus ... [carrying out] a Youth Festival which by a sheer mixture of music, witchcraft, and happy spontaneous disruption would so exacerbate the anxiety of the Establishment ... [with the Yippies embodying] a politics of confrontation which searched to dramatize the revolution as theater. (134)

The crowd is counter-culture theater, costumed and parading, like the Boston "Indians", in this case against the possibility of an election between Richard Nixon and Hubert Humphrey, close to an ekphrasis of Ensor's *Entry of Christ*:

> A Yippie clown marched through the crowd, a painted egg with legs, 'the next President of the United States' [i.e., Hubert Humphrey, known as Humphrey Dumpty], and in suite came a march of the delegates through an impromptu aisle from the stage to the rear of the crowd. A clown dressed like a Colorado miner in a fun house came first, followed by Miss America with hideous lipsticked plastic tits, stars of rouge on her cheeks; Mayor Daley's political machine — a clown with a big box horizontal to his torso, big infant's spoon at the trough on top of the box, and a green light which went on and off. ... (143–44)

Mailer's description of the Chicago rioters is of something closer to carnival than sedition.[166]

But it is the policemen themselves, he observes, "who had exploded out of their restraints like the bursting of a boil, and nonetheless he felt a sense of calm and beauty" (142). Indeed, it is to the police action that he applies the conventional riot imagery of eruption and avalanche, describing "the massacre of Michigan Avenue" in a lengthy passage as "the absolute ferocity of a tropical storm," and, he adds, turning the politics of riot into aesthetics,

> watching it from a window on the nineteenth floor [of the Hilton], there was something of the detachment of studying a storm at evening through a glass, the light was a lovely gray-blue, the police had uniforms of sky-blue, even the ferocity had an abstract elemental play of forces of nature at battle with other forces, as if sheets of tropical rain were driving across the street in patterns, in curving patterns which curved upon each other again. (169)

"The reporter", one of those "well-dressed men" of the Gordon riots, he repeats, is "watching in safety from the nineteenth floor". Moreover, the demonstrators themselves "were afterward delighted to have been manhandled before the public eye, delighted to have pushed and prodded, antagonized and provoked the cops ..."

Mailer's description of the Lincoln Park rally ("It was the orderly crowd" [142], i.e., *concordia discors*) has all the elements of the English riot including the ratio of "rioters" to spectators, those who "worked forward to get a better look". And of the Wilkite, the rioters crying out to the occupants of the Hilton: "Turn on your lights, and blink them if you are with us. If you are with us, if you are sympathetic to us, blink your lights, blink your lights" (158). Like the Wilkites of the 1760s, the Yippies are laying out a parody of their betters — a presidential nominating convention.

Mailer's recognition that he has aestheticized (or fictionalized) the riot, his feelings of guilt that he was himself above the riot and not *in* it, a spectator and aes-

166. Mailer found the same carnivalesque spirit in Miami at the Republican convention: "Miami Mummers wearing pink and orange and yellow and white and sky-blue satin outfits with net wings and white feathers, Miami Beach angels playing triangles and glockenspiels piped up tinklings and cracklings of sweet sound" (24) — but this was middle-class, Rotarian high-jinks, what might be expected at a Republican convention.

thete rather than a participant, lead him to venture out, after it's all over, and make a mini- one-man riot, which is of course another police riot: he incites the police to apprehend him and another man to sock him in the face.

A photograph, I presume taken from the Tribune Tower, and now used as cover design for the new edition of *Miami and the Siege of Chicago* (fig. 44), sums up, or ekphrasizes, Mailer's book: You see the mob straggling up and down, on and off, Michigan Avenue and, separated by several feet, the long straight lines of police parallel with the bottom line of the photograph, all the way across it, serving the same function as the columns of soldiers in the far distance of *The March to Finchley*. The energies of the crowd are being dissipated, both by the bottom line of the military and by the containment of Mailer's prose, in its form of reportage, seen from something like the nineteenth floor.

Festive Riot and the Question of Perception

The most powerful passage in Mailer's book, at the very beginning, does not describe the riot but rather the stockyards adjacent to the Chicago Amphitheater, where the convention was held. It opens:

> Endless files of animals were led through pens to be stunned on the head by hammers, and then hind legs trussed, be hoisted up on hooks to hang head down, and ride along head down on an overhead trolley which brought them to Negroes or whites, usually huge, … the Negroes up from the South, huge men built for the shock of the work, slash of a knife on the neck of the beast and gouts of blood to bathe their torso (stripped of necessity to the waist) and blood to splash their legs. (88)

And on and on for three pages. It includes the pigs who will return as epithets for the police, and it ends with the human "beasts on the street" and the mayor "who grew into a beast — a man with the very face of Chicago". (One of the Yippies' theatrical gestures was to advance a pig — "Pigasus the Immortal" — as a candidate for president.) What is so striking about the passage is the reciprocity: the conflation of beast and slaughterer into an image of lynching and scapegoat. I believe the slaughterhouse next to the convention hall is Mailer's displacement of his feelings about the police riot, over and above the detachment of his reportage, as if seen

by a colleague of Hunter S. Thompson.[167] Mailer gives us three perspectives on riot—that of the artist, the police, and the detached spectator; but the artist has assumed the lost aesthetic position, which Mailer tries to repudiate by displacing the imagery of riot onto the Democratic convention itself.

In *Miami and the Siege of Chicago* Mailer is describing the new rioters of the 1960s: the Hippies, the Gonzo rioters of Hunter S. Thompson's *Fear and Loathing* books (1960s) and Merry Pranksters of Tom Wolfe's *Electric Kool-Aid Acid Test* (1969), and their apotheosis in the Yippies. A phenomenon of the early '60s, the Hippies used drugs to explore alternative states of consciousness while they listened to psychedelic rock and talked of sexual revolution. In Thompson's case the spectator, Thompson, transforms the people he encounters into a riot, bodies of crocodiles and swine, faces melting and metamorphosing grotesquely. The riot, "the tendency to push it as far as you can", is in the eye of the spectator who is under the effect of cocaine, ether, mescaline, LSD, not to mention alcohol. The question is what in fact is the riot—which Thompson defines as "nothing in the world more helpless and irresponsible and depraved". In sum, he says: "What we need is someone already suffering from severe brain damage from a paranoic fear of government officials, and who takes risks without realising what's happening to him".[168] It is as if Thompson were the police, designating this or that as riot. His rioter, like General Dyer at Amritsar, is the spectator who sees the conditions of riot all about him, in this case the hallucinatory result of drugs and drink; his own insane behavior is the riot, with chaotic consequences, though at the same time he urges us to see in these grotesque fantasies the truth about America in the '60s. Mailer, by contrast, displaces his Gonzo perception of the Yippies onto the stockyard and the politicians rather than the rioters—as if to register the true source of riot.

Wolfe describes, from a more detached perspective (all white coat and tie), the behavior of the Merry Pranksters climbing into their famous bus:

> in high costume, ringing bells, chanting, dancing ecstatically, blowing their minds one way and another and making their favorite satiric gestures to

167. It might be useful to compare Mailer's *Miami and the Siege of Chicago* with Hunter S. Thompson's *Fear and Loathing: On the Campaign Trail '72* (Topsfield, Mass.: Salem House, 1987).

168. Hunter S. Thompson, *Fear and Loathing in Las Vegas. A Savage Journey to the Heart of the American Dream* (New York: Vintage, 1971), 4. The second quotation is Thompson's words quoted by Ralph Steadman in a cartoon in his book *Gonzo: The Art* (New York: Harcourt, 1998), 7.

the cops, handing them flowers, burying the bastids in tender fruity petals of love … thousands of high-loving heads [i.e., pranksters] out there messing up the minds of the cops and everybody else in a fiesta of love and euphoria.[169]

But they are Ken Kesey's Merry Pranksters, his bus. He fills the crowd's role of the necessary leader, the guru, the lord of misrule, a situation which prompts us to ask what has happened to the Christ figure after Wilkes and Gordon? He has become the artist, as Ensor gave Christ his own face in *The Entry of Christ into Brussels*. Tod Hackett included himself in his painting, and Kesey only required a Tom Wolfe. Another guru, Allen Ginsberg, appears in both Mailer's and Wolfe's books conducting the sort of Indian festival described by Forster in *Passage to India*.

The Kesey bus is another house, but this one full of rioters, always threatening to debouch, much like the figures in a Rowlandson coach or house, into an un-hip middle-class suburb. The police outside are a constant threat against the use of drugs and the extension of their activities beyond the bus. The girl called only Stark Naked is harmless on the bus, zonked out on drugs; when she leaves the bus, she is hustled into drug rehab. Prank describes their actions. High-jinks might be a better term: a very mild form of riot, a frolic, a very lively, perhaps noisy party. Aside from drug-taking and love-making, what they produce visually are merely sight gags — silly signs and objects (or their persons) lit up with day-glo. The riot impulse is turned inward, part *Midnight Modern Conversation*, part *Gin Lane*, if one regards them objectively.

For Wolfe, riot is a form of perception; he sees the Pranksters as a sort of movable riot; the police see them as breaking drug laws and the peace; and they see themselves as counter-culture heroes, the twelve Disciples. Their theatrical festivalism is a recovery of the carnival and Saturnalia we saw in the English eighteenth century.

Yippies (Youth International Party), established in 1967, were "a cross-fertilization of the hippie and New Left philosophies".[170] They added activism, were highly theatrical and anti-authoritarian, and associated carnival with a form of political sedition. Their ethos is illuminated by the names of their cultural heroes: the Marx

169. Tom Wolfe, *The Electric Kool-Aid Acid Test* (New York: Farrar, Straus and Giroux, 1968), 11.

170. Thomas Geoghegan, "By Any Other Name. Brass Tacks", *The Harvard Crimson*, 24 Feb. 1969, 421–22; cited, Wikipedia, to which I am grateful for my knowledge of Woodstock.

Brothers and Lenny Bruce. In 1968 in Chicago their plan was to counter the Democratic convention, the "Convention of Death", with a six-day "Festival of Life", which was to be a celebration of the counterculture as well as a protest against the Vietnam war (as Mailer puts it: "An immediate end to the war in Vietnam" [137]) and the state of the nation.

If Thompson and Wolfe summed up the riot of the "flower people" in fiction (or semi-fiction), the huge gathering in Woodstock, New York, in August 1969 offered the reality, an unretouched reflection of what Mailer described the year before in Chicago. It began as an outdoor music and arts festival on the model of the unruly rock concerts of the period (Beatles, Rolling Stones), a "free concert" of 200,000 festival-goers. The fence, for example, was cut in order to create "a totally free event". Such an influx of people created a massive traffic jam and closed the New York Thruway. The facilities were unequipped to provide sanitation or first aid; many of the musicians found themselves performing in bad weather, short on food; but minds were "open", drugs were freely employed, and love was "free", all described in the Yippie activist Abbie Hoffman's book *Woodstock Nation*.[171] The festival took place during the crucial riot time — Vietnam abroad, the Chicago convention and race riots at home. It was intended as a musical celebration of "peace" and "love". Seen from the left, and probably accurately, it was half a million largely young people gathered for three days to sing, dance, and make love, and against all the odds of disaster, riot, looting, it succeeded.[172] Most of the response, vis-à-vis the music and festivity, was aesthetic. At one point, when Abbie Hoffman attempted to introduce a political spiel, he was batted off the stage by a guitarist with The Who.[173]

The police played no very large part, but the role of the police was assumed by the press, which put its emphasis on the drugs and alcohol, the congestion, traffic jam, shortage of food and proper sanitation, and two deaths (one from an overdose, another when a tractor ran over a sleeper in a hay field) and two miscarriages. *The New York Times* pressured its reporters into playing up the bad conditions and the use of drugs: "Every major *Times* editor up to and including executive editor James Reston insisted that the tenor of the story must be a social

171. See Abbie Hoffman, *Woodstock Nation: A Talk-Rock* (New York: Random House, 1969).
172. See Robert Stephen Spitz, *Barefoot in Babylon* (New York: Viking, 1970).
173. Hoffman, *Soon to be a Major Motion Picture* (New York: Perigee Books, 1980), 86.

catastrophe in the making".[174] *The Times*'s object was the police object, to designate the festival a riot.

If the photograph on the cover of Mailer's *Chicago* (or photos of police dragging rioters, spraying them with water, or attacking them with dogs) carries one representation of the police riot, distinguished by the "detachment" but also the selective focus of the camera, the Gonzo equivalent was Ralph Steadman's illustrations for Thompson's books and his many independent drawings, summed up in *Scar Strangled Banger* (1987). These remarkable drawings, an ekphrasis of Thompson's LSD vision, are also a summation of the graphic tradition of riot: a summation of the imagery of Bosch, Hogarth, Rowlandson, Goya, Grosz, with bits of Picasso (*Guernica* horses) and Francis Bacon (the 1944 *Figures at the Base of a Crucifixion* triptych), as well as elements of surrealism (ink blots, collage).

Although Steadman has plentiful images that materialize the LSD projections of Thompson and Wolfe, I reproduce one that sums up the sense of riot in the '60s (fig. 45): the poor, drunken Gin Laners are made, by the policeman, both rioters and vagrants, and the relationship has become symbiotic: "Don't knock it! — You need me like I need you". (The verbal equivalent might be Mayor Daley's often-repeated malapropism: "The policeman isn't there to create disorder. The policeman is there to preserve disorder".[175]

But also the artist? There was the same question with Rowlandson's drawings: Is the riot an image in reality or only in the artist's post-Gordon perception? It was not an issue with Hogarth; but beginning with Rowlandson, the artist intrudes himself and we can legitimately ask whether what he shows has any reality outside his style, or his genre, or his (artist's) mind. So with the Hippie and Yippie spectator of Thompson and Wolfe's Merry Pranksters high on hallucinogens: Are they the rioters? Or do they see the truth the rest of us do not? Which means that they have assumed the role of the artist (not the police) for designating riot. With the artist's transforming imagination or with hallucinogens, the work is a merging of here and out there, but is it not an aesthetic rather than a political experience?[176] — or is this a question we could also ask about the Gordon riots? That is, to what

174. Barbara Collier, "Tired Rock Fans Begin Exodus", *New York Times*, 18 August 1969; see Simon Warner, "Reporting Woodstock: Some Contemporary Press Reflections on the Festival", in *Remembering Woodstock*, ed. Andy Bennett (Alderson, UK: Ashgate, 2004).

175. Davey, "41 Years Later in Chicago", A11.

176. They also, of course, raise the subject of riot as it applies to modern art — but offer simply another adjective designating "make it new"; see, for example, Jerry Saltz on "Drunk v. Stoned" art ("Blotto, Meet Buzzed", *Village Voice*, 11 May, 2004).

extent *were* those riots planned, a rational crowd ritual, and to what extent were they a form of *folie à deux ou trois*—even before reaching the distillery—or, in Swift's terms, sheer madness?

George Romero's *Night of the Living Dead*

Earlier in the same year, in the spring of 1968, shortly after the Martin Luther King riots, George Romero's film *Night of the Living Dead* appeared in theaters and was instantly read as an allegory of the race riots. Romero claimed this was adventitious and none of his intention, though it is hard to believe him. (In *Diary of the Dead* [2007], the most recent of the many sequels to *Night of the Living Dead*, Romero has an over-voice admit that the horror film may come "with an underlying threat of social satire"). There are the facts of riot—and the fantasy: The artist weaves a fantasy riot based on politics and ideology—a fictionalizing of riot in which the writer talks about one thing while intending or referring to another: about animals revolting against their former master and forming their own society and the unfortunate consequences, when the real subject (the tenor vs. the vehicle of a metaphor) is the political history of Communist Russia in the twentieth century.

The unburied dead are jolted back to life by some sort of a nuclear blunder. They have one emotion, one drive, which is hunger—in this case the extreme hunger for human flesh, and they do a "march" upon a house in which some folks, plainly middle-class, are holed up. They attack the house. At first there is only one, in the graveyard (he is recognizable again in the mob breaking into the house at the end), and then two and three, and so on, ever more until there is something like a crowd. The originality and strength of Romero's movie lies in the ambivalence the audience feels as this crowd of the living-dead approaches: they are frightening and threatening—up close their mouths are unpleasant to behold—but we sympathize with these lurching, unsteady bodies, in their nightgowns and underwear and their pathetic faces showing a mixture of hunger and yearning. They can't help themselves.

The force that sets out to stop them—and in the morning (in the light of day) kills every one of them—is a sheriff and his deputies and attack dogs. Each deputy has a rifle, and the living-dead, seemingly so threatening when they overrun the house in the night, are pitifully few in the morning when they are being shot one

by one. The scene is Pennsylvania, but it recalls the newspaper photos of the sher-
iffs and their dogs attacking the peaceful marchers in the South. The indelible im-
ages are of the living-dead staggering toward the house and breaking into it, and
the police killing them one by one.

The sole black man, the last man alive in the house, believes that the approaching
police are the living-dead, out to eat his flesh, and the police (who metaphorically
are as he sees them), believing him to be another of the living-dead, shoot him.
The moment of rescue is both a police riot and a lynching, a moment of thwarted
law enforcement and a case of mistaken interpretation between whites and blacks.

The living-dead are less protesters than laborers, strikers, hunger marchers —
simply the oppressed, the untermenschen. Physically they recall William Vaughan
Moody's famous poem "The Man with the Hoe" (inspired by Millet's painting):
"stolid, stunned, brother to the ox" — very close, in movie terms, to the Haitian
zombies of *I Walked with a Zombie* (1943), the dead kept semi-alive in order to
serve a sorcerer master. Even more, they recall the strikers of *In Dubious Battle*,
after Joy has been killed, moving in relentlessly toward the deputies: "The guards
were frightened, riots they could stop, fighting they could stop; but this slow, silent
movement of men with the wide eyes of sleep-walkers terrified them".[177] Romero's
rioters do not anticipate in any way Mailer's Yippies in Chicago, but for one chill-
ing moment the Yippies in the darkened Lincoln Park make one wonder if Mailer
had seen Romero's film: "the night nonetheless not without horror, very much
not without horror, as if a fearful auto accident had taken place but ten minutes
before and people wandered about now in the dark with awareness that bodies
wrapped in bloodstained blankets might be somewhere off a shoulder of the
road".[178] There is even something carnivalesque about these weird figures stagger-
ing toward us across the lawn. The dead come alive is, after all, the reversal cele-
brated by Saturnalia.

The film begins with a brother and sister in a cemetery. The first of the living-
dead appears and attacks the sister, she is saved by her brother, who as a result
dies and becomes another living-dead. She escapes to the safety of the house, and
at the end the first zombie returns for her with the other living-dead (but, inter-
estingly it is her brother who takes her). The "riot" is, in short, initiated and con-
cluded by another rape-like attack. The scene inside the house focuses as well on

177. Steinbeck, *In Dubious Battle*, 128.
178. Mailer, *Miami and the Siege of Chicago*, 147.

the sexual: A pair of young lovers, trying to escape the house, die together in a fire (though not consumed because we see their body parts being eaten by the living-dead). And for contrast, the house also shelters a dysfunctional bourgeois family hiding in the basement (which at the time would have recalled the fallout shelters being built by those fearful of nuclear holocaust), the difficult husband who will not follow the sensible instructions of the African American. It is not clear whether his intransigence is racial, or jealousy of the one person with leadership qualities and common sense. What is clear is that he and his wife are killed and devoured by their daughter (although he has already been shot in self-defense by the black).

Though in a metaphorical sense the living-dead are the rioters, the protagonists are the escapees inside the house, from whose viewpoint it is a siege situation and an example of H.G. Wells's *War of the Worlds* fiction — as another movie version *The Invasion of the Body-Snatchers* (1956) suggests — of an alien nation that, like Steinbeck's Okies, has been left without sustenance and, in extremity, must kill our natives or die. With memories of the basement fallout shelter, they are the last traces of human life after an H-Bomb explosion, reinforcing the dimension of apocalypse we also saw in *Day of the Locust*. Both works portray the End of Days (the "resurrection" of the dead in Romero's film). For West, riot was apocalypse; for Romero apocalypse is, or takes the shape of, riot. Romero distances the reality of riot into allegory — those corpses are the strikers, the blacks, if not the Yippie protesters. Like *Day of the Locust*, expressing the imminence of World War II, Romero's film appeared at the moment when a social apocalypse seemed imminent. What followed were the Watts (1965), Stonewall (1969), Kent State (1970), Attica Prison (1971), Rodney King (1992), and Seattle (1999) riots.

The Hollywood premiere, the Democratic presidential convention, and Woodstock are all loci, first for a real riot, then for fictions of riot. Since the nucleus is equally disenchanted people, whether movie fans or Yippies/Hippies, they serve as a metaphor for public discontent without the point of some particular wrong to be righted; rather the intent is generally insubordinate — the adoration and/or lynching of the Star. These riots, fictional in their very nature, are further fictionalized by the artist — by Tod's painting and West's novel itself. West made his riot on the literary model of Pope's *Dunciad*; Mailer, with the help of actual events, made a riot on the model of Hawthorne's "Maypole of Merry Mount"; Romero on the model of the horror movie. Romero's film sums up in fabular form the fiction of riot for our time, supplanting the Whig-Tory fiction of Dryden, Swift, and Addison.

The basic elements are a house — "ship of state", carriage, or *locus amoenus* — that is besieged by rioters, who have become some kind of automata (no longer energized libertarians) with a single, local aim, whether higher wages or the hunger for human flesh. The other element is the police, who respond by killing the rioters. We begin with fear of the rioters, and then of the police whose intervention provokes pity for the rioters. The house is equally ambiguous: in *In Dubious Battle* it is the ad hoc domestic haven constructed by the strikers, which is attacked by the strike-breakers and police; in *The Siege of Chicago* it is the unlicensed encampment in the park; in the case of the Merry Pranksters it is the Kesey bus. Finally, there remains the hint of a human, private nucleus; the constant is a sexual act, ranging from the right's demonizing of riot as unnatural, rooted in what were regarded, going back to Augustine, as man's most disgraceful body parts, to the left's celebration of the same as Nature and "make love not war".

The distinctively twentieth-century riot was the peaceful or passive protest — in England carried out by the suffragettes, in India by Gandhi, in America by Martin Luther King Jr.; a protest that, as seen by the police, defied and incited them to reaction, from dragging away the rioters to killing them; seen by the protesters, a "police riot". In the twenty-first century, what? Why, in the present apocalypse of Wall Street, has no one rioted? Back in the 1900s some agitators like Steinbeck's Mac, seeing the state aligned with the employers, strikes and protests unavailing, struck back with dynamite. The anti-union *Los Angeles Times* building was bombed in 1910, and Wall Street itself was ineffectually bombed in 1920. With the failure of the riot, the natural, or only feasible, transition was from riot to terrorist attack, a strategy that has in the 2000s reached America from abroad, and the efficacy of the terrorist attack has replaced that of the riot. Riots are collective actions; though directed, or represented, by a cadre, they require the twelve or more people acting in concert. In America the public, pro-life, anti-abortion protests, and other demonstrations of the right, have minimal effect; the effect is not in riot but in the acts of the lone terrorist (from twelve reduced to one).

The police riot has compromised both seditious and festive riots. Seditious riot, in this country, has lost its efficacy to other forms of persuasion, ranging from the terrorist attack to the lobbyist. The festive riot, with much but not all of its seditious content sacrificed, has survived outside in rock concerts and sports events. Inside, the festive riot may remain in the film sequels to *Night of the Living Dead*. The aesthetic detachment of the horror, slasher, or "action" movie still recovers the festive aspect of riot while also, as in the old crowd ritual, domesticating riot,

putting it inside Everyman's living room alongside *Desperate Housewives* and *Masterpiece Theatre*. The artist—a Romero, a Steadman, or a Hunter Thompson—transforms a group of innocent people into a riot and in this respect replaces the police. The spectator also sets off and defines, like the police, the fact of riot by his or her response to the scene. The perception of the police, the artist, or the spectator now seems sufficient to define the affective riot.

Plates

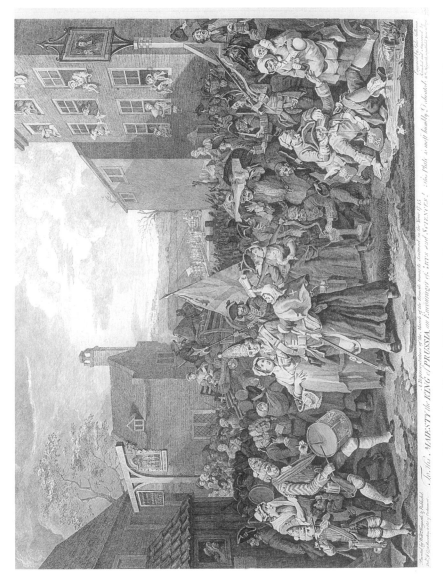

1. WILLIAM HOGARTH, *The March to Finchley* (1750), engraving. Ccurtesy of the Trustees of the British Museum.

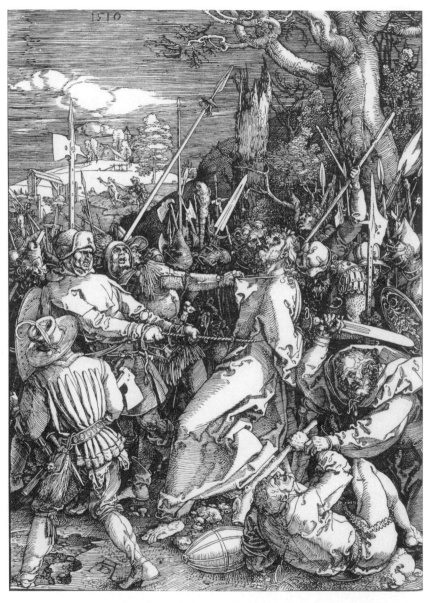

2. ALBRECHT DÜRER. *The Taking of Christ in the Garden* (from the *Great Passion*, 1510), woodcut. Courtesy of the Trustees of the British Museum.

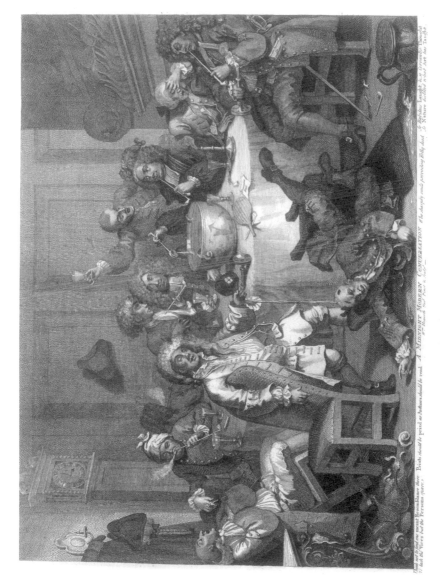

3. HOGARTH. *A Midnight Modern Conversation* (1733), engraving. Courtesy of the Trustees of the British Museum.

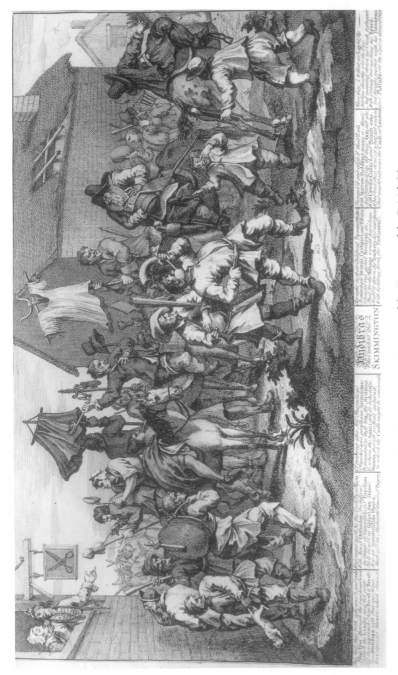

4. HOGARTH, *Hudibras and the Skimmington* (1726), engraving. Courtesy of the Trustees of the British Museum.

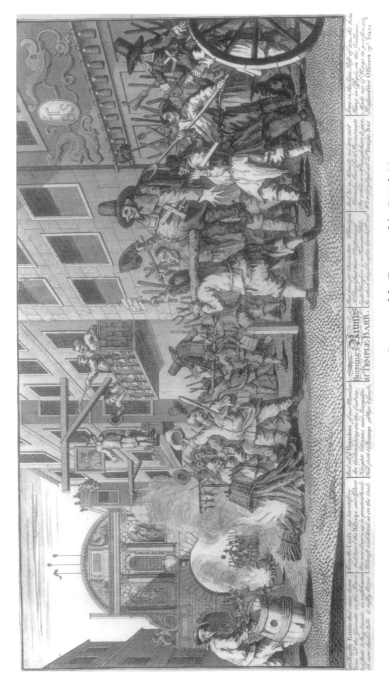

5. HOGARTH. *Burning the Rumps at Temple Bar* (1726), engraving. Courtesy of the Trustees of the British Museum.

130

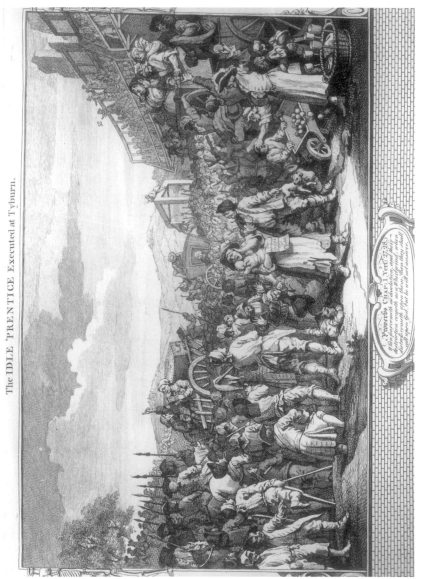

The IDLE 'PRENTICE Executed at Tyburn.

6. HOGARTH, *Industry and Idleness*, Pl. 11 (1747), etching. Courtesy of the Trustees of the British Museum.

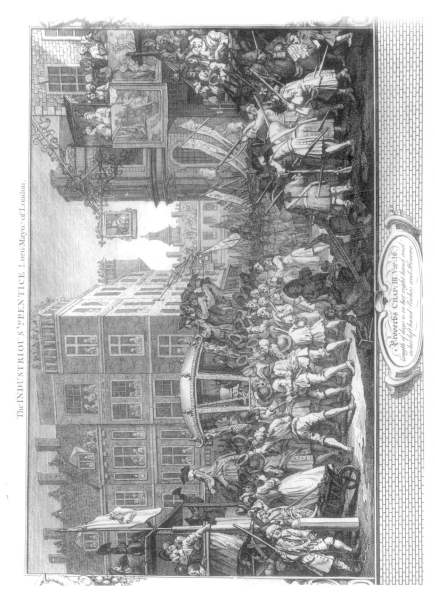

7. HOGARTH, *Industry and Idleness*, Pl. 12 (1747), etching. Courtesy of the Trustees of the British Museum.

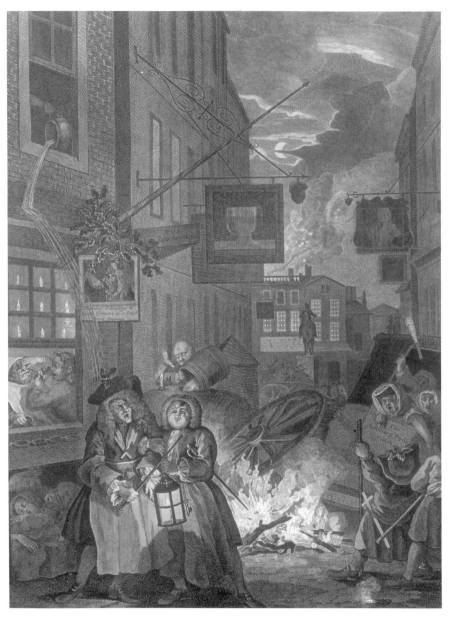

8. HOGARTH, *Night*, from *The Four Times of the Day* (1738), engraving. Courtesy of the Trustees of the British Museum.

133

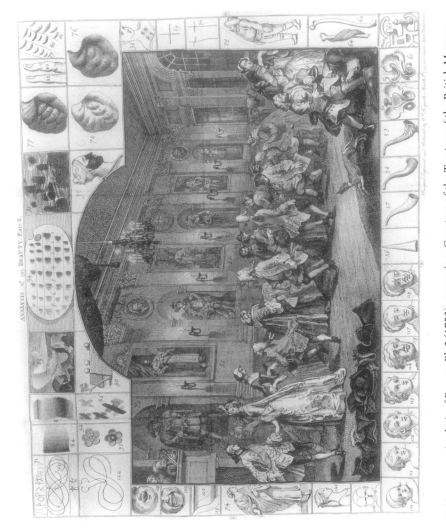

9. HOGARTH, *Analysis of Beauty*, Pl. 2 (1753), engraving. Courtesy of the Trustees of the British Museum.

134

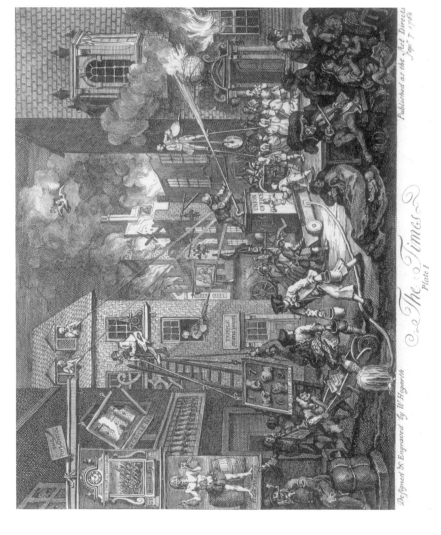

10. HOGARTH, *The Times, Plate 1* (1763), engraving. Courtesy of the Trustees of the British Museum.

11. HOGARTH, *Tailpiece, or The Bathos* (1764), engraving. Courtesy of the Trustees of the British Museum.

12. HOGARTH, *Gin Lane* (1751), engraving. Courtesy of the Trustees of the British Museum.

13. Hogarth, *Enthusiasm Delineated* (1761), engraving with pen markings. Courtesy of the Trustees of the British Museum.

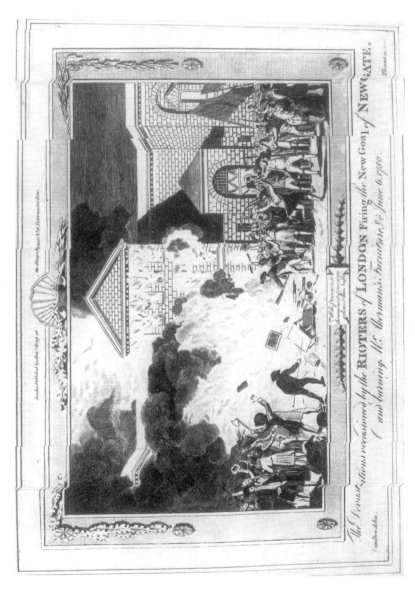

14. [?] HAMILTON, *The Devastation occasioned by the Rioters of London Firing the New Goal of Newgate* (1780), engraving. Courtesy of the Trustees of the British Museum.

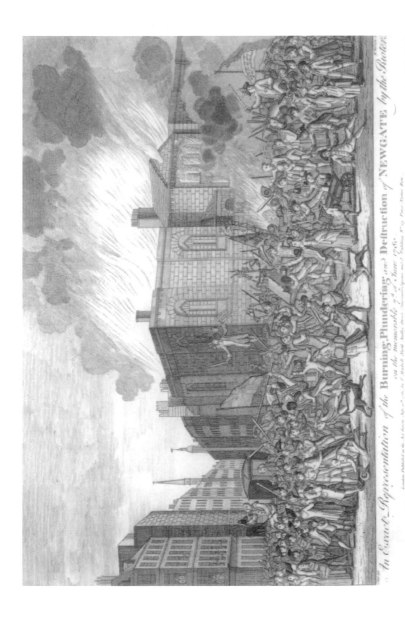

In Exact Representation of the Burning, Plundering and Destruction of NEWGATE by the Rioters

on the memorable 7th of June 1780.

15. O. Neil and H. Roberts, *An Exact Representation of the Burning, Plundering and Destruction of Newgate by the Rioters on the Memorable 7th of June 1780* (1781), engraving. Courtesy of the Trustees of the British Museum.

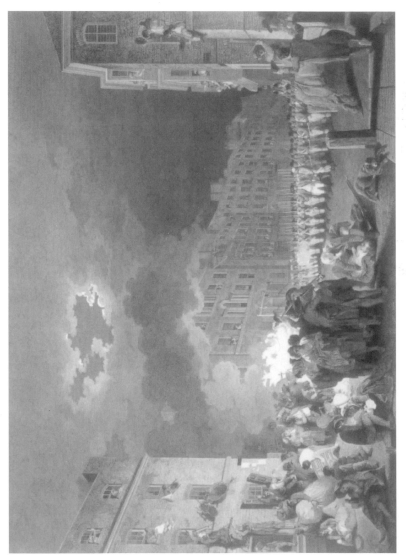

16. FRANCIS WHEATLEY, *The Riot in Broad Street* (1784), painting, engraved by James Heath (1790). Courtesy of the Trustees of the British Museum.

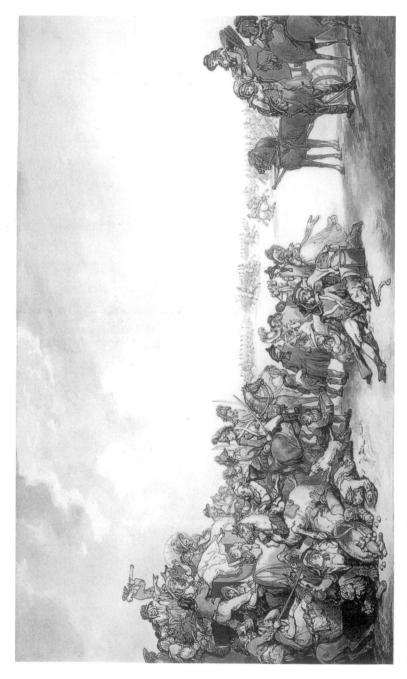

17. THOMAS ROWLANDSON, *The English Review* (1786), watercolor. The Royal Collection © 2009 Her Majesty Queen Elizabeth II.

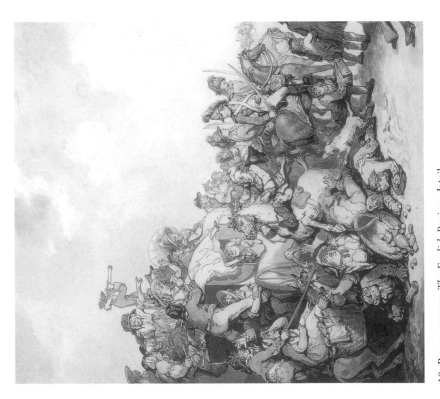

18. ROWLANDSON, *The English Review*, detail.

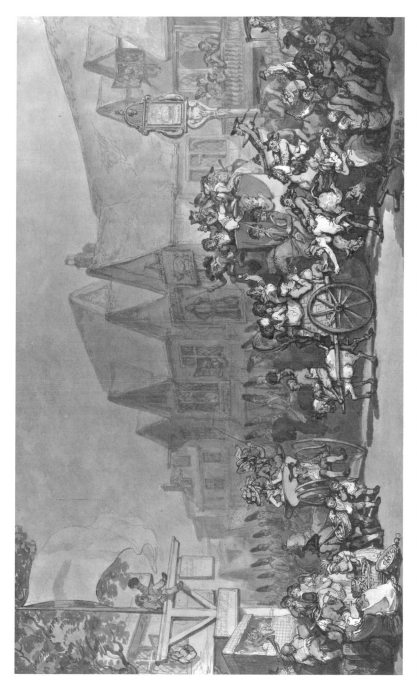

19. ROWLANDSON, *George III and Queen Charlotte Driving through Deptford* (c. 1785), watercolor drawing. Private Collection in England.

144

BY AUTHORITY.

PERSONS AND PROPERTY PROTECTED.

Published by S. W. Fores Caricature Ware-House Nº 3 Piccadilly London — Nov 26th 1785

20. ROWLANDSON, *Persons and Property Protected* (1785), etching. Courtesy of the Trustees of the British Museum.

THE WATER FALL, O-, AN ERROR IN JUDGMENT.

21. ROWLANDSON, *The Water Fall, or, an Error in Judgment* (1784), etching. Courtesy of the Trustees of the British Museum.

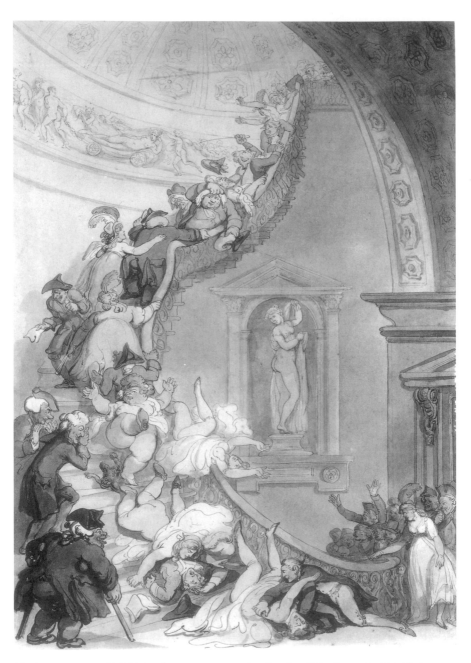

22. ROWLANDSON, *Exhibition Stare-case,* watercolor drawing. Yale Center for British Art.

THE SAD DISCOVERY or the GRACELESS APPRENTICE.

23. ROWLANDSON, *The Discovery or the Graceless Apprentice* (1785), etching. Courtesy of the Trustees of the British Museum.

24. JAMES GILLRAY, *A View in Perspective: The Zenith of French Glory* (1793),
etching. Gillray Folio.

25. GILLRAY, *Un Petit Soupir à la Parisiènne*, etching. Gillray Folio.

150

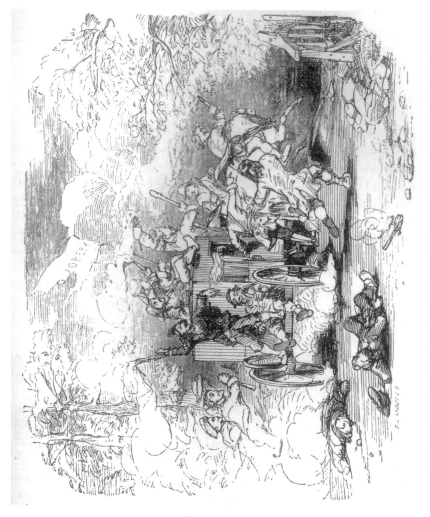

26. Hablot K. Brown ("Phiz"), "The Taking of the Coach", illustration for *Barnaby Rudge*, chap. 59.

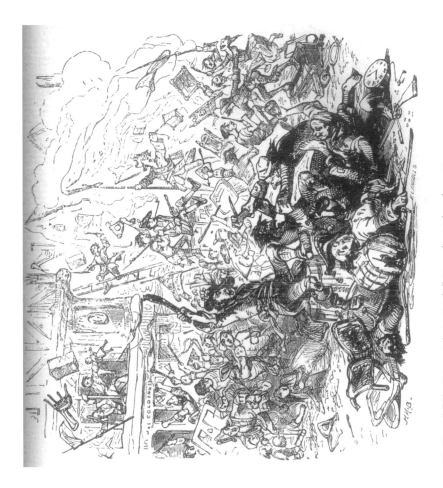

27. "Phiz", "The Riots at their Height", *Barnaby Rudge*, chap. 46.

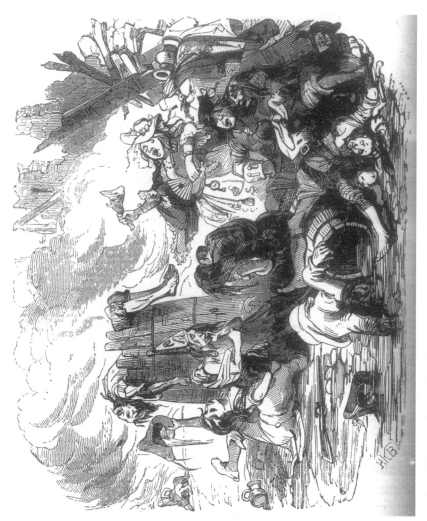

28. "Phiz", "Riot in the Distillery", *Barnaby Rudge*, chap. 69.

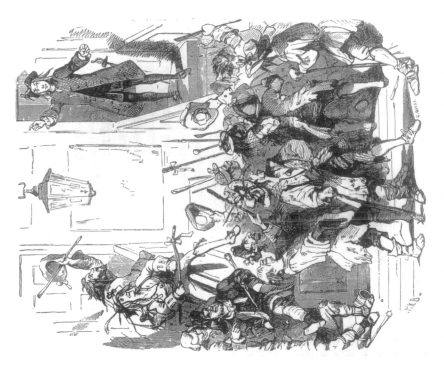

29. "Phiz", "Gordon and the Mob", *Barnaby Rudge*, chap. 49.

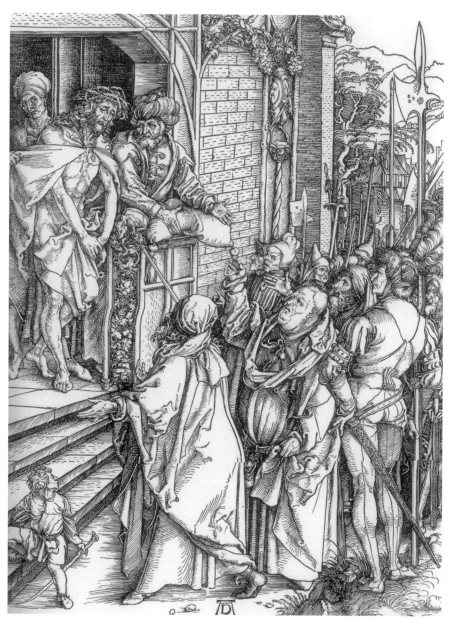

30. ALBRECHT DÜRER, *Ecce Homo* (from the Great Passion, 1510), woodcut. Courtesy of the Trustrees of the British Museum.

31. "Phiz", "Gabriel Varden and the Mob", *Barnaby Rudge*, chap. 64.

32. "PHIZ", "Mr. Chester Blushes", *Barnaby Rudge*, chap. 32.

33. GEORGE CRUIKSHANK, *Massacre at St. Peter's, or "Britons Strike Home"!!!*, etching (1819), Courtesy of the Trustees of the British Museum.

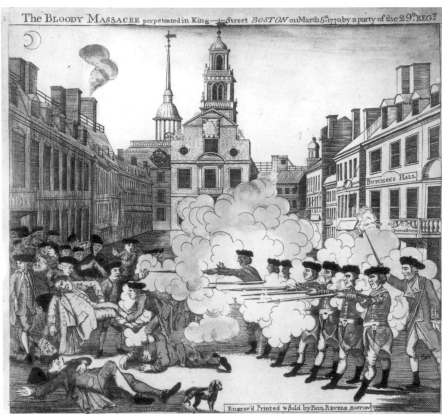

34. PAUL REVERE, *The Bloody Massacre Perpetrated in King Street Boston in March 5th, 1770* (1770), engraving. Yale University Art Gallery, The John Hill Morgan Collection.

35. WILLIAM JAMES MÜLLER, *Queen Square* (1831), lithograph by R. Cartright. © Bristol's Museums, Galleries & Archives.

36. MÜLLER, *Queen Square*, watercolor. © Bristol's Museums, Galleries & Archives.

Drawn on Stone by L Haghe.

CHARGE of the 3ʳᵈ DRAGOON GUARDS.

T. L Rowbotham, & W Müller delᵗ

37. MÜLLER, AND THOMAS C.L. ROWBOTHAM, *Charge of the 3rd Dragoon Guards upon the Rioters in Queen Square*, lithograph by L. Haghe (1831). Courtesy of the Trustees of the British Museum.

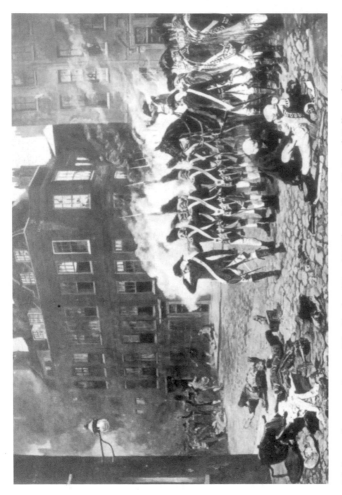

38. James Seymour Lucas, *The Gordon Riots* (1879), painting. National Gallery of Victoria, Melbourne.

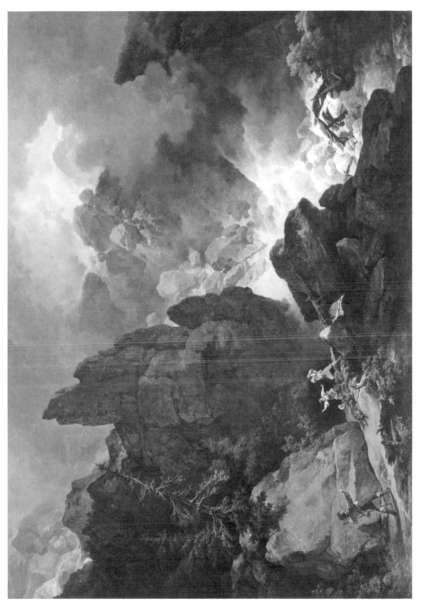

39. Philippe de Loutherbourg, *An Avalanche in the Alps* (1804), painting. Tate Britain, London.

164

40. J.M.W. TURNER, *The Fall of an Avalanche in the Grisons* (1810), painting. Tate Britain, London.

41. TURNER, *Burning of the Houses of Parliament* (1833), painting. Cleveland Museum of Art (John L. Severance Collection).

166

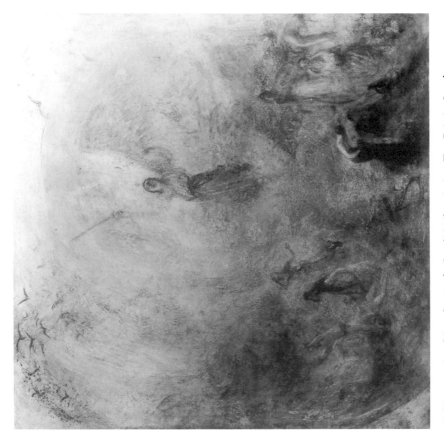

42. TURNER, *Angel Standing in the Sun* (1846), painting. Tate Britain, London.

43. Ross A. Lewis, "Sure, I'll work for both sides", cartoon, *Milwaukee Journal* (1939).

44. COVER, the *New York Review of Books* edition of Norman Mailer's *Miami and the Siege of Chicago* (2008).

45. Ralph Steadman, Untitled drawing, from *The Scar Strangled Banger* (London: Harrap Limited, 1987).

Acknowledgements

The central section of this essay was delivered as part of a symposium on the Gordon riots at Roehampton University in July of 2008. My thanks to Ian Haywood, the chair, for his invitation and hospitality. The essay recalls two books I published in the '70s and '80s. The subject of the crowd was dealt with at greater length in *Popular and Polite Art in the Age of Hogarth and Fielding* (1979) and I might have called the present essay *representations of riot* since it is an adjunct to *Representations of Revolution* (1984). Parts of Chapter 3 appeared as "Four American Riots" in *The Hopkins Review*, autumn 2009. I am particularly indebted to Susan de Sola Rodstein for the talks we had over Scott's *Raj* novels and for her study of the strategies authors use to embed or alter violent topical events, "Invisible Empire: Event and Revision in Modern British Fiction" (Johns Hopkins doctoral dissertation, 1997). My thanks also to Brian Allen, Julia Carver, Colin Dayan, John Irwin, Karen Lawson, Richard Macksey, Ann Stiller, and especially, DeAnn DeLuna, who saw the book through the press.

Index

References are to artists and scholars.